Living the Creative Life

IDEAS AND INSPIRATION
FROM WORKING ARTISTS

RICË FREEMAN-ZACHERY

NORTH LIGHT BOOKS

Cincinnati, Ohio

11 10 09 08 5 4 3 2

Library of Congress Cataloging-in-Publication Data

Freeman-Zachery, Ricë.
 Living the creative life : ideas and inspiration from working artists
/ Ricë Freeman-Zachery.
 p. cm.
 Includes index.
 ISBN 978-1-58180-994-7 (alk. paper)
 1. Art--Psychological aspects. 2. Creation (Literary, artistic, etc.)
I. Title.
 N71.F657 2007
 701'.15--dc22

 2006102898

Distributed in Canada by Fraser Direct
100 Armstrong Avenue
Georgetown, ON, Canada L7G 5S4
Tel: (905) 877-4411

Distributed in the U.K. and Europe by David & Charles
Brunel House, Newton Abbot, Devon, TQ12 4PU, England
Tel: (+44) 1626 323200, Fax: (+44) 1626 323319
E-mail: postmaster@davidandcharles.co.uk

Distributed in Australia by Capricorn Link
P.O. Box 704, South Windsor, NSW 2756 Australia
Tel: (02) 4577-3555

F+W PUBLICATIONS, INC.
www.fwbookstore.com

Editor:
Jessica Strawser

Designer:
Maya Drozdz

Production
Coordinator:
Greg Nock

Photographer:
Al Parrish
unless
otherwise
credited

Dedication

TO THE EVER-GORGEOUS EARL

Acknowledgments

I have always been lucky in having wonderful editors, and this adventure was certainly no exception. Tonia Davenport championed the idea from the very start, and it wouldn't exist without her enthusiasm and diligence. When she turned the project over to Jessica Strawser, the book—and I—were placed in the most capable of hands. Jessica has been both a joy and a huge help. Plus she has a good sense of humor—always a wonderful thing in an editor!

The artists you've met here are truly amazing: They're all working artists wearing multiple hats and juggling lots of balls at once (now there's an image for you!), yet they took the time to answer dozens of questions and help me sort out which title went with which piece of art. Their generosity in sharing their stories and their work is wonderful, and this book wouldn't exist without it. I am ever so grateful to them all.

I'm especially grateful to Susan Shie, who believed in the book way before it ever began and encouraged me throughout the process; and to Violette, who drew many of the illustrations just for these pages. Her enthusiasm and generosity are inspiring, indeed.

Thanks also to those who provided images of Melissa Zink's far-flung art: Parks Gallery in Taos, New Mexico, Frank Silverstone in New York, and Bette Brodsky of *New Mexico Magazine*, which published the wonderful book *Zink, The Language of Enchantment*, by Hollis Walker.

Please visit the artists' Web sites, listed by their photos, to see more of their artwork. If we'd had one thousand pages in this book, we would have shown it all.

And, of course, I owe everything to my husband, Earl. Being the partner of a writer/artist is not an easy life, but he handles it with grace and good humor, cooking meals and cleaning the house (including the toilets!) and making me laugh. A lot.

About the Author

Photo by Ricë Freeman-Zachery

Ricë Freeman-Zachery has been writing since her daddy taught her how to print when she was five and she started her first diary. She taught college composition for eight years before ditching academia to become that oddest of creatures: a freelance writer. She has written for a variety of magazines and writes regularly for *Art Doll Quarterly*, *Belle Armoire*, *Legacy*, *Somerset Studio* and *Rubberstampmadness*. She has written two previous books: *Stamp Artistry* and *New Techniques for Wearable Art*.

Ricë has been making fabric art as long as she can remember and writes extensively about her creations; you can find her journal clothing in many books and magazines. She lives in Midland, Texas, with her husband, The Ever-Gorgeous Earl, and an impressive herd of cats. She spends most days in her pajamas, asking artists nosey questions, making things out of fabric, and celebrating the joy of living The Creative Life.

You can reach Ricë at voodoocafe@clearwire.net or www.voo-doo-cafe.com. Be sure to read her blog at voodoonotes.blogspot.com for information about workshops, appearances and book signings—as well as just the creative life in general. You can also join The Creative Life online group at groups.yahoo.com/group/thecreativelife.

CONTENTS

a le plaisir de vous offrir
gracieusement ce journal
et vous souhaite une agréable journée

Introduction: The Creative Life

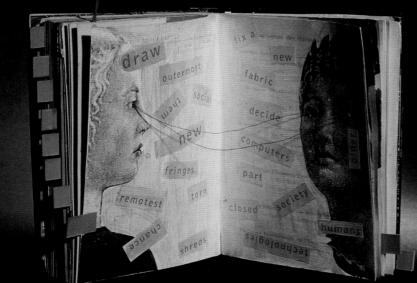

A spread from an altered book by artist Sas Colby. This 2004 work, titled *Harmonika*, features ninety-seven pages with mixed-media techniques.
Photo by Kate Cameron

What is creativity? Where does it come from? Do we all have it, or is it a gift to just a few of us? What can we do to be more creative?

These are questions you hear people talking about all the time. My recent Internet search for "creativity" yielded almost 200,000,000 hits. Granted, many of those were for workshops for business creativity or creativity coaching, but just the fact that there is discussion of either of these topics—the fact that creativity coaches even exist—shows you what widespread interest there is in creativity. For me, the questions people ask about creativity have always been interesting, but even more interesting are the other, deeper questions: What does creativity feel like? Where do artists find inspiration, and what do they *do* with it once they find it? How does it feel when they first realize an idea is going to work?

As a writer for a number of art-related magazines, I have interviewed countless artists. I get to ask them about how they work and where they get ideas, but an article never seems long enough to really delve into their views on creativity and inspiration.

As I've met so many talented artists and marveled over the lives they've crafted for themselves—lives that give them space and freedom to do what they have to do in order to make their work—I began to wonder how much a factor that freedom is in being able to create. Which is true: artists have to resist the rules of society in order to create most fully, or it's important to live a regular, sensible life and spend all your creative energy on making art? Some of the artists make their own clothes and have funky hairstyles and painted cars, but most would blend right in with a roomful of accountants. Does that reflect the way they view creativity?

So I started thinking about writing a book. I didn't want academic research, with charts and tables and graphs about creativity. That would be like trying to describe the taste of an artichoke using only numbers. No, what I wanted was musing about what it feels like to get an idea, and how you can live a life that welcomes and nurtures those ideas and the creative sparks that crackle up from somewhere in our soul. Well, what better way than to ask. And since I'm lucky enough to have

met dozens of the most creative people in the universe, who better to do the asking?

I hand-selected fifteen diverse, prolific and successful artists to interview in depth for this project. Over the course of several months, I asked them everything I always wanted to know about creativity. The result is this book, a compilation of these artists' fascinating insights alongside plenty of their inspirational artwork.

How do some people fashion these incredibly creative lives that not only let them do what they love to do, but allow them to make a living at it? Maybe it's a tiny living—but it's a pretty good one. If you spend every day doing what you love and are still able to keep the lights on and put food on the table, you must be doing something right!

How do people do that? How do you craft a life that's filled with inspiration and energy, joy and discovery? What is it that allows some people to live a life like that? What can the rest of us do to get a little bit more of that in our lives?

Let's find out!

A collection of antique keys from around the world and other artistic inspiration in the studio shared by artists Gail and Zachariah Rieke.
Photo by Gail Rieke

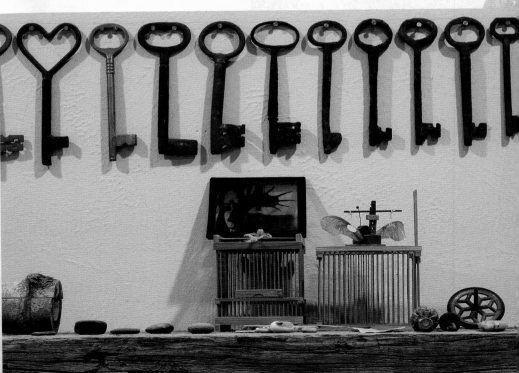

MEET THE ARTISTS

Who are these artists who've bared their souls and their studios and their art so that we can get a glimmer of what it means to live the creative life? You've seen their work in galleries and in books and on the pages of your favorite magazines. You've read their interviews and, if you're lucky, you've taken their workshops. But tell the truth: You really want to know more, and you'd give half your art supplies to spend a day in their studios, looking over their shoulders, finding out about their lives and how they work. Wouldn't it be great if you could visit them all? Yes, indeed! But it would be a long, long road trip. Your travels would take you across the United States—with stops in Ohio, Missouri, Texas and New Mexico, to name only a few—and all the way up to British Columbia.

If you could take that trip and meet them all, you'd find that some are young, and some are in their sixties and seventies. Melissa Zink has been a self-supporting full-time artist for over three decades; others teach workshops in their field or pursue other creative endeavors to supplement the income from their artwork sales. Sas Colby has been teaching summer sessions at Georgia O'Keeffe's Ghost Ranch, near Taos, for many years, and Claudine Hellmuth and Michael deMeng travel internationally to teach workshops in collage and assemblage, among other offerings.

You'd find some of our artists painting on canvas and some making jewelry and some stitching on fabric. Since, however, you probably don't want to drive all those miles to meet them all in person, we've invited them all here, where you can brew a cup of tea, settle back against the cushions, and turn the page.

Sas Colby began her art career in the 1960s with textile art—wall hangings, quilts, garments and masks. After a divorce, she moved to California to pursue the creative life and hasn't looked back. For many years, she's taught a summer art retreat at Ghost Ranch, the home of Georgia O'Keeffe. She makes her winter home in Berkeley, California. You can see more of her work at *www.sascolby.com*.

Photo by Ralph B. Colby

Wendy Hale Davis is a bookbinder in Austin, Texas, but binding books is just part of the art life she's created around the book form. She teaches book structure and calligraphy, but she's quick to point out that the journal is her primary art form—and once you've seen her journals, you can see why. From the inlaid handmade leather covers to the elaborate illustrations, every volume is a work of art. Check out more of her work at *www.home.earthlink.net/~worldbridger*.

Michael deMeng is a jewelry and assemblage artist living in Missoula, Montana, where he creates works of art from things other people throw away. He is the author of *Secrets of Rusty Things*, and he travels extensively to teach at art retreats, where his classes are always a huge hit. You can see more of his work at *www.michaeldemeng.com*.

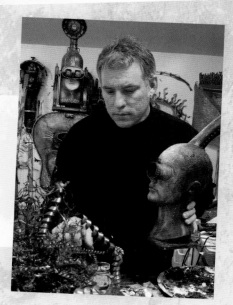

9

BEAN GILSDORF is an art quilter in Portland, Oregon, where she also creates sculptures and installations. While she usually works alone, she sometimes collaborates with her husband, Dan. Art is her "day job"; at night, she teaches English at Portland Community College, believing that contact with other humans is a nice way to balance her creative life. Visit her at *www.beangilsdorf.com*.

CLAUDINE HELLMUTH is a mixed-media artist and the author of two books, *Collage Discovery Workshop* and *Collage Discovery Workhop: Beyond the Unexpected*. She lives in Orlando, Florida, with her husband, two cats and a dog. She creates artwork, both for commission and for sale, and travels extensively to teach workshops on her techniques. You can see more of her work at *www.claudinehellmuth.com*.

REBEKAH HODOUS says simply, "I am a bead artist." She spends eight hours a day in her Cleveland, Ohio, studio sewing beads by hand, intensely painstaking work that she loves. She says that anything she can't find locally can be shipped right to her front door. See more of her fabulous beadwork at *www.hodous.com*.

WENDY HUHN is an art quilter who was given her name after her older sister saw the movie *Peter Pan*. She lives in Dexter, Oregon, in a log cabin that she says has "multi-room hippie construction." Her quilts are immediately recognizable for their flawless construction and wonderful color, but what captures people and brings them back are the kitschy 1950s images. Check them out at *www.wendyhuhn.com*.

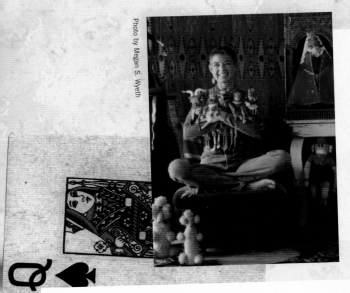

KELLY BUNTIN JOHNSON hates labels and will happily tell you what she *does*, rather than what she *is*. She's an artist, but that's not a title she uses. She spends her days on a farm outside Dearborn, Missouri, in a wonderful studio above what used to be a carriage house. She makes Holy Dolls and Intercessors, elaborately constructed and finely beaded creatures with detailed histories and protective properties. She also has a great wardrobe of vintage clothes and a really cool haircut. Find out more about her at *www.diddy-wa-diddy.com.*

SCOTT RADKE makes puppets, but they're not like any puppets you've ever seen before. His are wonderfully quirky characters that emerge only briefly from Scott's Cleveland, Ohio, studio before being snatched up by dedicated fans across the country. His first puppet was created to woo the woman who is now his wife—and the mother of his daughter, who's growing up in the middle of Scott's home studio. See more of his puppets—before they get away—at *www.scottradke.com.*

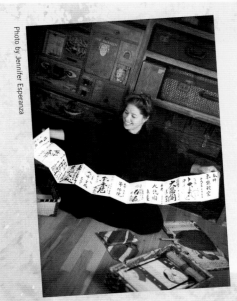

GAIL RIEKE is a mixed-media artist and travel journaler living in Santa Fe, New Mexico, where the home she shares with her artist husband, Zachariah, includes fabulous custom walls and shelves that are artworks all by themselves. She teaches and leads travel-journal retreats to Japan. (Here she is shown with her "pilgrim's book" of stamps and calligraphs from temples she's visited in and near Kyoto.) She and her husband host an open studio every August—it alone is worth a trip to northern New Mexico. See more of her work at *www.riekestudios.com.*

SUSAN SHIE is a visual artist in Wooster, Ohio, working in "writing, drawing, painting and sewing." Most of us think of her as a fabulous art quilter whose wonderfully funky wall pieces are so detailed it takes hours, literally, to see everything on one of them. Her favorite tools are, she says, "paintbrushes, my airbrush and air pen, and my Pfaff 1473 sewing machine." Visit her Web site and online journal at *www.turtlemoon.com*.

Photo by Jimmy Acord

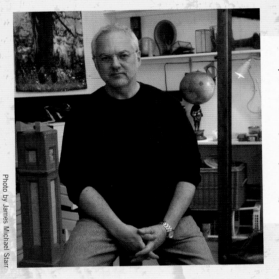

Photo by James Michael Starr

JAMES MICHAEL STARR is a Dallas, Texas, artist whose collages and found-object sculptures have appeared in galleries and exhibitions in the United States and abroad. His work was selected for four consecutive Critic's Choice exhibitions at the Dallas Center for Contemporary Art and included by invitation in the 2001 International Exhibition of Contemporary Collage in Paris, France, as well as in Assemblage 100, which toured New Zealand in 2004. He is represented by Conduit Gallery in Dallas and by Hooks-Epstein Galleries in Houston. You can see more of his work at *www.jamesmichaelstarr.com*.

VIOLETTE lives in a purple Magic Cottage in White Rock, British Columbia. She works as an illustrator and art educator, but her true passion is, well, passion: her Glitter Girl Van, her Magic Cottage, and her fanciful wardrobe are her ways of spreading the joy of creativity and self-expression everywhere she goes. Her creativity blog gets hundreds of hits a day from people around the world who learn, through Violette's example, that the creative life is a joy, indeed. Check it out at *www.violette.ca*.

Photo by Reinhard Boerner

LINDA WOODS, of Valencia, California, is a mixed-media artist and author. Her primary art form is the visual journal, and her work is inspired by her life and "the people, places and events that make up my days." She's written two books: *Visual Chronicles* and *Journal Revolution*. See more of her work and read her blog at *www.colormetrue.com*.

Photo by Dustin Woods

Photo by Robbie Steinbach, courtesy of *New Mexico Magazine*

MELISSA ZINK had a retrospective of her work at The Harwood Museum in her hometown of Taos, New Mexico, in the fall of 2006 in conjunction with the release of *The Language of Enchantment*, a book about her work. She makes mixed-media wall art and bronze sculpture, but her decades-long career has included scrimshaw and ceramics, as well. She is represented by Parks Gallery in Taos, and you can see more of her work at *www.parksgallery.com/artist_info.php?artistID=15*.

Now that you've met the artists, let's find out what they have to tell you about living the creative life—you're in for a real treat and a fun ride, and you don't even have to leave your favorite chair!

What *Is* Creativity, Anyway?

chapter 1

What do you think of when you think of a "creative life"? Do you think of some famous designer jetting back and forth across the Atlantic, creating living spaces for the Rich and Famous? Or do you imagine an artist painting wildly year after year in a tiny attic in Paris, slowly starving and going mad? Or maybe you think of Martha Stewart on a good day, pre-jail term. Regardless of what comes to your mind, one thing is certain: Most of us certainly wouldn't think of our own lives.

The creative life, if we had to define it, would require more money, more time and way more imagination than we possess. We'd have to get rid of our old life—our drab house and our boring job and our tired friends. We'd have to completely change everything about the way we've lived up to this point to have a truly creative life.

But that's not what it's about, of course. You know that already. We don't have to get rid of anything but our way of looking at the world. You don't have to change your wardrobe or your politics or your religion or your social circle. All you have to change is one thing: Instead of looking at the world as it is, look at everything as being full of possibilities. Instead of seeing what is, look for what could be. If you're an artist, you look at everything as a possibility and inspiration because you know that ideas can come from anywhere.

SeaRching foR youR HigheR Self

Violette says, "I truly believe that everyone is creative, but some people 'allow' the flow more readily than others." Her work, seen here, has a very distinctive style.

Violette, an illustrator and art educator in White Rock, British Columbia, believes creativity is out there, filling the universe. Creativity is "opening up to the Source/Spirit/Universe and becoming a vessel for inspiration to pour through you in an unadulterated fashion." This idea—of there being a stream or pool of creativity that is available for everyone to tap into—is a popular one, and many people believe that our task is to learn how to do the tapping in. There are all kinds of workshops that teach students how to do this, often with great success, giving people the confidence that creativity is out there, ready to be accessed, instead of being some elusive trait buried deep inside themselves, something they just can't seem to reach.

Wendy Hale Davis, a bookbinder, musician and journal artist in Austin, Texas, says: "When I lived on the reservation—Rosebud Sioux—I took a class in singing. The guys always said the songs 'just came to them'; they didn't write them. It was like they were a channel. I am not a religious person at all, and not even a particularly 'spiritual' person, but this is what [creativity] feels like to me—that I am a channel for something coming through me from the universe."

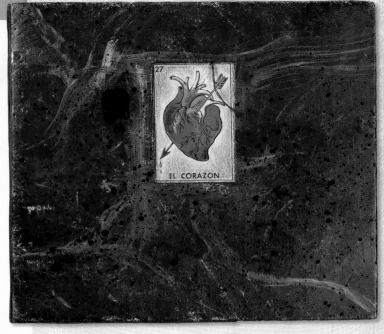

"Creativity is the ability to pull things out of one's self or the universe or wherever you think stuff comes from, and give it shape and form," says Wendy Hale Davis, creator of the *El Corazón* journal cover, made from dyed tyvek, shown here. "I truly don't know where it comes from."

ART RETREATS

There are all kinds of art retreats, from the big national ones like Artfest, Art Continuum, Art and Soul, and Art Unraveled to smaller, local ones. The good ones—and you can find out more about them by doing a little research on the Internet—can be marvelous opportunities to explore your own creativity. Here are some things to think about if you're considering attending a retreat:

Cost: This varies, and the big retreats can come with hefty price tags when you add in airfare and lodging. Think about sharing a room with a friend or staying off-campus, if that's a possibility. Or think of it as a vacation-cum-birthday-present and start a savings account just for this.

Time: Lots of people plan their yearly vacation around their favorite retreat. Often, these are held in cities that offer plenty to do for the rest of the family, so you can spend the day taking classes while your partner takes in the sights. If you don't have enough vacation time for a weeklong retreat, check into smaller, local weekend retreats.

Pressure: While the idea of being in the company of a whole gaggle of other artists may seem intimidating, most of these retreats are designed to provide a safe, encouraging atmosphere for artists at all levels, from the beginner just discovering her passion to the accomplished painter who wants to find out more about collage. Most retreats ask participants for feedback about the instructors and classes in order to keep the energy positive and supportive.

What does "creativity" mean to you? In your journal (or on a piece of paper if you haven't yet succumbed to the lure of keeping a journal or sketchbook), make a list of the creative things you've done. Do you think of creativity broadly, in terms that include any activity that requires your imagination? You might list:

* *Making up songs in the shower*
* *Inventing bedtime stories for your nephew*
* *Cooking from scratch*

Or is your definition narrower? Do you have requirements that must be fulfilled before you believe you've done something creative? Your list might look like this:

* *Painted a picture with oils*
* *Wrote an outline for a screenplay*
* *Took a roll of black-and-white photographs and developed them myself*

There is no right or wrong way to define creativity, as long as it's your way.

James Michael Starr, a collage and assemblage artist, writer and filmmaker in Dallas, Texas, believes creativity is innate. "I believe true creativity is a uniquely human intellectual activity that resides in every individual. In my opinion, it usually appears and functions in connection with some interest or ability we're born with or develop over time. For instance, I believe that I was born with or developed an affinity for communication. In addition to my visual art, I like to write. And so creativity in me will most often reveal itself through some form of communication, even if it is the relatively inscrutable medium of my visual art. Even someone at the other end of the spectrum of rationality, perhaps a scientist, can exhibit creativity in a field we don't think of as being creative." So there are two ideas about where creativity comes from: out in the universe, and deep within all of us.

One of my creative outlets is the clothes that I alter, create and wear. People are always asking about my painted shoes or my altered clothes and then saying, "You're so creative," often admiringly, but just as often sounding like what they really mean is, "You're so weird." People aren't really sure what to say about things that are different, things that aren't cookie-cutter copies of familiar objects. "Creative" becomes a catch-all term for anything out of the ordinary: "creative carpooling," "creative marketing," "creative infrastructure design." Anything that doesn't follow the standard path, the flow chart or the laid-out-on-a-grid blueprint is called "creative." Someone who makes his meals from scratch is "creative" compared to people who eat most of their meals from fast-food bags. And someone who makes her own clothes is "creative" compared to people who buy their entire wardrobes at the mall. Is that what we mean when we use the word "creative"?

Most of us have a tendency—or even an inherent need—to define and categorize people and things, even though we really aren't in favor of doing so. We naturally want to know what things are and which side of the line we land on. We're willing to concede that there are all kinds of ways to live a creative life, from arranging fresh flowers in jars to painting the walls of our studio a color we have custom mixed at the paint store. Some people refer to that kind of creativity as being crafty, and there's a whole new interest in craft, from DIY magazines to television shows that feature projects from artists in almost any medium you can think of. Craftiness is where you see something in a book or magazine and figure out how to do it yourself. Where you take the sleeves from one dress pattern and the skirt from another and put them together in a fashion hybrid with a flair that's all your own. Where you can take recipes and combine them into dinners that win raves from all your friends. Crafty is not a pejorative term. It's a good thing, and saying someone is crafty is a compliment.

IMAGINATION, INNOVATION AND CREATION

Let's play devil's advocate for a minute, shall we? Let's consider these three terms: imagination, innovation and creation, or creativity.

Imagination is defined, loosely, as mental creativity. It's thinking up new things, getting ideas you haven't had before and haven't been exposed to anywhere else. So if you sit at your work table and dream up an outfit you'd like to submit to this year's Bernina fashion show—say, a tribute to Greek mythology's Leda, completely comprised of white feathers with a ten-foot train—that's imagination. You've thought of something that doesn't exist and have made it real in your mind.

Let's say that, instead, you take an existing outfit, some old ensemble that's seen its time, and change it. You bleach all the color out of it and sew a line of feathers at the hem of the jacket. That's innovation—"changing or altering by introducing something new to an existing object."

You can see where we're going with this, right? You're sitting at your work table and you get the idea for Leda's gown. You open your journal and make some sketches, check the Internet to find out how big swan feathers are and then check sources to be sure swan feathers are actually available. You wrestle that huge roll of butcher paper onto the floor and begin drafting the pattern, adding details as you work. Then you make the dress in muslin and make some adjustments. You then order the fabric, the feathers, the beads, the netting for the train. You spend the next six weeks constructing the dress, which began in your mind but now, at last, exists in real life, on a mannequin in your studio. That's creativity. Of course, it doesn't have to be that much work—not every creation requires swan feathers!

With those distinctions—imagination, innovation, creation—you can begin to think about what creativity might mean, in concrete terms. "To create" means to bring something into being from nothing. Having those labels can be handy in thinking about what creativity means to you.

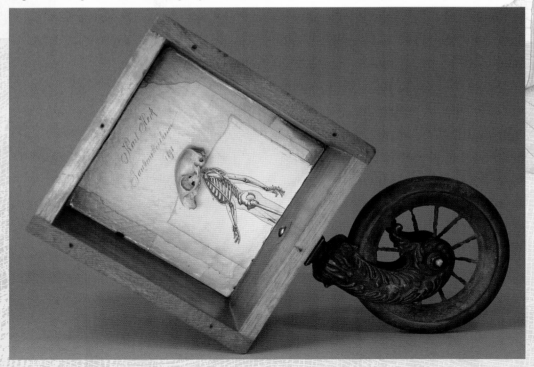

James Michael's unique 2006 assemblage piece *The Short Life of Karl Heck*—made from a wood box, piano wheel, book pages and a squirrel skull—is shown here. He says, "I won't speak for other people and can only speak for myself, but I believe that, as an artistic person, I am actually no more gifted creatively than anyone else, only that I was encouraged at an early age to express myself and developed particular skills, like those requiring hand-eye coordination. These factors opened the door for my creativity to come out in the form of the art I create."

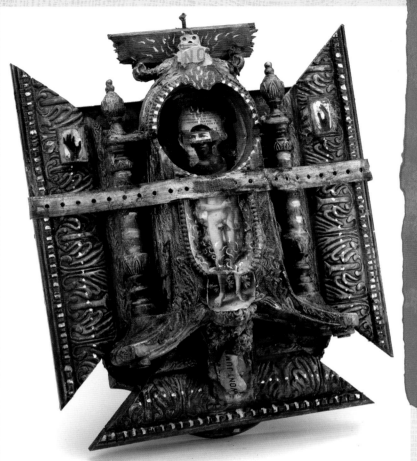

try this

Take a sheet of paper and divide it into thirds. In the first column, write "Imagination." In the second, write "Innovation" and in the third, write "Creativity." Then go back and try to list at least half a dozen things you've done in the past week that would fall into each category. Did you daydream a painting in shades of blue and turquoise that exactly matched the colors of the sea outside the window of your mother's house? Did you think of a way to improve the existing layout of your studio space by employing the principles of feng shui? Did you do a drawing that captures the look on your dog's face just before he falls asleep on the foot of your bed? If it was easy to list half a dozen, try doubling that. Then look back over your lists and notice the differences between them. Which things gave you more satisfaction? Which were easier? Which were more demanding? Don't think of some as being better than others; instead, think of how you can get the most satisfaction from your creative life and work to expand the opportunities to pursue those things.

"No person completely creates from nothing," says Michael deMeng, creator of the assemblage titled *Adam* shown here. "People are always influenced by something or someone."

IDEAS AND INFLUENCES

In the studio, though, the labels get tossed into the scrap box, and all the categories become blurred. Working artists don't have time to quibble about whether something is 100 percent brand-new, never-been-seen-on-the-planet-Earth-before unique. They make what they make, ending up with something that wasn't there before. Creativity is the ability to do that—the ability to bring things into existence. Michael deMeng, a mixed-media assemblage and jewelry artist in Colorado, likens that ability to something almost divine.

"Creativity is the process of acting like a god. From nothingness, to create something." If you look at it that way, it seems almost impossible to achieve. But Michael says, "This said, I see the act as being like a martini shaker, in which you add all those ingredients that you like or admire. Three parts Picasso, two parts Joseph Cornell, seven parts Mexican Folk Art, a splash of abstract expressionism, and garnish with a twist of Dadaism. Strain into a martini glass, and voilá … what comes out is one of a kind." For Michael, the act of creating is more definitive than what sparks the impulse. So much so that he says, "In my view, creativity is rampant thievery mixed with reinterpretation." He's not talking about the kind of

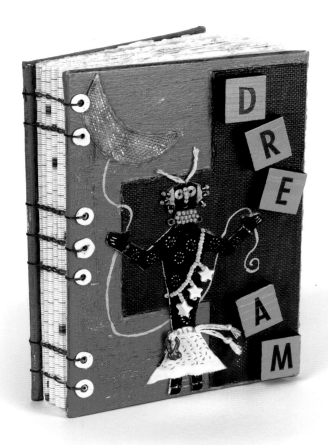

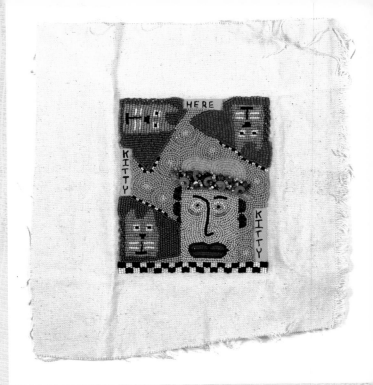

Kelly Buntin Johnson believes that innovation is an important part of creation. Above left, her *Dream Journal* is a coptic-bound book with hand-torn pages and a handmade book cloth cover, painted and embellished with a two-dimensional beaded leather figure she calls an Intercessor. Above right, *Here Kitty Kitty* is a work of glass seed beads sewn on canvas, created to be the cover of a children's book.

thievery we're all too familiar with, where you open a book or magazine and think, "Oh, look. More work by X," but then read the credit and find it's not X's work, but someone else's, someone who has managed to make her work look exactly like X's. Nope. Michael's talking about a kind of thievery that's not copying but influence: taking so many parts of so many things that only the human brain could synthesize them into something that makes sense.

Kelly Buntin Johnson, a figurative and bead artist who lives on a hilltop outside Dearborn, Missouri, sees innovation as one true form of creativity. She says, "In the antiques world there is a phrase, 'a make-do.' It refers to a mended

or transformed piece that was destined for the rag bag or the junk pile but, because of someone's frugality and ingenuity, was rescued and given a new purpose. It is this act of saving, mending or transforming an object so that it can continue to be useful that is one definition of creativity for me. The evolution of an object." Transforming something, or innovating, is another way of making it new, making something that wasn't there before.

That's the creativity we're talking about here: the kind that begins with ideas and influences and ends in something new, something exciting or something shocking or odd or amazing. That kind of creativity wakes you up in the middle of the

night with ideas that propel you into the studio and fill your brain with sparks, and you have no idea where they came from. Oh, sure—you recognize a bit of something from an old 1940s movie, and maybe that part over there is the same color as that billboard you pass on the way to the gym every morning, and over there is a shape that looks rather like the distributor cap on your 1983 Toyota. But all together like that? Where did that come from? It seems to come from out of nowhere, or from deep in some region of your brain you can't always access consciously. We'll be talking more about that in Chapter 3.

How does creativity work, then? Most of us think there's a right way to do everything, from the "right way" to brush your teeth (up and down, not side to side) to a "right way" to paint a picture (like Rembrandt, or Jackson Pollock, but definitely not like your five-year-old nephew). Most of us, given a canvas, a brush and a set of paints and told, "Paint a tree," would be terrified. A tree? What kind of tree? How big? What shades of green should I use? We'll search the Internet for photographs and paintings of trees, hoping to learn the "right way" to paint such a thing.

An artist—and let's define "artist" as someone who's lived and worked with creativity and has achieved an intimacy with it that gives creativity the comfort of a really soft, well-worn T-shirt—would say, "Pooh. Paint a tree?" And he would pick up the brush and paint something. Maybe he'd begin to write a poem on the canvas with the brush because, in his head at the moment someone told him to paint a tree, he was channeling Joyce Kilmer and hearing the line, "I think that I shall never see / A poem lovely as a tree"—and so "poem" becomes the path to painting a tree. Or maybe she'd just re-read *A Tree Grows in Brooklyn* and suddenly remembers a scrawny little stick of a tree that grew next to the front stoop at her aunt's house in 1963—and so she paints a brown line on the page and then, next to it, Aunt Gladys holding a bag of groceries from Leo's Deli on the corner. Or maybe, instead, he takes a pair of scissors and cuts a tree shape out of the canvas and paints clouds all over it: He's painted a tree. What an artist doesn't do is stew about what it means to paint a tree, about the "right way" to paint a tree or what someone else expects of her. She knows there are all kinds of trees, and all kinds of ways to paint, and all kinds of ways to get from here to there.

Sas Colby, a mixed-media artist and teacher in Berkeley, California, is a firm believer in multiple paths. "Being creative means you can find many ways to think about an idea or solve a problem. … Perhaps it's 'making something from nothing.' For me, it often means I see something and immediately think of how I would improve it, or change it, or beautify it. Or it reminds me of something else, setting off a chain of ideas. Scientists and engineers are as creative as those in the arts, and these fields often fertilize each other." Absolutely—no one would argue that Einstein wasn't wildly creative. Or Stephen Hawking or Stephen Jay Gould. In all of them—and in so many others—you have all the elements of creativity: the sparks of ideas, the multiple solutions, the ability to put diverse things and ideas together to come up with something new.

My own definition of creativity has always been to make something you've never seen before. It's seeing something in your imagination that doesn't exist in reality—or at least as far as your own personal reality goes (meaning it may exist in Topeka, in the studio of a painter there, but you haven't seen it before). It's about imagining something—in many cases, literally seeing something in your mind, down to the tiniest details—and then figuring out how to make it concrete. This is true with art, and it's also true with literature: Think of Samuel Taylor Coleridge dreaming the entire text to "Kubla Kahn" and then waking up to transcribe it. And in science: Think of Friedrich August von Kekule (the name was right on the tip of your tongue, wasn't it?) and his dream of the snake with its tail in its mouth, providing him, on awakening, with the solution to the puzzle of the structure of benzene. Of his discovery, he said, "Let us learn to dream." He could have added (and maybe he did, but nobody wrote that part down) that once we've dreamed something, we need to do something with it. That's the creative drive—to make our dreams, our visions, our imaginings concrete.

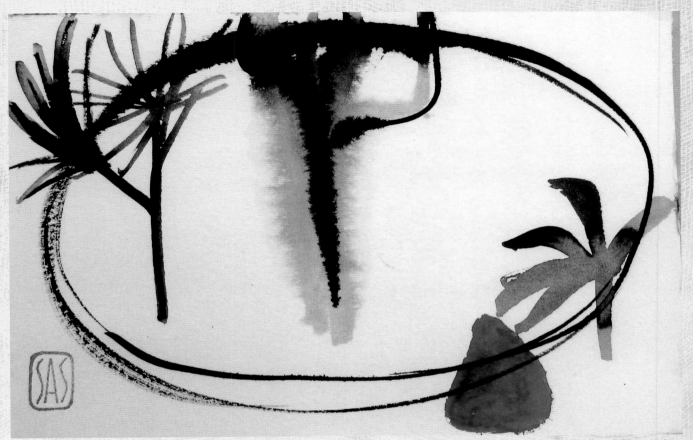

Sas Colby, a mixed-media artist whose untitled postcard is shown here, says, "Creative people can draw parallels between diverse ideas and things, connecting seemingly disparate notions to come up with something new." Photo by Sas Colby

If every idea that popped into someone's head was realized, we'd be constantly bombarded with wild leaps in fashion, amazing music unlike anything we'd ever heard, and other things so different from anything we'd seen or tasted or heard or touched that our mouths would drop in wonder.

It's not like that, though, because most ideas never come to fruition. They're there, in someone's head, and then they're gone. Sometimes they get as far as being written down or sketched on a bar napkin, and sometimes someone will tell his best friend about this terrific idea he just had. But mostly, it's just an idea, a little spark that isn't fanned into life. And

therein lies the fundamental difference between those who have ideas (and that's everyone) and those who are creative: the act of bringing the idea to life. This is something you're going to hear the artists talking about a lot: Creativity is less about having the ideas and more about working with ideas.

Work. Now there's something most people don't think of when they think of creativity. Creativity is about lying in a hammock or sitting on the couch, daydreaming a bass line for the next top-forty hit, imagining the foreground for a painting that's going to bring international artistic acclaim. It's not about work! Work is what regular people do, not artists.

Au contraire! Artists will tell you, again and again, that creativity is in the work. Rebekah Hodous, a bead artist in Cleveland, Ohio, makes beaded pieces, one bead at a time (she never uses glue), that may take years to finish. She sees it this way: "True creativity is having the vision and drive to first imagine the piece and to be able to see it in its completed form. Secondly, it's the drive to complete the piece. Crafts are easily backed out of if things get rough, if you decide you don't like the craft or if life's little distractions creep up." She'll tell you later, in Chapter 3, about how it feels when she gets an idea for a new piece and knows, from years of experience, that it's going to demand a huge commitment of her time and energy and will dominate her life for months and months.

DRIVING FORCES

So if creativity is as much about the work as the idea, the good news is that this kind of work is more fun than just about anything else on the planet. Even though you're working hard at it, it doesn't feel like work. Let's go a little deeper, then. What lies beyond the work? You have an idea, and you're willing to do the work required. You practice and take whatever additional lessons are necessary. Is this, then—doing the hard work—the ultimate expression of creativity? Or is there more to it?

Susan Shie, a visual artist and quilt artist in Wooster, Ohio, believes that the *intention* of the artist plays a vital role. She says, "There is conscious making as a unique self-expression, and there is unconscious making, in which you make stuff but are not purposely being unique. Making bread [from a recipe] is creating but is not deliberate creation, like making a sculpture is."

So now we've added intention to the equation: idea + work + intention = creativity. But where does that intention come from? What spurs the artist to take the idea and do the hard work? Is it fame? Fortune? Many of the artists here say they do it because they feel compelled to, as if they have no real choice—which, unfortunately, doesn't really help us figure this whole thing out. What compels us to keep making art,

Make a list of the ten most creative people you know. Try to include at least five people you know personally. Then list some of their creations. What makes these people seem especially creative? Is it sheer volume of fresh artwork? Or is it the diversity of their art—you never know what they'll make next? Is it that they seem to have another world inside their heads, following a path and making a body of work that's unlike anyone else's but seems governed by some secret, internal logic? Pick out the similarities among these people, even seemingly silly ones: Do they all drive blue cars? Did they all take piano lessons in childhood? What do they have in common with you?

even when no one else likes what we do, when we don't have enough money in the bank and our family is very gently suggesting it might be time to apply for a "real" job? What propels us to the studio day after day, night after night? What is that urge, and where does it come from? Melissa Zink, a mixed-media artist and bronze sculptor in Taos, New Mexico, offers this idea:

"Almost everyone is creative to some extent. I think that perhaps I haven't considered the extent to which culture makes a difference in this drive. I think what we call creativity is at the very least a partial expression of our cultural values. We value individuality, assertiveness, and the ability to begin something new. I think of the Japanese expression: 'The nail that sticks up is hammered down,' a concept very alien to our expectations [in the United States]." She then refers to a long article on Darwinism, "The Proper Study of Mankind" by Geoffrey Carr, that appeared in the December 24, 2005, issue of *The Economist*. In it, Carr muses about sexual selection, about the traits that one sex uses to attract the other, such as the ruby breast of the male hummingbird, or the full mane of the lion. In considering the evolution of the human mind, Carr writes:

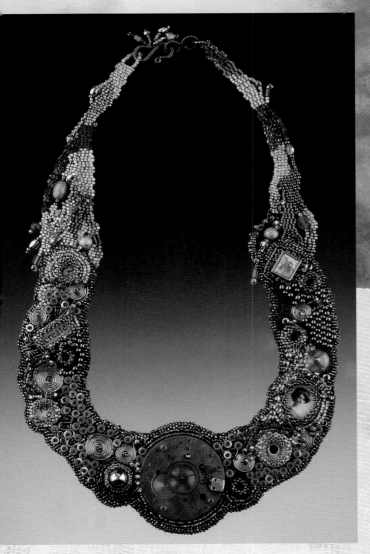

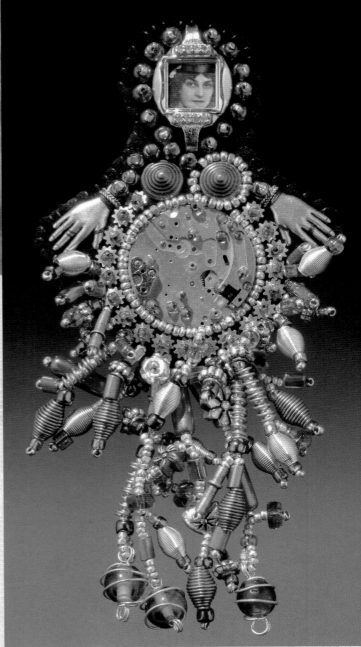

"I feel an artist knows where their heart lies," says Rebekah Hodous. "The drive comes from within as a way of expressing their passion." Her untitled brooch shown here is made from a brooch, a watch plate, seed beads, a pewter scrapbook eyelet, watch face with vintage photo reproduction, pewter hands and her signature bead embroidery. Her necklace, *Virtue*, features glass and seed beads, wire coils, watch parts, hardware, reproduction laser photos, pewter scrapbook findings, bead embroidery and peyote stitch. Both photos by Jerry Anthony

"The creativity we think of as coming from an 'artist' is the conscious kind, where you want to communicate something of your own self through what you make," says Susan Shie. Her quilted diary painting on cloth titled *The Pressure Cooker / Tower: Card #16 in the Kitchen Tarot* is shown here in its entirety and in detail.

Photos by Susan Shie

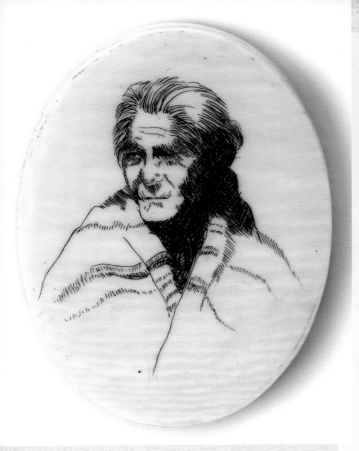

"I see creativity as a bell curve," says Melissa Zink, the prolific artist who created the scrimshaw portrait on ivory shown here.

"Sexual selection does provide a satisfying explanation for such otherwise perplexing activities as painting, carving, singing and dancing. On the surface, all of these things look like useless dissipations of energy. All, however, serve to demonstrate physical and mental prowess in ways that are easy to see and hard to fake—precisely the properties, in fact, that are characteristic of sexually selected features. Indeed, a little introspection may suggest to the reader that he or she has, from time to time, done some of these things to show off to a desirable sexual partner."

Melissa says, "I have talked with friends about this and we have all had to admit an uncomfortable similar response to the last sentence. I like theories like this because they remove Romanticism, mysticism and the Muse from thinking about what we're doing when we say we're making art. Between culture and biology, I think art making illustrates a marvelous complex of human abilities."

It's interesting to have that range, from mysticism to biology, to explain why we create. If you like, you can entertain the idea that, when you throw a pot and fire the glaze, or carve a grizzly bear out of maple or stitch a silk tapestry, you might be subconsciously showing off for potential mates. Maybe, but it's hard to think so when you spend most of your days dressed in stained sweatpants and a torn Grateful Dead T-shirt, forgetting to brush your teeth or scrape the paint from under your nails. You're hardly striving to be an attractive mate, if you look at it from that angle. But if you separate the artist from the art (as so many artists will tell you is important, in Chapter 10), the art itself—without the distraction of the messy, unkempt creator standing to the side—can be a powerful attractor.

Think about how you feel when you visit a gallery and walk around a corner and POW—you're hit with a piece of work that makes you need to sit down, just so you can catch your breath. Perhaps it's exactly the way the female bowerbird of Australia feels when she stumbles across the marvelous "bower" created by the male. Male bowerbirds spend most of their time building, decorating and maintaining elaborate structures to woo as many females as possible. The male

bowerbird uses bits of bark to paint the walls of the structure with a mixture of saliva and colored berry juice. He decorates his painted home with flowers, shells, berries and any human detritus he can find lying around: bits of glass, shiny candy wrappers, discarded AAA batteries. Is he being creative? You bet. Is he doing it to woo potential mates? It certainly looks like it, although some might argue he's doing it just for the joy of making something beautiful.

Scott Radke, a puppet maker in Cleveland, Ohio, readily admits that his artwork is inextricably tied to his relationship with his wife, whom he actually wooed with his very first puppet. They had been dating only a short time when she left town to spend Thanksgiving with her parents. Scott created a figure that roughly resembled him, dressed it like he had been dressed when they met, and gave it a little of his own hair. He gathered leaves from under the tree where they first kissed and used those to pack the figure, which he mailed to her family's home in Atlanta. It worked. (Their daughter just turned two.) Today, as he makes these puppets that sell as soon as they're finished and posted on his Web site, he can't help but remember how they began.

This isn't to say, of course, that creativity is all about trying to attract mates, or even just trying to get attention from society. We create for all kinds of reasons: We're good at it, it makes us happy, we feel incomplete when we don't do it. But it's interesting to consider this: Have you ever made anything and showed it someone, holding your breath and hoping, hoping, that it would make him see you in a different, more favorable light? We wear our art, send slides to galleries and submit to juried shows. If we haven't gotten quite that far yet, we're hanging our work on the living room wall and e-mailing photos of our work to fellow artists, asking for feedback, hoping for exclamations of delighted approval. Few of us make art and never, ever show it to anyone else at all. It's an interesting idea, even though there's no real answer to why we do what we do. Few of us can even come close to figuring out why we do it.

Many artists say they create because they're good at it, because it's what they do best. They talk about it in a sort of

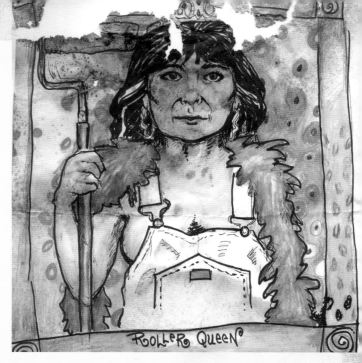

ROLLER QUEEN

bemused way, as if it had always been a foregone conclusion that this was the path their lives would take. Violette says, "I create because I have an inner drive to do so." She tells about a period of her life without art, when she spent most of her time painting houses for a living. "I fell very ill and became dangerously depressed. If I could make lots of money doing something else, I wouldn't, because it would be soul destroying. It's akin to marrying a man you do not love because he has oodles of money. Not only is that unethical, but it would be a death knell for the soul."

James Michael agrees, telling about one experience with a lucrative career that confined his art to his spare time. When he came to feel that he needed art full-time, he gave up the money without a backward glance. "In February 2002, when I left my career in graphic design, I was on the verge of making six figures; and it was creative work that had many rewards to it. But it wasn't the same as making art for myself, and I knew then that I would be willing to give up even more in order to have this life. I know I wouldn't be happy not doing the work I'm doing, because I was unhappy then." He's seeing

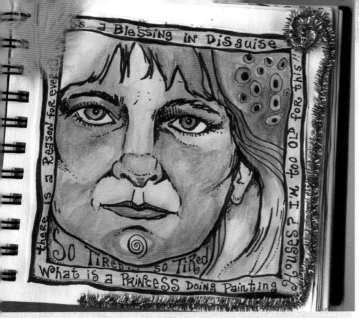

"If I were unable to create, I'm certain that I would die," Violette says. These journal pages—*Roller Queen* at left and *The Princess Painter* at right—show a few of her many artistic depictions of herself.

this process unfold again with his wife, who began creating art after their marriage. "Now she's in the boat with me, seeing that making art is the thing we want most to do." Between them, they've figured out ways to make ends meet so they can both spend as much time as possible in the studio, creating.

Sas explains the need to create, to make her art, even though there are all kinds of other forms of self-expression available. "I realize I have many creative outlets, such as gardening and cooking and dancing, but I still have the impulse to make things with my hands, to paint images and live in the world of visual art." She's talking about a passion to make things, and that idea—passion—is something that comes up over and over in the artists' responses about why they do what they do. It's what makes every day an adventure. Michael says, "You gotta do what you gotta do. I believe everyone has a drive or passion. For some people, it is business; for some, gardening; for others, science. In my case, art keeps my heart pumping." It's that simple: It's what makes you alive.

"I am thinking these days quite often about what I will do if I become unable to work," says Melissa Zink, who is seventy-four and has been a full-time working artist for many decades. "Sometimes I think it will be possible to compensate with other interests; other times I feel that the prospect is too dreadful to contemplate." When creating is your life, it's difficult—if not impossible—to imagine a life without it, no matter the sacrifices. Not to do it would be not to be who you are, like forgetting everyone you've ever known in your life, or never again speaking the language you learned in childhood.

To indulge your creativity, on the other hand, is to be truly free. It's like flying, like soaring. Bean Gilsdorf, a quilter, sculptor and installation artist from Portland, Oregon, likens creativity to mental freedom, to the ability to make what she imagines without considering anything external. She says, "One must guard oneself against pretty much our entire capitalist, media-saturated culture and come to the work from a point of stillness. It should be noted that I rarely achieve this, but I try again and again. Every time I go in my studio, my mantra is: You are free." That freedom is vital. It's a constant struggle; creativity *is* freedom, and it *requires* freedom. There is a definite sense that creativity is not easy, that it's not encouraged in any real sense. Oh, sure—we say we want everyone to be free to create, that we want to raise our children to be creative. But for most people, true creativity is pretty scary. It demands things of you. It requires attention and sacrifice. Think how much easier it is to take a regular nine-to-five job, do the things most people take for granted: spending the evening watching TV, sleeping through the night without waking up to scribble or sketch or check on the progress of something drying in the studio. Think of that, and then think about how flat your life would be. Creativity, if it holds you in its thrall, is worth every sacrifice, every risk, every moment of looking at life from a slightly different perspective from your family and friends and neighbors. It is, in short, life itself. Kelly quotes the poet Wallace Stevens:

"Things as they are
Are changed upon the blue guitar."

"Creativity," she says, "is playing the blue guitar."

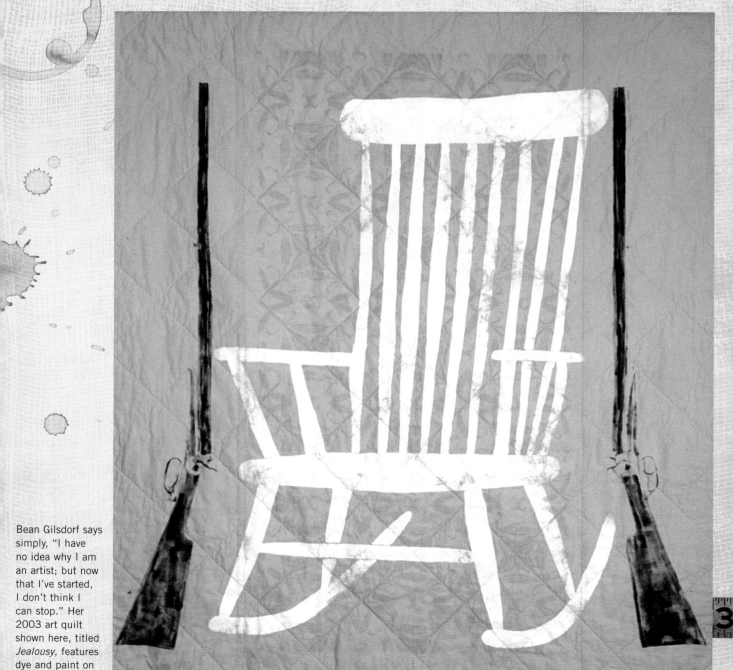

Bean Gilsdorf says simply, "I have no idea why I am an artist; but now that I've started, I don't think I can stop." Her 2003 art quilt shown here, titled *Jealousy*, features dye and paint on quilted cotton.

Photo by Dan Gilsdorf

The Creative Childhood {It's Never Too Late!}

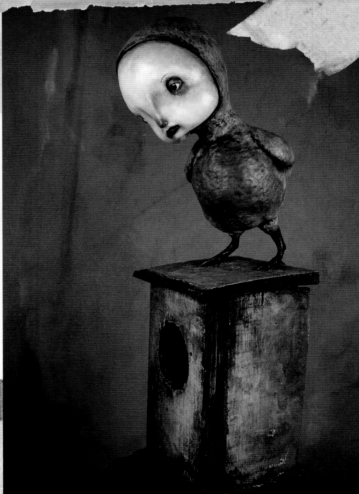

When I was a little kid, I had this set of children's encyclopedias, dark red volumes filled with everything from fairy tales to songs to the instructions for games like hopscotch. My favorite volume was "Things to Make and Things to Do." It had all these really cool projects you could make from things like popsicle sticks and empty toilet paper rolls. I tried every single one of them. And nothing I made looked anything at all like the drawings in that book. Where the constructions shown were sleek and snazzy, mine looked like popsicle sticks and toilet paper rolls held together with gloppy glue and rubber bands. Try as I might, I could never make anything that looked like I wanted it to. I wanted to make things, to create things from scratch, even to learn how to draw. But I had no idea how to go about it.

Scott, creator of this figurative art titled *Bird 1 2006*, says, "I suppose I have always felt unusual, when I think back at being a kid and how I always felt like people thought I was weird."

UNIQUE PERSPECTIVE

Thankfully, most of the artists here had a much easier time of it, even if not all of them had childhoods conducive to forming a creative life. Violette's parents immigrated to British Columbia from Morocco and didn't want their daughter to pursue art, fearing that it wouldn't give her a way to support herself. Many parents, even now, worry that their artistic children will be unable to find work in the larger world and will be forced to stave off starvation by flipping burgers and washing cars.

And there's the still-common idea that budding artists are weird little kids, hanging out indoors by themselves, fingers covered with poster paint. When you first realize that not all of our profiled artists had wildly creative childhoods or completely supportive families, you might feel sorry for them or think they've been traumatized. Turns out that's not the case at all.

Susan remembers, "I knew I was unusual, but it was fine with me." She didn't see "unusual" as being a bad thing and just set about entertaining herself—a common trait, as you'll see.

Violette says, "I was an immigrant child with English as a second language, already feeling like I was inferior to the other children. Art for me was a saving grace. It was my sanctuary." Art was where she went to feel at home in the world.

For Linda, art was a sanctuary of another kind. "Art for me was a way to escape a really bad childhood. I was painfully shy and also painfully angry that I had really bad parents and a very hard life at home. Art was my escape." This sounds traumatic, but if you look at Linda's art, you'll see a lively spirit and a real sense of *joie de vivre* that belie such rough beginnings. Art was the way out, as well as the way in—into a sense of belonging somewhere in a world that wasn't always hospitable. The world can seem like that for a lot of children, but artistic kids seem to have a magic key to finding a place for themselves.

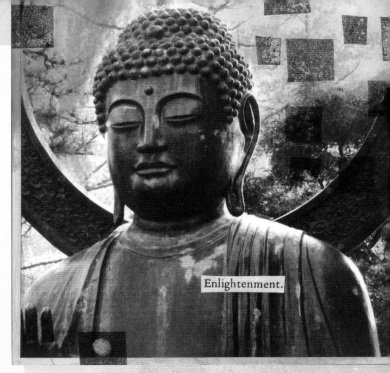

"Art and my passion for arty things was what got other kids to talk to me," says Linda Woods, creator of this piece, *Enlightenment*.

This quilt from Wendy Huhn, titled *Delivery*, features one of her trademark paper-doll-like images. Photo by David Loveall Phtography Inc, Eugene, Oregon

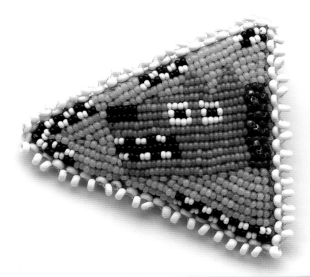 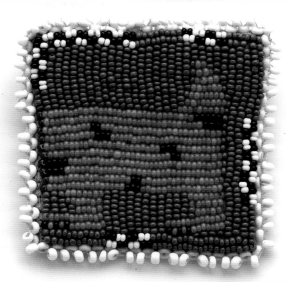

Kelly says, "I have always had a vivid imagination, a head full of stories needing to come out. I didn't fit into society for many reasons." She did fit in, though, in the world she created for herself. This creation is a *Cosmic Dog* two-part brooch Kelly made by sewing glass beads on buffalo hide.

The common attitude among our artists is that this difference from the rest of society hasn't ever been a huge problem, and they went right ahead and did what they did, never mind what other people thought. For many, what might have been seen as obstacles actually worked in their favor. Melissa believes her solitary childhood prepared her for the way she works today. "As a loner, I did not learn how to lose tranquilly. I think that inability has probably been productive, as I competed against myself and still do."

Bean believes that all the disparate parts of her childhood influenced not only her art, but her work habits in the studio. "I did not fit in much as a child. We moved to a new school district almost every year, so I rarely had friends, especially in the summers. I spent a lot of time by myself making doll clothes, building forts and playing with my older sister. When I got older I spent nearly all my time with books—and I'm still a voracious reader as a result. School was boring for me, but I suspect it's because I was never really part of the kind of established social order that comes from going through elementary school with the same

people. In a weird way, I feel like all these things inform my studio practice: the ability to shut myself away from people for long amounts of time, to construct large objects from tedious little pieces, and to be able to make work without needing acceptance or positive feedback from peers." Even the parts of childhood that, at the time, didn't seem all that wonderful can be a big help in constructing a creative life.

Just as solitary habits can be useful, so can fascinations—and even obsessions. Sometimes it's the images that fascinated artists in childhood that stay with them for a lifetime. Wendy Huhn's quilts often feature men and women that remind viewers of the paper dolls they played with as kids. There's a reason for that: Wendy adored paper dolls when she was a kid, although her exposure to them was just a little different than what most people remember. "I recall that male paper dolls were hard to find, so we would dumpster dive in the trash behind a drugstore and take all the discarded *Playboy*s back to our fort under the stairs and cut out the men." And here you thought playing with paper dolls was boring!

This *Autobiographical Box* created by Sas in 1978 reflects a certain childhood whimsy. "I recall a feeling of amazement when I got to art school and everyone was an artist—everyone was just like me!" she says.

In your journal or on a piece of paper, make a list of the things that fascinated you as a child. Snakes? Big trucks? Flying? Going to the moon? List everything, no matter how silly it seems. Maybe you were entranced by a particular shade of blue you found in the lining of your father's suit, or maybe you couldn't resist running your hands over velvet or smushing them into mud and clay. What captured every bit of your attention? When you're done with your list, circle or highlight the ones that cause a little shiver of interest. Those are the things that still call to you.

try this

Sign up for a class or workshop in something you've always wanted to know more about: pottery, pen and ink drawing, quilting, collage. Go in with no expectations other than to have fun and to give yourself a chance to learn something new. The best thing that can happen is that doing so will open the door to adventures you can't even imagine. The worst-case scenario is that you may find this medium or technique isn't for you, but even so, rest assured that your time won't be wasted: Things you've learned in a workshop tend to find their way into seemingly unrelated work when you least expect it. For example, the color mixing you study in a painting class may be perfect when you begin to dye your own fabric.

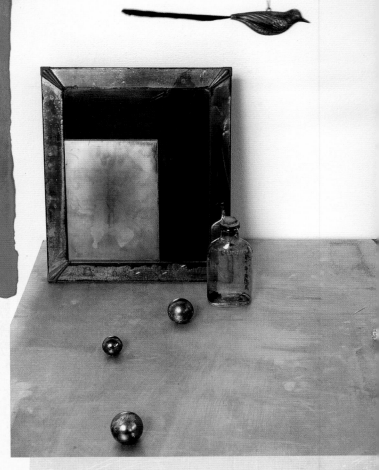

ENCOURAGEMENT AND EXPERIMENTS

Most of our artists were encouraged, in some way or another, by parents or teachers or the other kids who were quick to recognize real talent in their midst. Sas remembers, "As a kid, I was always making things, writing a neighborhood newspaper, writing letters to foreign pen pals. I was recognized as the 'class artist' and generally got approval for being 'artistic.' I knew I was different from the other kids because of my quirky notions, but I felt I was also appreciated for being artistic. People would ask my advice about color, for instance."

Violette says, "I have a vivid memory of finding 'my people' when I entered junior high school art class and connected with a group of artsy kids. We were known as the 'Art Nerds.' I had finally found my niche and a place of belonging. Much of my spare time and artistic daydreams were spent in the art room connecting with my creative friends, making art and discussing art."

Scott says, "I was encouraged to do art. I was told I was good at it and all that—I think if you encourage any kid to do something from an early age, they might pick it up later in life. I was told, 'You're good at this but you're not so good at that,' so inevitably I went for what I was told I was good at."

Gail recalls a particular drawing experience from when she was young. "I remember how beautiful a new box of forty-eight Crayola crayons was when you first opened them before they were used. I remember starting at one corner of the paper and making a colored shape. Then I made a border around that shape in a different color. I continued this process until a new shape presented itself, and then I made colored halos around the new shape. I kept doing this until the page was full. It was immensely enjoyable. I wish I could see any of those many drawings today, but they have all disappeared." This photo depicts her assemblage piece titled *Homage.* Photo by Gail Rieke

Just that little bit of a nudge is sometimes all that's needed to set a child on a path that continues into adulthood. It's one thing to have that encouragement, but it's something else entirely to know from earliest childhood exactly what you're good at and what you're going to do with it. It's nice to imagine that it's just that easy, but, of course, that's not the way it works. These artists didn't wake up one morning when they were five and begin making a quilt or soldering their first assemblage. Most of them talk about trying out everything—every technique and medium and experience that was available to them in childhood. Sas says, "I learned to sew and liked making things: refinishing furniture, planting gardens. My father was a building contractor, so I grew up around people who made things."

Rebekah says that as a child she was always attracted to color in any form. She loved using crayons, of course, but she also always loved beads, even then. This untitled purse was made using a plain wooden craft box as a base. Photo by Jerry Anthony

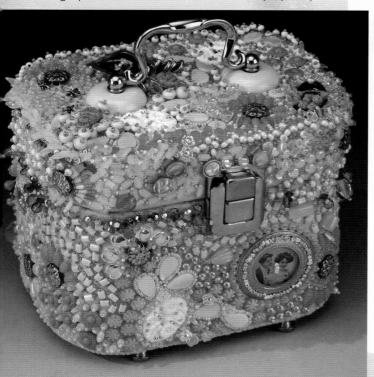

Bean says, "I've always had my hands in something, whether it was paint or cake batter. It's always made me feel both calm and powerful to create, but I didn't acknowledge the importance of that until I finished my MA in linguistics."

Another common thread through all the artists' comments is the memory of something from childhood that evokes the same feeling today. Michael remembers a specific drawing experience from very early childhood, before he entered school. "When I was a kid I was always drawing. Mostly I made picture books. The first one was about a monster on the moon who ate an astronaut's space ship. ... I was really into the monster thing. In fact, when I was in preschool, my mother's best friend was my teacher. One Christmas season Mrs. MacAllister brought me a plain white apron and a bunch of colored markers. At the top she wrote, 'Merry Christmas, Mom,' and then had me draw whatever I liked on the main portion of the apron. I proceeded to draw vampires, mummies, werewolves, ghosts, bats, a moon and an old knotty tree with a noose hanging from it."

Wendy Hale Davis remembers all the way back to nursery school, too. "My mother always told the story about how she had tried to teach me to use scissors for weeks and then, on my first day of nursery school, another kid showed me. I promptly came home and cut up all her magazines." She says happily, "I still have a Thanksgiving turkey I made from torn strips of construction paper from that era. It's one of my favorite pieces." It's often those seminal experiences—even ones involving glitter and cheap manila paper that don't seem particularly formative at the time—that lead, however circuitously, to the path through adulthood.

Several of the artists mention being attracted to a particular medium from the start. Melissa, whose work is filled with words and letters, many of them parts of her own invented alphabets, can trace her love of text and letter forms in art all the way back to her childhood. "My parents encouraged me to amuse myself and bought me material, paper, crayons, etc., including things like a French curve, which I had no idea how to use. I can still remember regarding it with awe, as if it somehow might contain great secrets

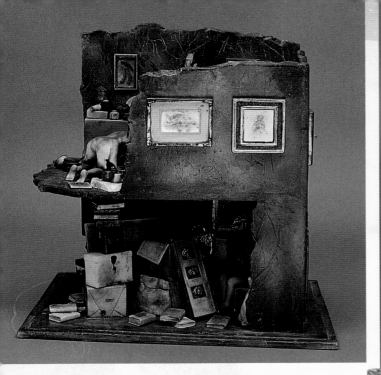

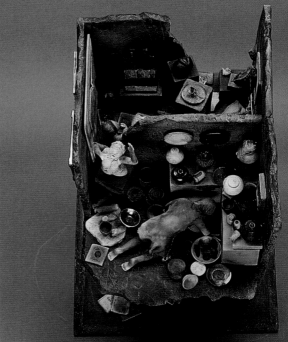

if only one could unlock them. My parents, however, had no artistic skills or knowledge with which to help me, which was perhaps just as well. I also had a little printing press with tiny rubber type which I would now and again attempt to use, but I always lacked the patience or dexterity to manipulate the tweezers and tiny rubber type. So much work, so few words. I fell in love with what I now think of as German black letter and spent hours making ever more elaborate letters."

For other artists, however, the path wasn't so straight and not quite so visible. Wendy Huhn didn't dream of creating art quilts when she was a child. She loved to take art classes and do all kinds of other things, but what she truly loved was ballet. "I really wanted to be a ballerina—and had dance lessons well into my forties—but as a child I was chubby and had big flat feet." She remembers childhood as being difficult because she was always in trouble. It had something to do with not liking to follow rules, which a number of artists mentioned. They didn't like the seemingly arbitrary rules at school, and they didn't like games with rules. For imaginative kids whose

Melissa, an only child, says, "I was a solitary child, very much overprotected, and I learned to amuse myself, having no one else to play with. I made things: doll clothes, pictures, doll house furniture. I painted with watercolors and wrote poetry. I begged out-of-date wallpaper sample books from the local paint store to use for paper doll clothes and furnishings. It was the only time, until I learned to ride a bike and could ride for hours, that I was completely happy." For her, the thrill ultimately came from making something, rather than of having made something she could then play with. "I still experience that and the waiting for the next thrill," she says. Her 1981 ceramic piece shown here in various views is titled *Museum of the Mind*.

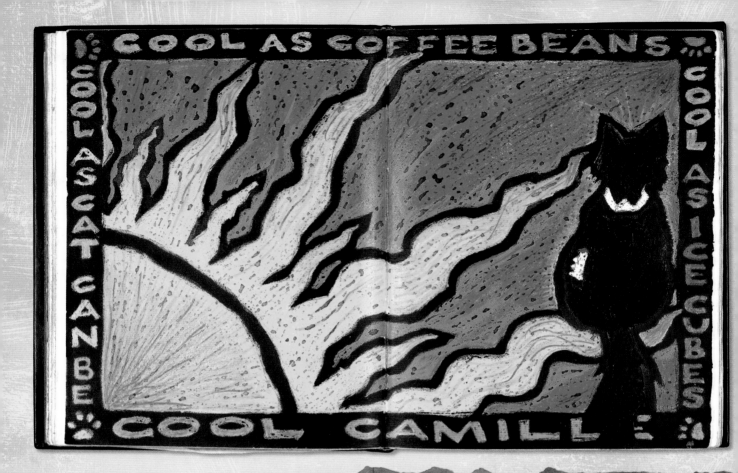

Almost every one of the artists mentioned reading as a child. Wendy Hale Davis is no exception. (A wax resist centerfold from her Crescent Star Orient art journal is shown here.) "We didn't have a TV because Dad was afraid I wouldn't learn how to read if we had one," she says. "To make up for this horrible deprivation, he read to me for an hour every night, mostly boys' adventure books that he'd loved as a child."

Here are two fun creativity exercises you can try with just a simple visit to your local library.

• Pick out some books that catch your interest but are not the kind of books you usually read. If you are a mystery buff, try a historical novel. If you typically read novels, try a biography. Ask your friends—or the librarians—for recommendations. Keep notes in your journal about how it feels to read something different, just like taking a new class when you were in school. Record any ideas that surface as you read. A historical novel with detailed descriptions of clothing might spark an idea for artwear. A biography of a molecular physicist might give you an idea for a painting inspired by molecule structures. Read with an open mind.

• Go to the children's section of the library and pick out half a dozen books that catch your eye. Or ask the children's librarian for suggestions. Tell him you're looking for creative, inspiring books. Take your books home and lie on the floor to read them, with cookies and milk. Make it skim milk if you have to, but don't skimp on the cookies.

try this

heads are filled with fanciful ideas, rules are often anathema. They need time and space to play and experiment and explore. Kelly and Scott remember spending a lot of time outdoors, exploring the woods, looking for animals.

Most of the artists read. A lot. And they made stuff: clay and wood sculptures, miniature houses and furniture, forts and tree houses, cakes and clothing. *They made stuff.* Sometimes it worked out, and sometimes it didn't. That wasn't the point, though: They were teaching themselves how to be artists by imagining things and then figuring out ways to make them come into being. They learned new techniques for that process by trying something and then trying something else and then, when that didn't work out the way they wanted, trying something else.

That's how you give a child a head start into the creative life. Give her the time and space to imagine and the materials to experiment. And then give her encouragement. Sign her up for art classes if that's what she wants, but don't push her into it before she's ready. If you're an artist, teach her what you know. If you're not, find someone who can.

Melissa remembers, "When I was in the third grade, we had a weekly art class. One week we were to take our watercolors, the ones in the little round cakes and the big point-less brushes that still seem particularly repulsive to me and paint the tulips in a vase that our art teacher had placed on her desk. I thought the tulips were so beautiful and I was excited about the project. But with the first daub of color on the ugly yellowish almost-blotter paper, I knew the attempt was doomed. No way could I capture what I saw, and the more I tried, the muddier the result. I went home to my mother and cried bitterly because I couldn't make a tulip. She consoled me by saying that she would find someone to help me. Somehow she managed to find a young art student who came to the house to give me lessons. I have no memory of what we did or what I learned, but apparently it was enough for the trauma to be assuaged. Assuaged, but not forgotten. About ten years ago I made several paintings of single tulips, mostly to allay my unresolved tulip-phobia. The results were quite satisfactory, but I used oil paint and fine brushes; I never have learned to paint in watercolor." Because her mother took her anguish seriously and found a solution, the tulip incident didn't become one of those huge blocks that are so overwhelming you don't even try to surmount them. Her story has a happy ending, and that's what matters with art in childhood. More than anything, children need the freedom to find out what they love and want to do.

BE A CREATIVE MENTOR

Violette mentors children—including Talia, shown here—as a give-and-take creative exercise. "Because my childhood was not as creatively memorable as I would have liked it to be, I decided to recreate it by connecting with young children, in particular two little girls whom I call my grandchildren. The girls and I come together for fairy adventures where we don fairy wings, tiaras, tutus and magic wands, granting wishes to passersby on the beach and in a forest park. It's easier to get away with doing this when you have small children in tow. Not only do the girls and I get much out of it, but the folks who are granted wishes are absolutely delighted as well. Another thing I do is have the girls over for crafting sessions. I get to be messy, get glitter all over the place, and teach my little charges how to let the muse out with a minimal amount of censorship. I end up trying new things because I search out the latest arts and crafts craze to demo for them. It's definitely a win-win situation!"

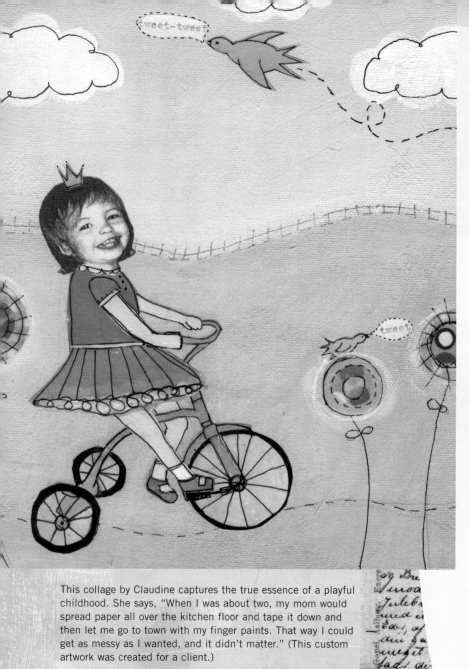

tweet-tweet

tweet

This collage by Claudine captures the true essence of a playful childhood. She says, "When I was about two, my mom would spread paper all over the kitchen floor and tape it down and then let me go to town with my finger paints. That way I could get as messy as I wanted, and it didn't matter." (This custom artwork was created for a client.)

Gail says, "I think most kids, if given the chance and the materials and time to play and daydream, are creative." She adds, "No filling up kids' time with schedules!" Exactly. Fill up every single waking moment with practice and classes and chores and structured activity, and there's no space left for dreaming. None of the artists remember childhood days crammed with scheduled activities. As a kid, I took lessons of every imaginable kind: piano and flute, tap dancing and jazz and ballet, tumbling and baton twirling, art and swimming. But I didn't take them all at the same time, and there was never a time when more than two afternoons a week had something scheduled. The other days, I was free to do what I wanted with the time between homework and dinner.

Something else you may have noticed as the artists talked about their childhoods: None of them mentioned video games (and some are young enough to have grown up with those) or television. If you wonder why children today don't seem to have the kind of imaginative inner lives you remember having, look at how they spend their time. While video games and television can be tools for learning and inexpensive forms of entertainment, what they are, most of the time, is a way to turn off our minds and let ourselves coast along on a tidal wave of simplistic popular culture. Kids who spend most of their time in front of the television aren't going to be making much of anything. The ideas and images with which they're bombarded aren't going to be imaginative or innovative or inspiring; they're going to be the ideas and images that can make money for the advertisers who support the shows that make television what it is.

Tips from Violette

Violette shares a *Glimmer of Hope* and some tips:

• Observe a child at play, imitate him, give him finger paints and copy what he does. Immerse yourself in creating and allow yourself to be messy. No rules! Just let go and be a child. Children can be your greatest teachers.

• Decorate a glass jar any way you choose—you might use anything from paint to flat-backed marbles, from glitter glue to silk flowers. Now, on small slips of paper, write creative words such as "paint," "collage," "glue," "embellish," "sculpt," etc. Pick one slip of paper every day and in some small way employ that word in a creative way.

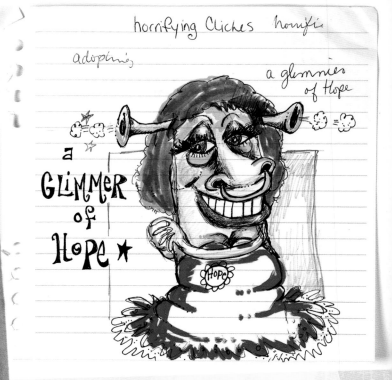

OK. Enough. You get the idea. Let's focus on the kinds of things you can do for a child who might, just possibly, go on to live a creative life. And let's imagine that that child is you, all grown up but without, perhaps, the foundation laid by the kind of childhood that encouraged you to follow your imagination. How can you provide just such a rich, creative childhood for yourself now?

First, buy some paper and some crayons. Buy a lot of paper—a big, thick pad of it. It can even be that cheap, off-white construction paper—anything cheap enough that you won't hesitate to use it. Then buy a box of crayons, the big box with all the colors. Buy a kid's set of watercolors and some bright modeling clay. Buy some fabric markers and dig out an old white T-shirt. Go to the craft section of the toy store and buy whatever catches your eye. Nothing fancy, nothing requiring batteries, nothing costly.

Then go home, or go to the park or the coffee shop or wherever you can find enough room to spread out your art supplies and just play. Start with whichever one looks the most enticing and play with it. That's the important word: play. Don't work, don't set goals, don't give yourself exercises. Just play. Scribble with the crayons. Draw the tree in front of you. Draw your cat, your feet, your coffee cup, your kid. Roll the clay into long snakes—remember those? Squish them up and do it again. Get some Silly Putty (what Wendy Huhn calls "the ultimate transfer medium") and copy the comics from the newspaper. Draw your face on your T-shirt. Write a poem.

Doodle. Wendy Hale Davis believes doodling is vital to artists, and she believes that they don't mention this because they don't really know they're doing it—it's just automatic. They always have a pen or pencil in their hand—on the phone, at their work table, during conversations at a coffee shop. Doodle a lot, and then play some more.

This page from one of Wendy Hale Davis's richly detailed art journals reflects her affinity for doodling.

Do this every day. Tell yourself that as soon as you finish your homework, you can play. Keep your art supplies where you can get to them easily, and don't let anything keep you from them. Remember when you were a kid, you didn't tell yourself, "Oh, I really shouldn't be wasting time building this fort when I could be spending time bonding with my brother," or "I ought to pick up my room before I draw." No. Kids know what they need to do: They need to play, because playing is learning what it is that you love. Children who don't get to play as much as they need to never find out where their hearts and minds and passions lie. They end up with jobs they hate and lives that seem dim, wondering what's missing. Sound familiar? If so, then you definitely need a prescription for more play. Write yourself one.

try this

Write yourself a prescription that says, "One hour of play each day to relieve dullness. More as needed." Post this on the refrigerator, where you're sure to see it. Since it's official, you can't ignore it. Forgetting to take this medicine is dangerous to your soul. While you play, keep a sketchbook or journal handy so you can jot down or sketch out ideas that come to you. Rolling clay between your hands can be a great way to access the part of your brain that's secretly full of ideas. You may think you don't have any creative sparks, but there's a whole room in your head that's full of them, just waiting for you to let them out.

Opening Your Eyes to Inspiration

One of Melissa's most important works, *Memoirs* (2006), featuring her unique letter forms.

Photo of *Memoirs* on display in the Parks Gallery in Taos, New Mexico, by Pat Pollard, courtesy of *New Mexico Magazine*

Your brain is full of ideas, and there are more waiting to get in all the time. Where do they come from? There are all kinds of ideas about where inspiration originates—from deep within your subconscious, from the work of other artists, from nature, from some divine source, from a stream of ideas that flows through the universe.

Artists have different sources of inspiration, and they can change over time. Melissa says, "I used to visualize a completed work and progress toward that end. Although there might be a few changes along the way, essentially the idea remained intact. These days, the 'idea' is far more diffuse and may begin with nothing more than a tasty bit of paper." So while her process once developed organically from her ideas, her ideas now develop organically once her process begins.

Melissa tells the story of this serendipitous experience that resulted in a major piece for her 2006 retrospective in Taos: "In the winter of 2005, I decided to make something to express my great affection for Kurt Schwitters, who was one of the first artists to use found scraps, tickets, advertising bits and discarded wrappings in his collages. Some of his works were immense and immensely beautiful. He called them Merz, a term he invented to characterize his work.

"I had this idea of putting a small sculpture resembling a human figure against a painted background and floor to see if I could unite two and three dimensions, visually if not actually. I had made this attempt often but never was able to make anything in which the dimensions merged seamlessly.

As long as I worked on this experiment lying flat on the work table, the idea seemed to develop well. However, once I propped it upright, the conceit vanished immediately. The figure was a three-dimensional object simply sitting on a background.

"Being loath to waste anything, I decided to abandon any preconceived notions and start riffing on 'Merz.' Words, letters—meaningful or meaningless—are some of my favorite elements, so Merz would became the bond that could hold a disparate assemblage together. I slowly created different, discrete parts, both two- and three-dimensional, in which I played with variations on the word 'Merz.' While I was working on this, one day during breakfast I happened to see a review of a Schwitters show in *The Times (London) Literary Supplement*. The article included an anecdote about an opening at which Schwitters rose from the audience and barked, causing many of the guests to faint in astonishment and horror.

"I had never really thought much about serendipity or synchronicity, but this was almost too remarkable. I had begun to think that I couldn't do much more with Merz, and here was a whole new story to include. It was short, funny and a keen illustration of how our cultural reactions have changed. And it led me to look up the German equivalents for 'bow wow' and 'woof woof.'"

Melissa began to play with fonts and letters until she found some she liked. Using the computer, she printed the letters, glued their images to Masonite and band-sawed each one. "I then started painting them, but the paint didn't have the intensity I wanted. Matte was too dull, gloss was too bright, and both had a flatness I didn't like. I decided to try fabric instead. I found a black microsuede that was darker and denser than paint. I covered the letters with the cloth and trimmed the edges. Nothing was left to do but make the background, arrange and attach the pieces. When it was finished, I had the sense that there was something new, something important in this piece. But I didn't know what it was.

Melissa doing final construction of *Lines in Remembrance of K. Schwitters* in 2006. Photo by Nelson Zink, courtesy of *New Mexico Magazine*

"I had an extra letter lying on the work table. I left it there for a couple of weeks. I noticed that it was upside down. Then it hit me. I'd been trying for years to make a series of shapes that would feel like an alphabet. I'd given up trying to make a literal alphabet in which there were new shapes for our normal alphabet. I knew this project was way too difficult for me. But I had never lost the desire to design a series of shapes that would *feel* like an alphabet. And here was a way to begin."

She modified the letters and sized them on her computer, creating her own alphabet and adding to it with bits and pieces from her stash of materials. The result became the centerpiece of a show of her work at the Harwood Museum in Taos.

"This was one of the most enchanting experiences I've had in art making, watching ideas occur and interact. I was merely the executor of a great estate that I had the great luck to be privy to. This experience has brought me a sense of accomplishment that I had never felt before, and took the sting out of knowing that, at seventy-four, tomorrow can't be better than today. But today can be wonderful."

"Assemblage is about combining things that have no business being together," says Michael. "It's about new life through reinvention." This work, *Spider Woman*, is the result of this process.

FILLING YOUR HEAD

To keep their brains filled with ideas, artists learn to look everywhere and see everything. Michael, as a mixed-media assemblage artist, has learned to be open to the apparently random juxtaposition of found objects in his studio. He says, "My life is clutter. Well, at least my studio life. I can't seem to find anything, but then again, it seems like everything is visible. When I say 'everything,' I mean everything. Despite all my griping about this studio style, it is ultimately the way I work the best. I have to have random pieces of junk lying about.

"Sometimes a piece just evolves because of its location in the studio. This was true recently with a piece I titled *Spider Woman*. I was working on a series called *Retratos* (portraits). On my studio table, a block of wood, covered in nails, rested. It was a failed object from an assemblage that never was resolved, and now it was being shuffled around because it showed signs of new life. I set it aside for a moment as I searched through dictionaries for imagery.

"Moments later I go to retrieve the block, when I notice that somehow a pair of opera glasses happened to be lying on top of it. Now, I swear I don't remember placing them there. Those with supernatural leanings might say it was a ghost or perhaps my art angel—or was it chance? You decide. Either way, the placement of the glasses on the block led to the finished piece. Both items worked together so well. I'm not saying I couldn't have resolved the piece without those optics, but one thing is for sure: It would have evolved in a totally different way." Ideas can come from anywhere, at any time. (And, yes, they can sometimes seem supernatural.)

Kelly creates elaborately beaded jointed leather figures she calls Intercessors. She explains their genesis:

"They first came about as a way for me to be able to create leather figures with bead decorations that were not as involved as my more elaborate figures. They would be affordable and something I could sell more readily in the galleries/museums that handled my artwork. But, of course, through the years, I couldn't help myself: They became more elaborate.

"The first figures were also a solution for my collectors who focus on African artwork, Native American art and contemporary art. I came up with figures that could fit in easily within any of these categories and would look at home. Then I heard a story on [National Public Radio] about Nightmarchers of Hawaii. A folk legend. Oh, dear—my mind went to work. Out popped the idea: The Forgotten Ancient Ones that come out at night. They were my version of astronomy. Through the years the stories evolved, culminating in the eight months of intense research that accompanied these figures of 2006."

Kelly explains the genesis of her hand-sewn and -beaded painted leather stuffed *Pink-Headed Duck Intercessor* (shown here with his custom-made chair by Rhett Johnson). "The world's chickens, ducks and migratory birds needed a leader to shepherd them to safety from the evil misguided human species. Whilst thumbing through a book about extinct and vanishing birds of the world, I spied the words 'Pink-headed Duck.' Oh! What a name, and I am very fond of pink. I turned pages to the chapter on this mysterious creature thought to be extinct. Here was a being that could lead bird populations of the world to safety."

Here is the story of the resulting Intercessor:

"Unconfirmed sightings in the 1960s and again in 2004 in remote wetlands of the state of Kachin, Myanmar (Burma) and the fact that large areas of Myanmar haven't been explored by ornithologists are the reasons why this duck is considered critically endangered instead of extinct. The last specimen in the wild was shot and killed in 1935 in Darbhanga, Bihar, India. The last known captive duck kept in an aviary at Foxwarren Park, England died in 1945.

"Historically the Pink-headed Duck's known habitat included northern Myanmar, north-east India, and central Nepal. Freshwater ponds, marshes, swamps, and wetlands surrounded by bushes, tall grasses, and subtropical forests provided aquatic plants and mollusks to eat and nesting areas. Swamps of the

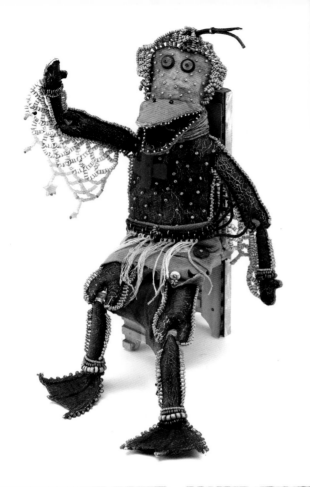

Pink-headed
Duck
Rhodonessa
caryophyllacea
CR
(critically endangered)
A
rare being
in the
best
of
times
lead
others
to
safety

Ganges and Brahmaputra rivers in northern India have been drained, cultivated, and heavily populated, leading to the decline of the species in that area. Many forests in Myanmar are being heavily logged, causing further stress on any of the ducks that might still be in this country.

"The male Pink-headed Duck has a pink head and neck, which has made it a sought after trophy by hunters through the years. The female has paler pink plumage on its head and neck. Not only does this pink coloration make this duck unlike any other duck, its pure white or pale yellow egg differs from all other duck's eggs by being almost perfectly spherical.

"The Pink-headed Duck has always been considered as rare."

Violette tells a story of being inspired to create this *Shiny Happy People!* drawing: "A friend of mine sent me a [handmade card featuring a] cute line drawing she created of a woman and man dancing. On it she wrote the words 'Shining Happy People … holding hands … dancing,' [borrowed loosely from an REM song]. She first of all wrote in her drawing/card what a wonderful inspiring person I am and that she loved me. After a paragraph of waxing eloquent about ME she told me that she has to have brain surgery. She might even have to relearn how to walk, talk and write. My lovely friend feels very blessed to be surrounded by supportive and loving family and friends. Her positivity simply floored me." The combination of the attractive card and her friend's positive energy was all it took to set the wheels in motion in Violette's head. "I decided to create my own rendition [of the front of the card]. It's quite a bit different than my friend's drawing but is simply my interpretation of REM's joyful song of making connections."

"I'm inspired by so many things, but they're usually not visual things; they're more like ideas or feelings," Bean says. "Although I like to look at art and stay informed about what's going on in the art world, I try to shed all that when I'm working because I want my work to be original, not derivative." Bean created this 2004 untitled art quilt with dye, paint and bleach on quilted cotton.
Photo by Dan Gilsdorf

46

PRIMARY AND SECONDARY INSPIRATION

Let's think of inspiration as coming in two forms: primary inspiration and secondary inspiration. Primary inspiration includes ideas you get from your experiences in nature, from your interactions and relationships with people, from things you see and hear in the real world: the colors of the sky, the sound of a creek burbling over stones, the texture of those stones, wet from creek water. Secondary inspiration is what you get when you look at someone's painting of the colors of the sky or hear a song inspired by the burbling of the creek or feel the texture of a pot whose surface took inspiration from the creek's wet stones. Someone else saw the sky or creek or stones and made art with that inspiration, and you are exposed to his art and inspired by that. Secondary inspiration is not a bad thing; some great works of art have been inspired by other works of art. Look at the paintings inspired by Shakespeare, for instance. Look at William Blake's *Pity*, or Dante Rossetti's *Study for the Death of Lady Macbeth*, both inspired by *Macbeth*. Think of Don McLean's song "Vincent," inspired by Van Gogh's *Starry Night*. There's nothing wrong with taking inspiration from other artists, either literary or visual. There's nothing wrong with taking inspiration anywhere you can find it.

Derivative art is what you create when you try to copy the art of someone else, when you try to reproduce something you've seen in a magazine or a gallery, rather than letting other artists' work spark ideas that are completely your own. Copying is not a bad thing in the learning process. Art schools often require hours and hours of copying as a way of learning how artists do what they do. As long as it's understood that this is learning, rather than creating your own work, it's an excellent exercise. But when you're ready to set out on your own artistic adventure, you want your own ideas.

Our artists find inspiration everywhere, knowing that the world is full to bursting with ideas of all kinds. They learned very early to open their eyes and really take a look at everything around them. When you do this—really look at the world—you don't have trouble finding ideas; you have trouble figuring out what to do with all the ideas that constantly bombard you, even during your sleep. Sometimes they seem to leap at you when you least expect them, which is really exciting, if a little startling. Kelly gives an example: "New ideas are a rush. While research-reading a Navaho religion book, I read about persuadable deities, one of them being Yellow Rat, and mentors, one being Big Fly. I caught my breath: last year I had created a piece of artwork I called *Red Rat Intercessor*. My husband whined until I consented to let him keep *Red Rat* for his collection, so I needed another rat for my grouping of Intercessors. Yellow Rat! Perfect! And then, just the name 'Big Fly.' How could I not create a mentor that is said to sit on the ear of a person who needs instruction and to whisper answers to questions or forecast the future? Luckily there were no pictures of Yellow Rat or Big Fly in this book, so I was not influenced by existing images."

try this

Make a list of the times ideas come to you: in the shower, on a walk, as you're falling asleep or waking up, when you're listening to someone boring on the telephone. Look for connections between those experiences and the ideas themselves. Do you always get an idea for a painting when you drink orange juice? Maybe that's because you always had a cup of OJ when you were finger-painting in kindergarten. If mowing the lawn makes you want to make a piece of furniture, maybe it's the odor of warm grass, from when you used to play with your dad's tools in the backyard.

SERENDIPITY

Violette tells about one of the innumerable unexpected ways she gets ideas. On a recent shopping trip she noticed that crocheted flowers were everywhere in the funky little shops she visited. This made her think fondly of the woman who had taught her to crochet. "When I was eighteen I used to visit an elderly lady in the hospital. She was riddled with arthritis. Her fingers shot off in every direction. ... The most amazing thing was that those gnarled hands created incredibly intricate afghans that were donated to different charities. Mrs. McIlvride taught me how to crochet during our many visits. I made afghans, vests and squares for about one or two years and then grew bored of it. ... [But] Mrs. McIlvride not only taught me about crochet but about kindness. In her long life she had fostered ninety children. In the hospital she enjoyed a never-ending stream of visitors, many of whom were the grown children she had once fostered. I just love it when life teaches us these beautiful lessons!"

Violette took something she saw in passing in a shop window and the warm memory of someone she knew decades ago and suddenly had an idea for something she couldn't wait to try: tiny crocheted dangling flower embellishments for her journals.

try this

Immerse yourself in color. There are lots of ways to do this: pick up paint samples in every color from the hardware store, or buy one skein of embroidery thread in every color. Play with these colors, putting unlikely combinations next to each other. When you have a few minutes to sit and relax at the end of the day, take out your colors and move them around, see which ones seem to speak to you and hint of hidden ideas.

Rebekah says, "Color combinations inspire me. An idea can come at any time or place. They often come uninvited. Too many ideas, not enough time—that's what I suffer from the most." She can look at a color, or one color next to another one that most people wouldn't think of putting next to it, and suddenly she has an idea for a piece of beadwork, just from seeing those two colors. This sculpture, *3*, is just one example of this influence in her intricate work. To create it, she used beach glass, springs, coils, postage stamps, a key, a washer, acrylic domes, a mannequin hand, vintage photo reproductions, beads, tin vines, bead embroidery and peyote stitch.

Photo by Jerry Anthony

BOMBARDED BY IDEAS

"I am constantly inspired," Kelly says. "Ideas hit me wherever I am and at any hour of the day or night. I constantly work at keeping my mind free of 'life clutter' so that it can recognize an idea that can be manifested within my artwork. I keep my eyes and ears wide open." Aha! A clue: "I keep my mind free of 'life clutter.'" You know life clutter—the lists and appointments you have to remember, the phone calls you have to make, the e-mails you need to send. And then there's the kind of clutter you get from having the TV on in the background every waking moment, and the clutter you get from reading every magazine that hits the newsstands, so that you know who's dating whom and what the stars are wearing this week. Sure, you may be well-informed about the world and as hip as your sixteen-year-old daughter, but where in that stew of news and culture and gossip is room for your ideas and imagination?

Of course, focusing your energy is one thing, and completely shutting yourself off from the world is another. For many of us—even for those of us who are absorbing all the mind clutter listed above—living in the twenty-first century means we walk around with all our filters firmly in place. We filter out the noise that's a constant din in our ears, usually by wearing headphones or earplugs. We filter out the bright lights and glaring sun by wearing dark sunglasses; we walk around in a hurry with our eyes focused either on the ground in front of us or off in space, rarely making eye contact or really looking at our surroundings. At times, the effect is that we experience our world through a bubble in which we've isolated ourselves from direct experience.

Truth.

Linda finds inspiration constantly bombarding her, and it's often during her routine walks. Her visual journal pieces like this one, *Truth*, reflect this. "I am inspired by the events in my daily life and what I observe. I rarely ever don't have inspiration. I do get ideas in my dreams, but also while I am having conversations with people or just when I am out for a walk. I feel like I often have too many ideas and not enough time to get my ideas out in a tangible form."

Exercise

For one week, don't let anything in from television, movies, magazines, radio or the newspaper. Avoid popular culture or the news or hit songs. Instead of reading the newspaper, read a chapter in a book. Instead of watching television, put a notebook and a pen in your pocket and take a long walk. Instead of looking at a magazine, sit quietly somewhere and just be, letting the ideas flow in and out of your brain, writing or sketching those that capture your interest.

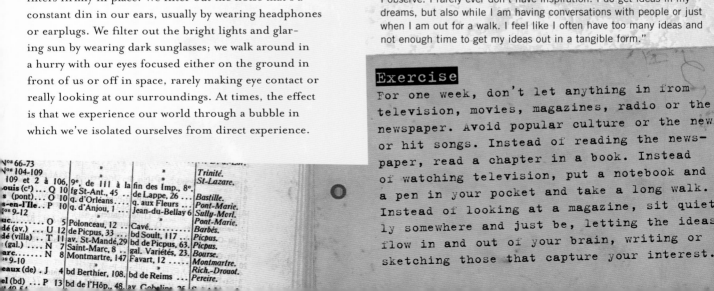

try this

Today, have as many sensory experiences as you can. Divide a piece of paper or a page in your journal into six columns: Tasted, Touched, Heard, Saw, Smelled, Did. Then, for one day, list the things you experience. Here's an example.

Tasted:
—the lemon I bit into while making iced tea for lunch
—pepperminty glue on the flap of the envelope I used to mail payment for the electric bill
—dusty old mint I found in my pocket—ick!

Touched:
—the fur on Lennie's nose when I petted her first thing this morning
—a splinter that slid under my thumbnail while I sanded Mom's back porch
—the surface of my desk after I cleaned it off and dusted it, finally!

Heard:
—the chime my computer makes when it receives e-mail
—my stomach rumbling because I forgot to eat breakfast
—my dad's voice on the phone when he called from Long Island
—the whir of humming-bird wings at the feeder

Saw:
—the intense green of the St. Augustine grass against the brown fence
—the striations of wood in the fence
—the way the puffy white clouds moved across the sun just before it set

Smelled:
—the neighbor's burning leaves in the cooling evening air
—Harold's wet fur after he played under the sprinkler
—the wonderfuly musty odor of Aunt Edna's dictionary when I turned the pages
—cigar smoke coming across the fence when my neighbor Ed smoked out on his deck
—a dead skunk some-where in the neighbor-hood—ick!

Did:
—took a walk along the creek and picked cattails to sketch after dinner
—tossed a quilt on the lawn (with Harold and his wet fur) so I could lie on my back and photograph the leaves in the maple tree
—squatted down by the gutter to really look at the colors that oil made on top of the water from when Ed washed his car
—sat at the coffee shop for an hour and sketched the regulars

In Our Own Image

Sas tells about the inspiration for her piece *In Our Own Image* (shown here), which features twelve paintings shown in a grid: "In the winter of 2004 I had the opportunity to be in Burma, which is now called Myanmar, although still popularly referred to as Burma. The reclusive nature of the country and its dictatorship certainly colored my impressions. The Buddhas, which represent centuries of devotion and merit, became the background landscape for all my experiences there. I felt them as figures of compassion and I found this same quality in the population.

"Later that year, traveling in Italy, the Madonnas of Piero della Francesca provided a counterpoint. These Madonnas, classic and regal, reflected an inner state as well, a calmness at the center. As I continued to draw and paint both the Buddha and the Madonna repeatedly, I too, was coming to my center.

"The series grew into twelve paintings as I kept trying to make the perfect Buddha and the perfect Madonna. While the imagery, gold leaf and gilded frames make reference to religious art, the unusual juxtaposition of Buddha and Madonna require a fresh look at what these images stand for. My intent was to paint images of compassion, to make an enduring work of art. Titling the series *In Our Own Image* encourages the viewer to think on these things as well."

Where did her ideas come from? Travel? Burma itself? The images of Buddha and the Madonna? A snippet of forgotten conversation? The idea of compassion? All of those things, in some mysterious mix that's unique to Sas. But there're just as many snippets in your brain, waiting for the chance to come together. All they need is a little time, a little encouragement.

Photo by Ralph B. Colby

Gail finds a lot of ideas come to her in the spaces between sleep and wakefulness: "Many of my ideas come at strange hours of the day or night. I may just see a picture in the state between sleeping and waking (the hypnogogic state), or I may dream about a new idea or solve a problem in a dream. Most of the time, I have no recollection of any of this creative activity unless I write or draw it immediately no matter how sleepy I am. … This is a really important part of my creative process, supplying a much needed connection or missing link." This portion of Gail's accordion-fold *Penland Journal of Possibilities* features photos from a Fourth of July Parade. Read more about this journal in the next chapter. Photo by Gail Rieke

DIRECT EXPERIENCE VS. INDIRECT EXPERIENCE

And is that the last clue? Direct experience? Think about the difference between direct experience—things you see and smell and touch and hear and do; and indirect experience—things someone else has done or seen or smelled and then told you about or written about. One comes to you directly, and the other is completely removed from your real life. It's been filtered for you by someone else's perceptions. Think about how much you actually experience on your own, without the filters. When was the last time you really listened to the sounds around you when you went for a walk? When, in truth, was the last time you went for a walk at all?

JUMP-STARTING YOUR BRAIN

If you're not one of those people who are bombarded by ideas constantly, that's perfectly natural. There are so many things you can do to jump-start those ideas. Exercise will often do the trick. Sas talks about getting ideas in the middle of yoga class, and it turns out that yoga is really common among artists. Scott says, "Most of the time I let ideas come to me. When I am the most calm and relaxed, I get inspired. Doing yoga or other stretching helps. I always feel like working on something after some good breathing exercises or stretching. I like to get to a place where it's like watching clouds." What a lovely image: Your mind going to a place where it's like watching clouds.

Susan mentions "walking, dreaming, lying in bed in the mornings. Ah, I love lying in bed. So relaxed! Ideas often come when I'm not expecting it, when I'm very relaxed." Michael mentions another common source of inspiration: showers. When he's "struggling with a visual dilemma on a piece," he says, "it is in the shower that these issues are resolved. This is why I often take half-hour showers. It is how I work out the kinks in my art."

All of this is lovely if you're someone who just needs to relax for the ideas to come pouring in. But what if that's not the way it works for you? Maybe your reservoir of ideas needs a little jolt to loosen things up.

Violette maintains a blog that draws hundreds of visitors every day, so it's vital for her to share visual inspiration regularly. She finds her own inspiration everywhere, from the walks she mentioned before to surfing online, looking at other people's art.

"The knowledge that there are people out there who click on my blog for inspiration is enough to keep the flow coming." When you must have ideas—when that's your job—you learn to look for them everywhere. Michael, who works with pieces of discarded objects, is always looking for more of those, finding inspiration in the process just from looking at, say, an old shoe or an empty tin box.

"Objects inspire me," he says. "I see a shape or a form and I immediately start looking at the ways I could transform it. This is especially true with rusty things. From this point the

Sas says, "So many ideas, so little time—that's my problem. I like to just lie down in the sun and empty my mind because that's when an idea will come in." The idea for this piece, *Dead Bird*, came to her at a residency in Hawaii in 2006.
Photo by Sas

object becomes more interesting when combined with other objects, and other objects and other objects. Mostly these ideas just occur as I see them." Rather than waiting for inspiration to come to him, Michael begins to handle the things he uses in his work, and the ideas flow. "My best, most honest work seems to happen when I am there in the studio actually working and not somewhere else trying to come up with an 'idea' for a piece. I begin by looking at one object I have and imagining how it might play a part in an assemblage with other objects or materials. I have to be there in the studio to do this, because the objects themselves guide me, not my mental image of them. It seems that I have to hold them in my hands, press them up against each other or hold one aloft over the other, crossing my eyes to blur reality and imagine what as yet missing piece will connect them. More than an 'idea' as such, they themselves seem to take me step by step through the process of assembly, almost crying out for the most suitable item that's needed to take it to the next stage."

TIP: If you haven't tried it already—or if it's been a while—take a couple of yoga classes. You can often find them for free; check churches and community centers in your area. After each class, go somewhere and sit quietly with a cup of tea and write in your journal, capturing any thoughts that came to you during the yoga, or that come freely to you now. While it's often a real struggle to find the time to exercise, think of this as getting two benefits for the time scheduled for just one: Your body is getting a healthy workout, and your brain is finding inspiration.

James Michael says, "My own experience has proven what I've heard from many other working artists: that making art is work, and if you want to be about it as your life's work, you must approach it with the same discipline you would a regular job—showing up in your place of work at the appointed time and making yourself available. So for me, I must start working for the ideas to come." His 2006 mixed-media work *Between These Shores*, shown here in full view and in detail, features a mailbox, a photographic print, maps, book illustrations, a plaster figurine and book covers.

James Michael speaks of a similar phenomenon. "I'm not sure ideas 'come to me' so much as I'm simply inspired to work, and then ideas come when I am actually working. The things that inspire me to work might be seeing the work of another artist; seeing or reading the biography of another artist, which can remind me of how important it is to make art, or coming across a beautiful object of the sort I use in my work. ...

"Sometimes the best way for me to make the ideas come is to start to clean up my studio. As soon as I begin picking up and handling the beautiful objects that are left lying around my workspace, I can't help but think about how I might make something new with them." Other artists echo this idea that work begets ideas, which beget work, which in turn begets more ideas.

Melissa says, "I have always kept working even when I knew that this was not what I wanted. I've felt that somehow the continuous engagement of hand and brain was necessary to find the next step. I am old now and have a great backlog of ideas and thoughts, which continuously cycle. I add to them. I try to look at them in new ways."

Wendy Hale Davis says, "Work is that main thing, and exposure to other people's ideas. If I find myself having a hard time working, it means I need to be working more. Ideas come to me when I'm working on things. I think of it as being akin to 'priming the pump.'" Susan says almost exactly the same thing: "I often just start in working and channel the ideas, watch them come out. Then, once I get into the groove, I follow it."

Sometimes the ideas come serendipitously. Melissa tells about an idea that came to her through what sounds like pure coincidence. She recalls a time when she had all kinds of tricks for overcoming blocks: "Twenty-five years ago—to say 'a quarter of a century ago' sounds even more distant—I was creating narrative ceramic pieces that required a fairly complete mental model before I could make them. My idea of having a block was hunting for an idea for more than two or three days, and I had various strategies to cause images to appear. I would tree gaze, walk, listen to music or bake bread. We lived in a rural area of New Mexico next to the Rio Grande. ... We could cross the river and hike for miles. One evening after dinner my husband and I crossed the river and began a little trek up a steep sandy single-lane path. I was desperate for a

Claudine says of her collage work like the custom artwork (created for a client) shown here: "I generally get my ideas while I am creating. I have to begin, and then the ideas come. I rarely get an idea in advance and then start working on it. So the actual process of working is what inspires me."

new idea, since a week had passed and nothing. I was begin-
ning a terrible spiral into 'I've lost it. I'll never make anything
again.' We struggled up the path and wandered across a mesa
of pinon and chamisa. A typical New Mexico landscape, which
that evening I wasn't admiring or even noticing, so intense
was my frustration. We began to make our way down the same
path, and I hadn't even found a pleasant rock to pick up or
a bone to admire. Running and stumbling down the slope,
I saw something sticking out from the sand. I stopped to dig
it out. It was the most wonderful little wooden motorcycle,
probably six inches at its widest point. I had never seen any-
thing like it. It must have been handmade, but done well
enough to have the feel of an accurate miniature motorcycle.
The wood was partially rotted, and the nails were rusted.
Instantly, I knew what it was: This was Lawrence of Arabia's
motorcycle (T.E. Lawrence), about whom I had been read-
ing. The entire piece [at right] appeared, T.E. seated on one
side writing his memoirs in the sand (literal sand) and on
the other side, the motorcycle lying on the ground in front
of a painted pyramid. (It helps to know that Lawrence was
killed in a motorcycle accident.) As I write this, I realize that
what made this so marvelous to me and why it has remained
so memorable was that in an instant, a bit of wood could
elicit a complete idea, which apparently formed without any
conscious assistance at all." Melissa says that describing this
incident lacks "the intensity of my memory, perhaps because
it was one of the best pieces I ever made. In it the idea and all
aspects of the physical object were completely wed."

Who would have thought an idea would be buried there in
the sand? Sometimes, when the ideas don't come out of the
blue, you have to do a little digging.

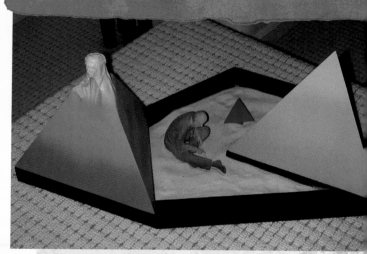

Melissa's 1987 *Colonel Lawrence Wrote His Legend in the Sand,*
currently in the Nan Laitman Collection. Photo by Franklin Silverstone

Flexing the Creative Muscle

Begin something. If you have an affinity for watercolors, begin a painting. If
you like to work with fabric, start stitching. There's some project you have in
mind, something you've thought about starting "when I get a better idea of what I
want to do." Don't wait for that idea to gel; just start working. Gesso the can-
vas, work the clay, sand the wood. Whatever the first step is, take that. Then
take the next one. Don't try to think through the process. Instead, pay attention
to the materials—the way the clay feels in your fingers, the consistency of the
paint, the texture of the cloth. Follow whatever seems to guide you.

Kelly's *Tolerance*—a square board covered with handmade book cloth, painted and embellished with various beads and *milagros*—came about through her process of "inviting the muse to dinner."

I always have at least three or four projects going at any one time. A magazine article or two, the novel I've been working on for several years, a couple of fabric pieces. When the ideas aren't coming for one thing, I work on something else. When I get stuck on *that*, I get up and take a walk. Usually, though, I don't get that far: In the act of working on one thing, ideas for something else almost always present themselves.

I'm far from alone in this way of working; it's actually quite common. Of the many artists who spoke of this method, one stood out: Kelly and her marvelous story about preparing for a big gallery show in this multitasking, simultaneous manner. It even has its own title: "You Can't Invite Anyone to Dinner If the Dining Room Table Is Cluttered and the Phone Is Ringing."

A MULTI-PROJECT METHOD

Kelly explains: "In my workshops, I outlaw cell phones. If your life is so busy that you can't dedicate the amount of time needed to take part in the workshop, then you shouldn't be there. Your mind (which is the dining room table) is too cluttered, no room for ideas. If there are stacks of bills, to-do lists, letters and a phone strewn across the surface, how can you enjoy the delicious meal and glass of wine and chocolate cake? You have to get the day-to-day buzz out of your head before you can be receptive to creative ideas. I believe that this is a hurdle that many people cannot jump over. They don't know how to declutter their lives. Baby steps in any direction work for me.

"Recently I prepared for an upcoming group show that I was a part of. The idea for the show was that each of us (there

are four) would take a 12" x 12" (30cm x 30cm) board and create a piece of artwork that would hang on the wall. The other three artists work two-dimensionally most of the time. I do not. (I create mostly Intercessors and handmade books.) Hmm. What should I do with this big 'ol board? I found that not only was I outside of my comfort zone with this impending project, but that my dining room table was very full. I was still trying to finish the last Intercessor figure for my own show and to start on the text that I wanted to present with each figure. Deadlines were looming, and regular life still went on. What to do? I set the board on the floor next to my table and glanced at it from time to time as I continued with my primary focus: writing words to accompany my Intercessors. Having cleared my dining room table (this is my head, remember) of clutter, I suddenly had an idea: Why not treat this board as if it were a cover for one of my handmade books? So I took my first baby step. I still had no idea what would be on the surface of this big, thick, square book cover, but I knew that I needed to begin by making some book cloth. The first day, I took old cotton fabric, ironed it flat and cut it to shape. I then went to the kitchen to cook up a batch of book paste and then back to the studio to make the book cloth from old fabric that I had salvaged. This takes a day to dry, so I continued writing my words for the show.

"The following day, I removed the book cloth from the stainless steel sheet where it had been drying. It was time to glue the cloth to the board. This also took many hours to dry, during which I returned to my writing. The following day, I applied a coat of gesso, let it dry, returned to my writing, sanded the gesso, applied another coat of gesso, wrote some more, sanded this coat of gesso. Now I was ready to apply a coat of acrylic paint. What colors to use?

"I keep a table covered with the handmade books I've made. They inspire me and give me ideas for new directions to take. I found myself drawn to one of my favorites, which I had created by coating the cover with several coats of paint, the final coat being black. I had then sanded the whee out of it to expose the layers of color below. I decided to use this color palette for the 12" x 12" (30cm x 30cm) board. I began the process of applying three layers of paint, writing during the drying times in between.

"By now I had decided that I wanted to include a red cross image on this book cover. I cut this shape out of canvasette and painted it red. Several coats of various colors and antiquing later, I had a cross to use. Where to place it? And then what? Time to let it sit on the floor next to my table, where I could look over at it and meditate on its progress while writing more content for my show. I knew that I wanted this giant book cover to tie into the theme of my body of work, which deals with extinct and endangered beings from around the globe. Part of the message I wanted to convey was that there is room on this planet for all beings, whether four-legged, two-legged, winged, whatever. I write poetry of a sort and a phrase from a poem that accompanied a previous group of Intercessors was "lean away so that others may breathe." This is still my thought with this grouping of creatures. I am suggesting tolerance of others.

"Taking a break from writing my words, I walked over to an antique yellow-painted cabinet, opened the door to look at the treasures inside and spied a sack of thin turquoise blocks with letters on them that I'd purchased at a flea market years ago. I had used these on real book covers in the past, so why not use them on this project? Great—another baby step. I spelled out the word "tolerance," and then another idea hit me: I could also include the letters "CR," which stand for "critically endangered" in the code used by the International Union for Conservation of Nature and Natural Resources. I believe that tolerance is critically endangered. Then I had the idea to add synonyms of the word "tolerance." I typed them on old paper with my vintage Royal manual typewriter, then tore them apart.

"Now it was time to begin to assemble the piece. I glued the wooden blocks and the cross on the board, then arranged the synonyms around the cross. I decided to put it aside again and return to my writing. After a while, I rummaged again through my yellow cabinet and found some vintage handmade wallpaper beads. What great decoration for the edges of my "book cover"! My husband helped me drill holes in the

side of the board so I could nail the wallpaper beads to the edges. Then I returned to meditating on the rest of the surface, all while writing more words for my Intercessors (baby steps, baby steps). I had written a couple of poems that dealt with this body of work, but I wasn't sure where I was going to fit them in. Then a small voice whispered, 'Why not use the poem on the board?' I dragged out the old Royal once again and typed the verse onto old paper. I tore the lines of poetry apart and arranged them on the board around the cross. Perfect. The words dealt with my body of work and the word "tolerance":

To Earth Surface People
the world is holy
all beings
are
equally significant
Mother Earth
is sacred
tread lightly
honor
her frock
of flora

"I then glued the words to the surface. I also wanted to place something in the center of the cross, which was glued onto the front of the board. Time to set it aside and meditate whilst continuing the writing. Another theme I wanted to get across with this work was the concept of wearing someone else's shoes, of placing yourself into someone else's world before judging them or, in the case of putting on another creature's 'shoes,' thinking about what we as humans are doing to their habitat.

"Hmm. A pair of shoes in the center? I rummaged in another box. No shoes, but I did have a foot—which also complemented the poem's words of treading lightly. I glued it down, and the book cover was finished. I had created a two-dimensional piece of artwork for my show—all by taking baby steps!

"This exercise of creating a giant 'book cover' that can be hung on the wall has inspired me to try my hand at a few more wall pieces. This unexpected gift of an idea came about all because I cleaned off the dining room table to make room for a guest. By creating a calming sanctuary in your mind—and by listening to your inner voices, observing, staying centered, being 'awake' and aware, maintaining self-discipline to put aside the real world for a while, and realizing you are not wasting time while the creative process unfolds—ideas and inspiration come. The dinner guest arrives."

ENTICING THE MUSE

This is just one method of enticing ideas, and it doesn't work for everyone. Perhaps you don't like to think about two or three projects at the same time. Maybe you don't have any projects underway—maybe this is the first one! In that case, you're going to have to build the table before you can invite the muse to dinner.

Violette has a different method, one that involves listening to her inner voice, which can manifest itself during work or sleep or any other activity. She explains how she overcame her creative blocks in her piece *Walking Stick & The Tao*, shown on the following page. Now that she can tap into her muse, she no longer suffers from these blocks. "In fact," she says, "I wake up in the middle of the night with ideas galore and cannot sleep. Of course, I still experience little 'creative block-ettes,' but nothing to the extent I had ten years ago. Now when [I'm blocked] I simply begin with a blank page, put my pencil on the page and just doodle. The doodles essentially tell me what I want to do. It's as if they have a life of their own that allows me into a private world of my subconscious. When I let go it becomes a very exciting process. It's exciting because, quite frankly, I never know where I'm going to end up. And, if the truth be known, I don't want to know. It's so much more fun that way. Life is such a juicy, fabulous learning ground—all we need to do is shift our perspective from being blocked and being a victim to being the creator of our own reality!"

INVITE THE MUSE TO DINNER

Try Kelly's method, even if this isn't the way your brain seems to work. It can't hurt to experiment. You'll need at least two projects, maybe three or four. One or two should be things you've already started on. Then set out the supplies you'll need for a project for which you don't yet have any ideas. If it's a painting, get out the canvas, easel, paints and brushes. If it's a fabric piece, set up the workspace with a spread of various fabrics alongside your tools—scissors, fusible webbing, pins, etc. Once that's done, work on one of the in-progress projects, glancing now and then at the work yet to be started, maybe stopping now and then to move different colored paints or fabrics next to one another. Don't push yourself—keep going back to the piece that's working for you, taking tiny baby steps on setting the table for your invited guest.

Not all artists believe in The Muse (hence the subtitle of this chapter). Rebekah says, "I'm often asked about my 'muse,' and it makes me smile a bit to think that a lot of people think there might be some sort of muse fairy that comes in and sits on my shoulder when I'm in need of inspiration. I've always been a planner—not so much on paper as in my head. I make lists, check and double-check them; I prioritize and take action. The key to unlocking my muse is to clear my mind of the clutter of the day. The mind has to be clear in order to let the muse have room to work. My muse = my imagination."

Sas spent a couple of glorious weeks in the summer of 2006 at Red Cinder Creativity Center, an artists' residency on the Big Island of Hawaii. She now shares her insightful story of jump-starting creativity under self-induced pressure:

"Inviting the Muse to Dinner—You have to invite her to breakfast, lunch and midnight snacks—and to spend the night as well. After six months of travel and teaching, I was awarded these two weeks of uninterrupted time to get back into my artwork. Since I'd just completed a series I'd worked on for

Walking Stick & the Tao

the magical stick that unblocked the flow

Several years ago I was experiencing a horrible creative block. I was completely dry, shrivelled and on empty. People were getting incredibly tired of hearing me whine I was blocked. A mentor at the time encouraged me to read the Tao, a very deceptively simple book. After reading it I decided that I had been getting in my own way stemming the flow of my creativity. I grabbed a stick, a piece of driftwood and began painting it without thinking. Since then I have never been blocked. My ideas flow continuously like a river. A couple of years after painting my walking stick I gave it to the man who helped me get unblocked. Even though the stick had great meaning to me it was more important that I practise non-attachment

three years and didn't want to revisit my old imagery, I had
no idea what would come next. Given this precious expanse
of time, I would have preferred to arrive with a plan of
action, but I was devoid of any ideas for my next body
of work.

"One of the painters at Red Cinder had a foolproof
working method to ease her into a new body of work. All
of her landscapes were derived from photographs, so each
day she would go roaming with her camera and familiar-
ize herself with the island. Then she'd return, print her
photographs and select some to paint. I envied her modus
operandi because it was so concrete. My process also involved
roaming, but my landscapes were more intimate. I found
myself taking a close look at the plants, collecting seed pods,
leaves and flowers to draw. Since it was raining a lot, I added
rain to my materials, making ink washes and putting them
out in the rain.

"I found myself frustrated that 'it' wasn't happening faster.
Although I was working all day, going from drawing to paint-
ing, nothing seemed to gel, and I wasn't doing anything I
considered 'important.' At this state, I had to be gentle with
myself and trust that good work would come out of the set-
tling in process.

"I tried to keep my frustration in the background, because
I know it's not possible to rush the muse. You can only pre-
pare the way for her, and I was doing everything I could to
entice her. I've always felt my art comes directly from my
body as a sensual expression. I have to touch my materials,
not just look at them. When the paint leaves the brush and
disperses on the paper, something similar happens in my
veins. I feel a visceral correlation with the materials. Years
ago when I worked in textiles, I'd feel a direct infusion of
energy from handling the vivid silks. I later read about the
phenomenon of synesthesia, where the stimulation of one
sense stimulates other senses. ...

"Some of my best 'planning' takes place in the pre-sleep hours,"
says Rebekah. "Simple pieces don't get much planning, maybe
a quick sketch, a note or two on what beads will be used, a
ruffle here and a stack there. Planning larger projects—that gets
the so-called full treatment, a brief write down, a quick sketch.
When pressed for an idea, I often clear off my desk first. Pay
bills, read e-mails, balance checkbooks and tidy up. This is sure
to get the muse in gear, as she hates doing what's supposed to
be done, and I'll soon find my mind wandering to a new muse-
inspired idea." She created this untitled brooch—at just 3" x
1½" (8cm x 4cm)—from beach glass, yellow jade, a carved bone
face, seed beads and bead embroidery. Photo by Jerry Anthony

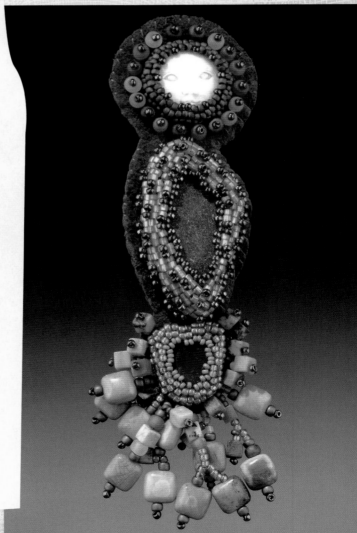

"After about six days of being in the studio, things began to happen. All of the paintings began to make sense together and evolve into a series. I was able to take the nature studies and abstract them, combining detailed drawings with the rain paintings. These works could only have happened here in Hawaii and are rooted in this physical place and these two weeks of freedom from any pressures. My daybook grew in importance as I drew my iconic alter ego bunny [shown here and on the following pages] every day and recorded what the days were like at Red Cinder. The Muse showed up about six days into my stay, keeping late hours and never wanting to quit. I realize that I go through this same process each time I begin a new series. It takes a lot of just being with the materials in my studio before something emerges."

Imagine how frustrating it would be to someone who hasn't gone through the process before: You're at an artists' residency. You have unlimited time and freedom to create whatever you want to. But the ideas don't come. Day after day after day. What do you do? Do you give up, lie around feeling sorry for yourself? Beat yourself up? No. Notice how, even though the ideas were slow in coming, Sas kept working, day after day. Sas says, "You have to show up in the studio even though nothing is happening. You have to be there with your materials. You have to switch off your brain. Your big idea will come in through the back door when you're not expecting it."

Sas's *Self-Portrait as Bunny* (2002) reflects her muse, an iconic alter ego bunny image she routinely draws for inspiration.

try this

Remember the list you made in Chapter 3, about the places where you get ideas? Go back and look at that list and see if there's a more general pattern. Are ideas coming to you when you're relaxed (lying in bed, relaxing in the backyard)? Or do they come to you when you're exercising, releasing endorphins (hiking, doing yoga)? Or do they arrive when you're doing something that makes it hard to capture them (driving, working, listening to someone talk)? Once you've figured out what these times and places have in common, figure out how to incorporate more of that kind of activity in your day, especially early in the morning and then again in the evening, before bed. If you get your best ideas when you're completely relaxed, try waking up slowly and spending half an hour in bed, in the dark, just lying quietly and letting your brain wander. If your brain likes mindless activity, give it something every day—mowing the lawn, vacuuming, pulling weeds, baking. Learn how your mind works in coming up with ideas and then feed it what it needs to be most productive.

emp mid 80's 5
overcast

light mist 6
in morning
real rain in
afternoon
saw a
rainbow

pretty much 7
RAINED
ALL
DAY

SUN 8

RAIN

FULL MOON

SUN til 1:30 9
MOON @ 5am

GRAY 10
& OVER
CAST ALL
DAY

SUN 'TIL 11
10:30

OVERCAST &
RAINY the
rest of the
day

SUN 12

IN TIL 3 PM 13

14
SUNNY
ALL
DAY !

sort of 15
SUNNY

MIST AFTER
2 PM

a mixed 16
day

17

sunny 18
& mixed

19

South Hawaii: Partly sunny today; a couple of
showers in windward areas. Wind east 12-22 mph.
Partly cloudy tonight; a shower. Wind variable 5-
10 mph. Partly sunny tomorrow; a shower or two.
Wind east 10-20 mph.

"To invite the muse [at the Red Cinder retreat], I began experimenting with the limited materials I'd brought, painting and altering postcards and making quick studies in my daybook," Sas says. "Each day I'd list the art I'd made, and on one page I devised a grid to record the weather: yellow stripes for sun, gray stripes for rain, blue for misty days. The other residents were congenial, and early on we interacted with each other's work. I recorded these conversations, and especially the jokes that occurred between us." Pages from that Red Cinder Day Book appear here and on the following page. Both photos by Sas

#4 - Chignet
Ch - Ricandbun
#3 -

GETTING IN THE GROOVE

Susan says, "I often just start working and channel the ideas, watch them come out. Then, once I get into the groove, I follow it. I don't want to think too analytically since, to me, that breaks the stream of creative energy. Just smashes it flat. I don't work from sketches, even if I do sketch ahead of time. I consider those warm-ups and let them sit while I work. But usually I just do my first drafts right on my work."

Sometimes music playing in the background can help with the process, but pay attention to how various music affects your brain as it's chugging along. Many artists match the mood of the music to the work at hand: jazz for coming up with ideas, classical for letting the ideas simmer, rock 'n' roll for working with the materials. Others watch television or have old movies running in the studio; but, unlike someone using those as a distraction, these artists have found what works for them, and sometimes it's a DVD of Bette Davis at her best.

BUNNY IN PARADISE

8.16.06

this statue erected at Kohala on the Big Island of HAWAII is bedecked with fresh flower leis honoring the King annually on June 11.

KING KAMEHAMEHA

CREATIVITY TIPS FROM SAS

＊ Write about your creative blocks in a journal. Sometimes just writing about your frustration will shake it up.

＊ Keep a visual journal. I have a little bunny figure that I draw in different situations (a few of which are shown here). I keep a sketch-book just for the bunny, drawing it at the beginning of the day to get loosened up in the studio. I date each page. This simple act frees me to get loose and get going on the 'real' art. In Hawaii, at Red Cinder, I drew the bunny swimming, walking near the volcano, as King Kamehameha, and with an orchid in paradise. The repetition of drawing the same form is important and eventually becomes intrinsic knowledge.

＊ Try this simple line drawing exercise (originally from the artist Pat Steir, though I've embellished). My students love this, and I find it's an effective way to bring you into the present, connecting the body with the mind with the materials.

1. Gesso a sheet of newspaper, half of a folded page.

2. Get a sharp drawing pencil, a 2B or softer, whatever you like to draw with.

3. Have a pencil sharpener available.

4. Hold the paper vertically and draw a line about ¼" (6mm) from the top of the sheet.

5. Continue drawing lines, about ¼" (6mm) apart, until the page is filled.

6. Draw straight lines, no gimmicks necessary.

7. This is like a meditation; thoughts will come and go. You will love it for a few lines and then you might get impatient to finish. Just let the thoughts come and go and try to make each line consciously. Stay with it until the page is filled with lines.

You can do this on a plain sheet of ungessoed paper, but I find the gesso has a good 'tooth' and intensifies the feeling of drawing. Also, when you paint the gesso on newsprint, it allows for some of the print to show, making an interesting ground for the lines. I've done this with hundreds of students over the years, and all are amazed at the beauty of a page of hand-drawn lines and at the individuality of each person's lines. The bonus is that you have made a drawing, and will be inspired to continue working.

Kelly gets many of her ideas from listening to news broadcasts. She says, "Sometimes an idea will jump out of a news report from the BBC or NPR as I am listening while working in my studio. I will jot down the topic and any other pertinent information I hear on a scrap of paper. Later in the day I will research on the [Internet]. Then I will head to the public library to find more background material." The days and weeks of research all begin with a sentence or a phrase or even just a word that sparks an idea—maybe a complete mental picture of an as-yet-unrealized creation.

CITY

all their shadows swayed

A Creativity Tip from Linda

If you see something you like or that triggers a reaction, take a picture of it. You can put it in your journal or tack it to a bulletin board and refer to it later when working on a project. Here you can see one such photo I took and how I incorporated it into this piece, titled *Shadows*.

James Michael says, "I often wish that as a young man I'd been introduced to fine art as a career path, but in my blue-collar family, just going to college was considered progress. As it turned out, the years I spent working as a graphic designer proved to be like the art school I never had. One very practical thing I learned while making 'art' for clients was the discipline of creativity. Because I had to produce on a fairly rigid schedule with unchangeable deadlines, I had to abandon the idea of waiting for the muse and instead was forced to go out looking for her with a net. One common technique I used to get started was to flip through professional journals and view examples of the very best graphic design being done at that time. I had no interest in emulating other designers, so this exercise was not for the purpose of copying their ideas but to set the bar high for myself, and it often resulted in getting my blood pumping and motivating me to accept only the best ideas that came to mind. Even now that I'm making real art, if I see a good gallery or museum show, or watch a video about a great artist or even read an interview with one, I am immediately inspired to go into the studio and start working. So I've learned that taking my attention off the struggle of creating and putting my 'eyes on the prize,' as they say, helps to eliminate my self-consciousness about the process and motivates me to focus on the possibilities and believe that I can make something beautiful."

Once you've caught her in that net, the muse gives you that one, perfect gift: that belief in the possibility of making something beautiful, just knowing that there's an idea, the wisp of a creation, that only you can bring into being.

how WiLL the MuSe viSit me today?

Tips from Bean

I feel blocked about once a year, and it usually begins at the moment of completion of a big project that has drained my energy. I let it ride for a while and read a lot of novels and eat terribly sugary food. When it starts to stress me out that I'm not doing anything in my studio, I try to make myself do something to get my hands busy again. The ideas will come back eventually. The first couple of times this happened, I did get scared and depressed. I thought my personal well of creativity had run dry. Now I almost enjoy it, but not quite—I really feel best when I am working in my studio.

* Take some tiny element of your process, perhaps a mindless one, like dying fabric, and do that for a day or two.

* Clean out your files, rearrange your paints and do an inventory, or clean everything so that when you're ready to work, everything is in order.

* When all else fails, go to a matinee.

Bean's 2004 *Specter*, made with dye and bleach on quilted cotton. Photo by Dan Gilsdorf

A Creativity Tip from Violette

Assemble your favorite quotes, type them on little slips of paper and cut them into strips. You can put them in a decorated glass canning jar. When you are feeling empty, or if you think the muse has abandoned you, just dip into the jar and let the quote guide you in your creative process. (A piece of Violette's artwork depicting her muse is on the opposite page.)

chapter 5

Journals & Sketchbooks & Notebooks & Ratty Little Scraps of Paper

All of the photos on this spread feature pages from Susan's hardbound sketchbooks. Below, a drawing in black pen and watercolor. On the opposite page, at top left, a Pentel marker drawing of her daughter, Gretchen, when she was about twelve years old. At bottom right, a Pentel marker drawing of her mother.

Photos on pages 68–69 by Susan Shie

Journals, notebooks, sketchbooks, daybooks, diaries. No matter what you call them, they contain worlds: your thoughts and dreams, your daydreams and nightmares, your plans and lists and sketches and random musings and periodontal appointments. For some artists, they're pure inspiration—the place where ideas begin and are fleshed out, maybe with sketches, maybe with random notes and color swatches and photographs and things torn from magazines. For others, they're companions—the place where they talk to themselves and muse about possibilities. And for yet still others, the journal *is* the art. Here we'll take a look at all kinds of artsts' journals, from those that serve as tool kits and workbooks, to those that function as companions, to those that are works of art—some of which you might not even recognize as journals until you get right up close.

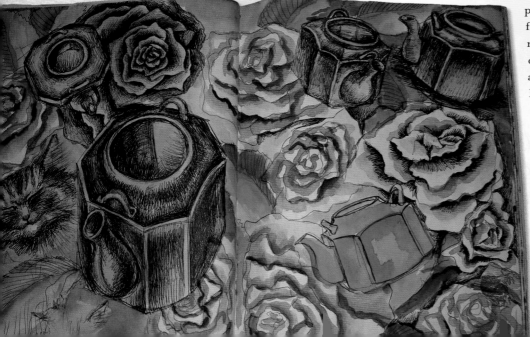

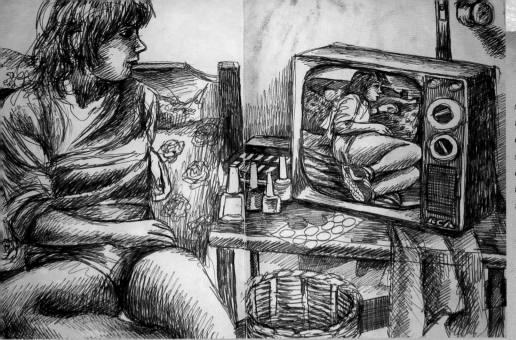

"When I was working in hardbound sketchbooks, I would carry the one I was working on everywhere, and work on my drawings. I tried to do one double-page spread each day, no matter if it was drawing or writing or both. My drawing then was more realistic, and I'd draw wherever I was—on the bus, at a party, in my studio, on the way to the grocery store. Each drawing wasn't preparation for a future piece: It was a finished piece. Looking back, my strongest body of work during grad school is my body of hardbound sketchbooks from that time. My 1985 thesis was the real start of the body of work I've done since.

THE ART JOURNALS OF SUSAN SHIE

Susan tells of the evolution of her journals throughout her years as an artist:

"I wish I could look back and see all my journals and sketchbooks in some kind of organized format all the way through; but they're in every conceivable kind of book, shape and size you can imagine. I've always looked for the perfect place in which to record my writing and drawing and painting, but I never settled on any one thing. For a long time, I just used those spiral-bound sketchbooks, and then for my senior project [at the College of Wooster], I got myself a fancy hardbound 11" x 14" (28cm x 36cm) sketchbook—the kind artists lust for. That was great, and I used those for many years, getting to maybe twenty-eight or thirty of them before moving on to something else. In those sketchbooks, it didn't matter what I wrote or drew or painted about—everything fit, everything made sense—because it was about my life. So I drew in any medium I wanted to, which was often Pentel color markers, and I watercolor painted on the pages. Having the art in a book kept the watercolor and markers from fading. I used a lot of ballpoint pens for writing and drawing, and I glued in stuff, like fortune-cookie sayings.

"Right now I'm trying to get back to making my sketchbooks more interesting again, more representative of my life. ... My newest large art quilts have so much writing on them, I don't need to record my thoughts so much in books. Now my sketchbooks are for the process, not the archive. Keeping a diary, no matter how irregular your entries are, is really good for an artist. ... But work in the studio—ahh! That is the best!"

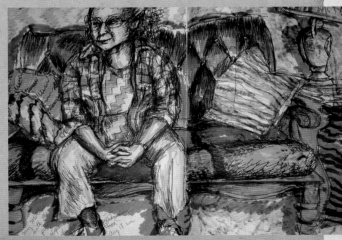

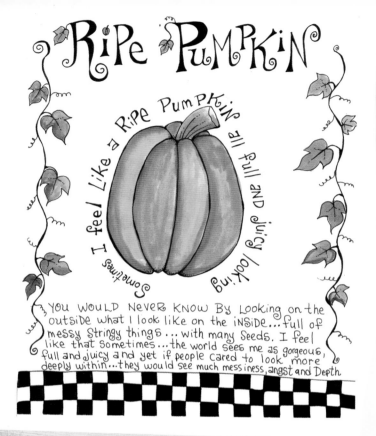

Ripe Pumpkin

I feel Like a Ripe PumpKin all full and juicy looking

Sometimes

YOU WOULD NEVER KNOW BY Looking on the outside what I look like on the insiDe...full of messy stringy things...with many seeds. I feel like that sometimes...the world sees me as gorgeous, full and juicy and yet if people cared to look more deeply within...they would see much mess iness, angst and Depth.

Juicy Journaling Tip from Violette

Choose an object—the first object that comes into your mind or that your eye falls upon—and create a journal page around that. Don't think too much about it; simply begin. Your page will naturally evolve into something that is going on in your life. For example, if it's close to Halloween, you might think of a pumpkin. Now ask yourself, 'How does a pumpkin relate to my life right now?' You might want to draw or write about how the outside of the pumpkin shows the world that you are juicy, gorgeous and ripe—when in fact the inside of the pumpkin is full of messy, stringy pulp and seeds. Maybe the inside reflects the messy emotional stuff that is occurring in your life.

Above is my art resulting from this exercise. Try it—you might be surprised at what you come up with. An incongruous image that presents itself to you might be the jumping-off point for a totally different piece of art.

THE JOURNAL AS INSPIRATION

When you think of "artists' journals," you probably think of the place where ideas begin. And, indeed, the journal can be a source of endless inspiration, no matter what it looks likes or how you use it. Violette keeps a blog, a kind of online journal. She says, "I used to keep a regular journal, and now I blog every day and often create a drawing to go with it. I use scrap paper to record ideas and have a drawer labeled 'originals' where I pop the ideas in. I have several blank books on the go with written and illustrated ideas as well, but this is done in a haphazard fashion, and often I don't know which book I recorded what in! It's pretty frustrating at times. Both drawings and words are usually incorporated in an illustration or sketch." Her blog is both a journal and a forum, a way to think through ideas and share them with others.

Whatever form it takes—from a scrap of paper to a blog—the journal can be an amazingly rich source of inspiration, one you can keep revisiting for years, finding something you'd forgotten about and now see in a new—and really exciting—light.

THE JOURNAL AS COMPANION

For many of us, the journal is a constant companion. It can be the same journal you use for inspiration—it's just a little more personal, a little closer to your heart. Or a little more indispensable. In addition to ideas about projects, it can be a pretty good friend to have around, and it can be a studio assistant and secretary and all those helpers we can't afford to hire.

Michael says: "I only use a sketchbook if I'm working on a piece that has certain requirements, such as a commission or something that has some thematic component that needs to be addressed."

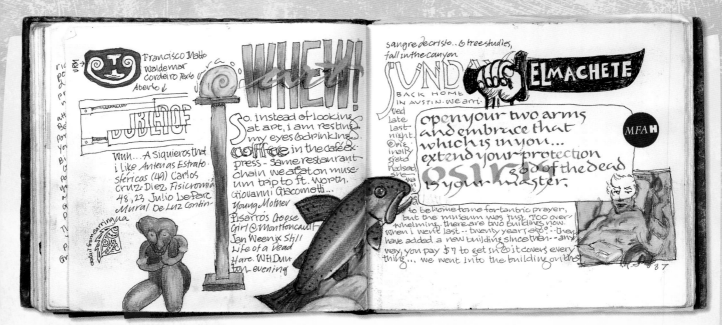

Yet other artists rely more heavily on their journals, often taking their notebooks with them everywhere and using them to capture everything from striking color combinations to bits of overheard conversation.

Wendy Huhn is a long-time journaler: "I'm a believer in journaling and have been keeping journals since 1975. I write down an idea, make a few thumbnail sketches. Then I start gathering imagery."

Linda's art journal, made famous in her book *Visual Chronicles*, is used for everything. "I keep a journal for sketching things, and I write down phrases or words I want to use in a piece so I won't forget later. I keep swatches of colors, textures and images in my journal. My journal is a place for me to keep my thoughts and little reminders. When working on art projects, it's like having a little book of inspiration I can flip through, and I can see what works and what doesn't. Sometimes, I get the beginning of an idea and put it in the journal. Looking back later, I either incorporate it in a new project or just leave it alone. The good thing about keeping an art journal is that even when my ideas or visions are just little bits of something, it's okay. In an art journal, projects don't ever have to be completed. It's a safe space to store my ideas until I can use them later.

"The flip side is that some days I look at older journal pages or notes and wonder what the heck I was thinking! At about 3 a.m., things that don't normally look good seem more exciting and daring. The light of day comes, and so does clarity!"

TIPS FROM WENDY HALE DAVIS

Take your journal when you go to a museum or exhibition. I use a shoulder bag to carry an 'abbreviated' set of art supplies: a small watercolor set and a Niji waterbrush, a fifteen-color set of Caran d'Ache watercolor crayons, and a bag of pens. I have a glue stick, too, so I can glue in postcards—or I just pop them into the pockets I put in the back of all my journals.

A lot of my inspiration comes from art in museums. It's interesting to try and draw other people's artwork and allows me to see the pieces in a different way. Even though I'm not normally working in the same medium as the artist, I can learn a lot just trying to recreate a particular color the artist uses. I also talk to the guards and docents about the works. They're often fabulous sources of information—like getting a little art history lesson! The spread from Mi Corazón *journal shown above is the result of one such trip.*

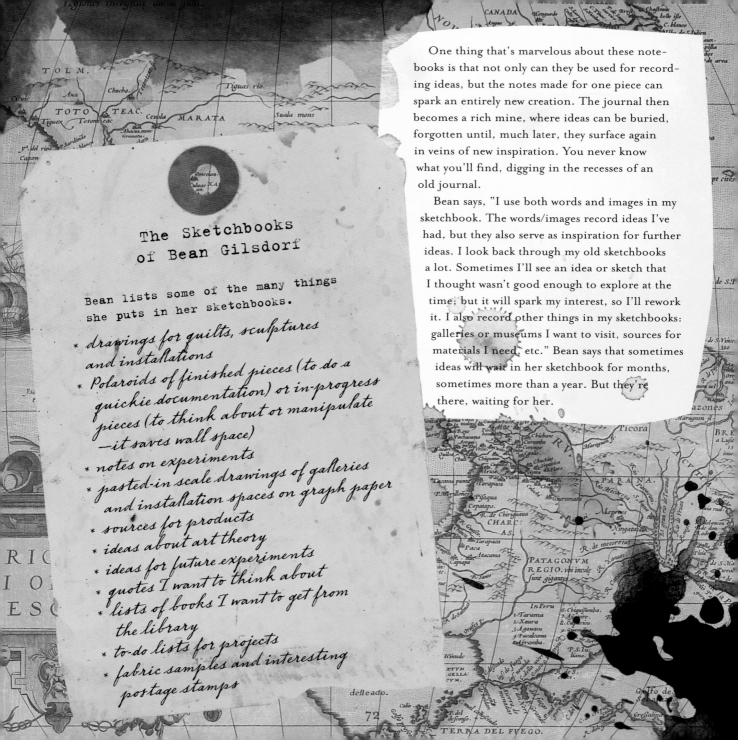

One thing that's marvelous about these note-books is that not only can they be used for record-ing ideas, but the notes made for one piece can spark an entirely new creation. The journal then becomes a rich mine, where ideas can be buried, forgotten until, much later, they surface again in veins of new inspiration. You never know what you'll find, digging in the recesses of an old journal.

Bean says, "I use both words and images in my sketchbook. The words/images record ideas I've had, but they also serve as inspiration for further ideas. I look back through my old sketchbooks a lot. Sometimes I'll see an idea or sketch that I thought wasn't good enough to explore at the time; but it will spark my interest, so I'll rework it. I also record other things in my sketchbooks: galleries or museums I want to visit, sources for materials I need, etc." Bean says that sometimes ideas will wait in her sketchbook for months, sometimes more than a year. But they're there, waiting for her.

The Sketchbooks of Bean Gilsdorf

Bean lists some of the many things she puts in her sketchbooks.

* drawings for quilts, sculptures and installations
* Polaroids of finished pieces (to do a quickie documentation) or in-progress pieces (to think about or manipulate —it saves wall space)
* notes on experiments
* pasted-in scale drawings of galleries and installation spaces on graph paper
* sources for products
* ideas about art theory
* ideas for future experiments
* quotes I want to think about
* lists of books I want to get from the library
* to-do lists for projects
* fabric samples and interesting postage stamps

Linda explains the genesis of the journal page above. She says, "When I was a little girl, I always noticed—and was jealous of!—people who could just zip upstairs really fast. I grew up in a one-story house, and when I'd go to the two-story house of a friend, she'd spring up the stairs, often two steps at a time, and I'd be trailing behind. I figured the ability to speed up a staircase came from practice, and if I lived in a two-story house, I'd be the master of stair climbing. I grew up. I got married. I bought a two-story house. I was ready to be the stair-climbing champion. How could I not be? I'd be going up and down those stairs a zillion times a day. I was so excited! Finally, I'd join the club of multiple-step steppers. Sadly, it was not to be. The first day in my new house, I fell going UP the stairs, and it has been downhill ever since."

Claudine records her ideas on scraps of paper rather than in a bound book. She says, "Usually if I have an idea I want to remember, I write it on a Post-It note and stick it in my studio. I also stick lots of paper and tape to my works while they are in process, reminding me of what I was thinking next for the piece. That way, when I come back the next day, I know where I left off." The piece shown here is custom artwork created for a client.

The Journal as Ratty Little Scraps of Paper

And then there are the artists who aren't quite so particular about the form of the journals they keep. We all seem to know someone who has a drawer full of notes that have been scribbled on everything from bank deposit slips to grocery receipts, all tossed together into a rat's nest of random jottings. Although it's terrifying to the more anal-retentive among us (no names, please), it seems to work just fine for them. Rebekah is a fan of this approach: "I'll jot down ideas for pieces on little sheets of paper when they pop in my head, say while I'm working on another piece. [When] little stacks of paper begin to add up, I'll sort them [and] toss out the so-so ideas or combine several ideas together. I might go so far as to gather the supplies needed for the dream piece, lay out the design on my worktable and mull it over for several days, then pack all the supplies up, store them away. These pieces may never be created. Those that aren't are restocked, and another idea is sure to come into play. I know I should have been keeping a journal or sketchbook for all these years, but I've never gotten around to it. Scrap paper works for me at the moment, and ideas are easily tossed away to make room for better ideas."

Kelly relies on ratty scraps of paper—and she actually calls them that. She says, "Journals and ratty scraps of paper are very important to me. In the first place would be the ratty scraps. There are piles of them in my studio. I can't seem to part with them, as there is always something worth remembering on each one. CDs to listen to, books to buy or check out at the library. I need to take the time to compile them into a journal. Since I listen almost constantly to news via NPR or the BBC, I always have paper and pen handy, usually scrap-sized paper. I jot down interesting stories I hear on the radio—names, dates, places. I then take those scraps of paper to the computer to research the Web sites of these news stations to get the facts straight. Of course, there are more stacks of scrap paper by the computer." She provides an example of how she uses these little bits of paper by referring to the animal Intercessors she created for a recent show.

"Each being has lists of factual stuff—such as age span, gestation period, habitat, diet, etc.—on one scrap of paper. Then another scrap of paper has characteristics such as yellow eyes, four toes in front and five in back, sixteen brown stripes on back. These are both checklists to use when writing the background information that will accompany each figure for the viewer/reader to absorb. Then there is a checklist of details I want to address whilst creating each figure. There are also scraps of paper with bibliographies of books and Web sites used to research. These scraps, along with the pattern pieces that I draw from scratch, all go into plastic sleeves that are then contained in a big three-ring binder. I use the scraps of paper method for the holy dolls, also.

"Someday it would be fun to make giant scrapbooks for each body of work and glue all the papers in them. This would be far more fun for someone to uncover in my studio someday than a three-ring binder full of untidy scraps."

These are, of course, perfectly legitimate journals and sketchbooks, no matter what they look like. Not every "notebook" has to be an actual notebook. Some artists make journals out of scraps of paper or index cards arranged in a file box, and others use giant sheets of watercolor paper as their journals. There are all sorts of "journals," and you can use all kinds of things to create them, often in forms you wouldn't think of as a journal. An example? Scott uses clay.

"I used to sketch ideas a lot," he says. "I suppose I will go back to that one day. Being that I sculpt more now, I sort of use the clay as a sketchbook even if I don't use what I sculpt all the time. I do make lists of things I have to remember. That helps. Just scribbling whatever stress is in there onto the paper helps to clear my head to work."

Kelly says, "I make my own journals, all from scratch. Well, I don't 'make' my own paper, although I do know how. I do hand-measure and tear each page, though. I make my own book cloth by using vintage fabric and cooking my own paste. Then the covers become paintings and/or collages. The whole shebang is Coptic-bound so that it will lie open flat. My favorite size is 6" x 4½" x 1" (15cm x 11cm x 3cm). It fits nicely in a big purse; and there is always one in my purse, protected by a cloth pouch, which is handsewn."
Three of her handmade journals are shown here: at top right, her *Dancing Intercessors Journal* features Japanese stab binding and hand-torn papers; at bottom right, her *Our Lady of Guadalupe* travel journal has its own travel pouch (made from a recycled Sweet Lassy feed sack) and "guardian cosmic dog"; at bottom left, her *Lapin* coptic-bound journal, painted and adorned with painted and stuffed leather rabbit ears.

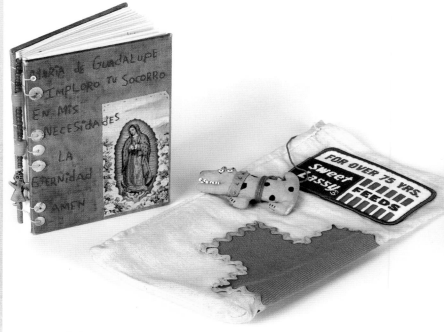

The Journal Itself

Some of the artists who rely heavily on their journals are very particular about the physical notebook itself. In the studio, Kelly uses her "ratty scraps of paper" method. When she's out, though, she always has her journal. "The handmade journals go with me in my purse for jotting down thoughts, ideas and inspirations and news stories I hear in the car whilst out in the world. My journals are used to record ideas in words. The scraps of paper and journals allow me to write down what is in my head at that moment and make room up there for new thoughts to intrigue me. For me, they are like to-do lists. These lists free me up to prioritize my time ... and yet allow me to deviate from them if the mood strikes me. Then I can come back to the ratty scraps of paper to refocus my thoughts. One of my 'to do's' in the coming year is to get more into sketching. My current work does not require sketching. I want to get back to sketching and storytelling."

The Journal as Art

Some journals go even further. They're both inspiration and companion, but they're also works of art in their own right, with pages that are worthy of frames. Wendy Hale Davis and Gail focus on their journals as their primary artistic medium. Wendy keeps everything in one book, from lists to finished art. Gail, on the other hand, creates intricate visual travel journals and also keeps a separate written journal. She explains each of them.

"In my written journal, a found-at-garage-sale or wherever (they seem to arrive when I need them) old ledger book, I like to use different-colored inks for keeping track of things I want to remember: green for books and quotes, purple for movies, a strange maroon for dreams, red for quotes from others scribbled down immediately, black for real life, blue for comments on it all, and brown for studio ideas. I jot down things all week and usually on Sunday I get out my pens and inks and try to translate and discern the bits and pieces of the week. Here's the important part: In the brown section

Make a journal from something other than a blank book or spiral notebook. If you don't feel wildly experimental, try keeping a journal on file cards. Carry around a thin stack of cards and use one every day to jot notes, make small collages, do quick sketches of things you see or ideas you have. At the end of the week, go through your cards and notice patterns and paths before you file them away. If you're feeling more adventuresome, try keeping a journal in clay, or on fabric. Journal on a shirt or pair of jeans or shoes. Or tack a large piece of watercolor paper to your studio wall and use that as your journal for a week or a month. Imagine twelve sheets, side by side, giving you an accessible chronicle of your studio life for the whole year.

for studio ideas, I write down any idea, no matter how ridiculous or impossible or minuscule. One never knows when the spark of one thing can ignite something else."

Gail's visual travel journals are another kind of journal entirely, and they truly are amazing: complex, layered, intricate constructions that she works on for months, from before embarking on a journey until long after she returns. Since she teaches a "The Artist as Traveler" workshop, Gail uses her books as both journal and teaching tool. She talks about *Wonder Wander*, a journal of her journey to Kyoto in 2001.

"I had several considerations and goals when trying to design the form of this journal. I wanted the journal to describe many differing aspects of the trip and to include many different kinds of materials. I wanted the structure of the journal to capture the fullness and spirit of this unique adventure. I wanted all these divergent fragments to be combined in a way that was coherent. I wanted the visual resolution to have a formal consistency and to function well on a practical level. I wanted the piece to be portable so that

A TIP FROM GAIL

"I like to capture the moment in the moment. I've developed several journal forms to enable me to do this and have shared this with others in my Journal of Possibilities workshops. I like to carry a very small and portable journal with me that has several kinds of pages that slide in and out of the hardbound structure. This allows me the great flexibility to incorporate all kinds of papers and to write and draw on the spot. The separate pages are bound at a later date."

Using Gail's travel journals as an example of what a rich, complex piece of art a journal can be, design your own many-layered journal to commemorate an event—a birthday, a wedding, a completed project—or to document an adventure. Start with a box—old cigar boxes are great. Add a fabric wrapping or hand-sewn pouch. Think of layers of wrapping, tied with fibers or twine. Imagine your journal as an excavation, with layers of text and imagery. Remember: You don't have to finish it in one sitting, or even one week or month. You can work on it for however long it presents ideas.

try this

At left, Gail's *Penland Journal of Possibilities*; at right, her *Kit and Caboodle.*

Photos by Gail Rieke

I could contain it in carry-on luggage for my workshops or send it easily to be exhibited elsewhere. I wanted the journal to act as a memory device and a catalyst for sharing my experience with others." Whew! It sounds like a tall order for a journal, but it worked out flawlessly and is a work of beauty and depth. Journals have no limits: They can be anything you want them to be, and they can take any form you envision and contain any elements you want to include.

Gail describes the resulting journal:

"The antique wicker suitcase contains books, an autographed fan, and four carefully wrapped packets. Each one is made from a different kind of Japanese paper and tied with kumihimo-braided haori ties.

"After unwrapping each packet, an expanded book format is discovered. Each experience or category lives in its own separate envelope—a sort of aesthetic filing system. The envelopes were made from special papers, Photoshop-printed photographs, color laser prints, calendar pages from Japan Air Lines calendars, collaged images, etc. Within each envelope, there are translucent folded papers, which pull out to easily accesses the contents. Most of the envelopes contain writings—quotes of words spoken, poems, comments gleaned from my own scribblings and that of others. There is much variation in the photographic aspects from envelope to envelope. One may contain postcards; another, portraits; yet another, abstract Photoshop-generated photographic images. There is much preservation of maps, lists, business cards,

brochures—so that this piece can be used as a specific travel reference for myself or others. There are jokes, quotes, letters, cartoons—a multitude of things collected that refer to aspects of the journey. All the envelopes can be lined up to make a long multicolored configuration, or they can also be viewed in various states of enclosure or revelation.

"Excavating the suitcase, one can also discover a 'visual conversation' book I made before leaving. I carried it with me, ready for the times I wanted to introduce myself and forgot all my carefully-learned Japanese phrases. Also, one can find a handbound stamp book and a pilgrimage book that contains exquisite stamps and calligraphy collected at gardens and temples.

"A journal of this complexity involves the desire to relive and preserve experience. As I work, I revel in a most unusual sense of being in two different places and times simultaneously. It is my own magic carpet and time machine!"

Most artists' journals are much less complex, but think of Gail's creations as inspiration for your own experiement.

Wendy Hale Davis is a bookbinder, so of course she makes all of her own journals. She fills each one with the perfect paper for her needs—most often Hahnemühle Schiller—and each book is encased in a cover she designs—most often from soft leather that frequently includes intricate leather inlays. In addition to the text, written in a calligraphic hand, there are drawings and paintings and wax resist images, all intertwined with her recollection of the days and adventures of her

Wendy Hale Davis says, "I love doing different kinds of illustrations in my journals. Some are fairly 'formal'—I think out in advance what I'm going to do and execute it over several days. Most of the wax resists (like the one shown on the opposite page, a foldout centerfold from her *Poco Más* journal) are thought out in advance because of the process. Some of the watercolor crayon illustrations are, but not all of them. I don't usually plan things out too much in advance even on the 'formal' ones. It's more like an image forms in my head, and I just have to translate it from my head to the page. Sometimes the translation is easier than others!"

Sas's artwork is also illustrative of the journal as a stand-alone art form. The spread shown here is from *Gauze* (1977), a book she created from quilted pages that is now in the collection of the National Gallery of Australia. Below that image is a spread from her ninety-seven-page altered book *Harmonika* (2004), featuring various mixed-media techniques.

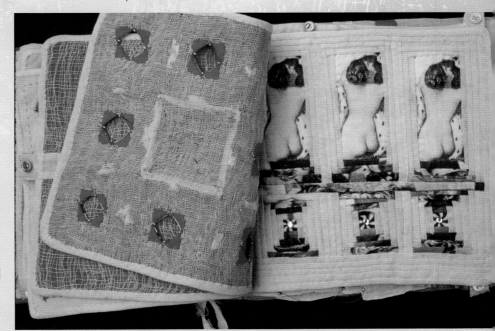

life. Wendy's journals have become her art. Her dream is one day to show them, somehow, in a venue where they can be fully appreciated. Something like a living room exhibit in a gallery, perhaps. She explains, "It's my primary art form. It functions as an art medium, songbook, diary, and record of what's going on in my life, my family's and friends' lives. It's really a diary, more than a sketchbook these days, but there's art in it. I usually write my songs down in my journals, sketch out ideas for my next journal in the previous one—and sometimes for

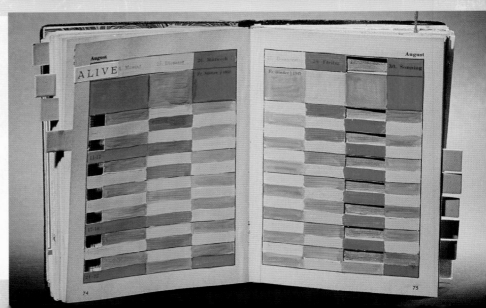

other bindings I'm working on, take notes for classes I take and the ones I teach. There are snippets of overheard conversations in restaurants and bars and airports and wherever; things my friends, kids, grandkids say; minute descriptions of where I am, what's happening and who's there; pictures of the sun's rays coming through clouds, pictures of my cats, people at my parties, etc. ...

"I suppose more than anything else, my journals are my imaginary friends—imaginary only in the sense that they're not human, of course. They fulfill a very impor-tant function in my life, one I think almost everyone needs or feels the need of in their life: the witness." Reading Wendy's journals is like re-living the days of her life, complete with notes about coffee shops and restaurants and those marvel-ous sketches from museum trips, where you can see her brain being sparked by the notes about her favorite exhibits. You look at everything she's included and realize there truly are no limits at what your journal can be.

If you've never kept a journal, give it a try—start with one kind of journal and, if that doesn't click for you, try some-thing else. If you already keep one, there are all kinds of books out there that offer tons of ideas for getting the most out of that notebook and those ratty little scraps of paper.

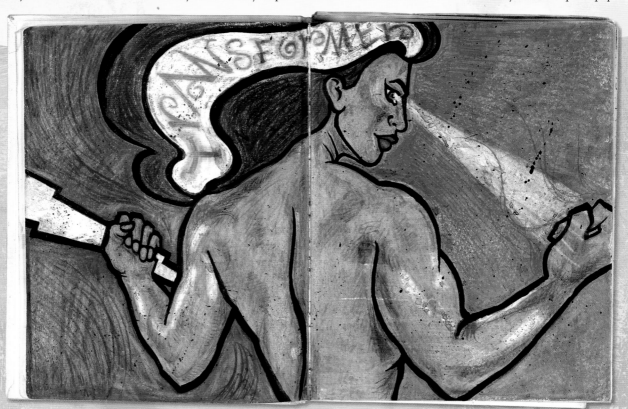

Another of Wendy's wax resists, this one an opening title page spread in her art journal titled *Transformer*.

So you have an idea. Maybe it came to you in your dreams, and maybe you worked it out in your sketchbook. However it evolved, there it is. And, somehow, you know it's going to work out. What does that feel like? You'd think it would always be terrific, a feeling of complete elation. When asked how it feels for her, Susan says, "Great! Doesn't it feel like that for everyone?" Surprisingly, it doesn't. Rebekah explains, "As odd as this may sound, a slight feeling of gloom sets in. The overwhelming feeling of a complex piece is daunting indeed. I've done enough pieces to realize that my next

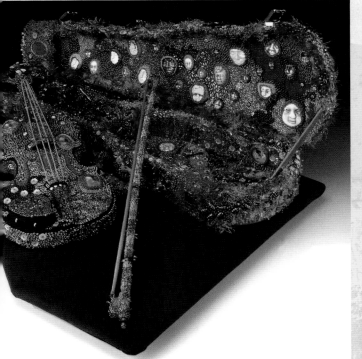

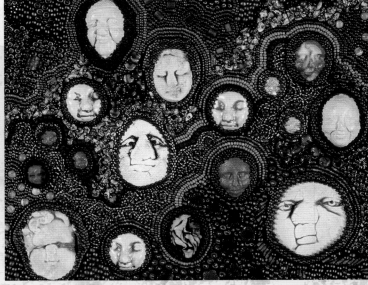

The creation of Rebekah's intricate pieces, like this beaded violin titled *It Speaks to Your Soul*—shown in the planning stages, in full and in small-area detail—can be all-consuming. This real, full-sized violin and case are transformed with thousands of beads and other elements. The faces and hands shown inside the lid represent an audience.

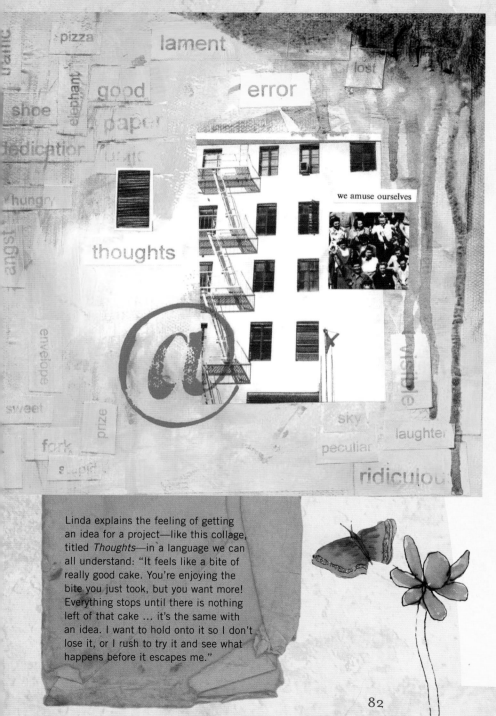

idea for a piece will take an enormous amount of time—planning it, working on it. I take a deep breath and start the planning process. It won't get done if I don't do it, so the challenge is on." Fortunately, Rebekah has the discipline to dive in and get the work done, even knowing what a huge amount of work it's going to be. For most artists it's a more positive feeling, that moment of realization that this idea, this brand-new, never-before-seen idea, is really, really good.

INSPIRATION POINT

Violette says, "When I realize an idea is going to work out, I get very excited and hurriedly reach for my sketchbook or a blank piece of paper to flesh out my ideas. Quickly, as if I have to do this before the muse leaves me, I begin to add color or glitter or whatever seems needed by the piece in order to make the idea real. After that, I work on a more finished piece."

Even if you don't use a journal to generate ideas, you might find it useful to use a journal to flesh them out once you have them. The journal becomes a tool for the work in progress, helping you feel your way along until you can see the whole path ahead.

Bean says, "I think Anne Lamott described it best by saying that it's a kind of mental diarrhea—you're just minding your own business, and the next thing you know, you need to rush off to the studio and get to work.

Linda explains the feeling of getting an idea for a project—like this collage, titled *Thoughts*—in a language we can all understand: "It feels like a bite of really good cake. You're enjoying the bite you just took, but you want more! Everything stops until there is nothing left of that cake ... it's the same with an idea. I want to hold onto it so I don't lose it, or I rush to try it and see what happens before it escapes me."

The sensation that an idea is valid, workable, makes me feel elated and a little anxious."

Sas explains the process further: "I usually feel very excited and flushed with my own brilliance. Then I get to the working-out part, and there are often a few snags. It's never the way I pictured it, but I'm open to the discovery of what it is. Recently I was painting with black gesso on a board painted with oil paint. The gesso, being water-based, began to resist and break up, creating abstract patterns I hadn't envisioned. It was not what I set out to do, but it set the direction for an entire series of images and is a technique I will continue to pursue. Much of my work evolves this way, from a tiny seed of an idea. It grows from the material outward." It's a common observation that you don't really know how a piece is going to unfold until you actually get into it, but there's also the truism that the more you work, the more you learn about working.

Wendy Hale Davis says, "I get really excited, but often I don't know right away if something is going to work or if I'm going to have to 'massage' it into working. It's pretty rare that it just complies right off the bat."

"My ideas come to me while I am working on a specific piece of art, so I test them out right away and see what happens," Claudine says. "If I'm not sure, I let them sit in my head for a while and then see what I think the next day." This collage is custom artwork Claudine created for a client.

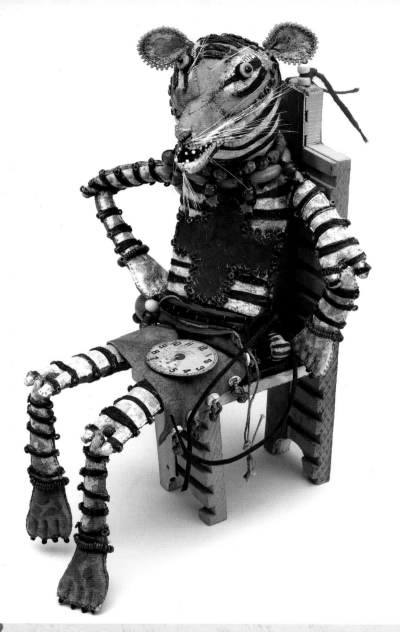

Siberian Tiger

Panthera tigris

ssp. altaica

CR

(critically endangered)

historically

Korea

Manchuria

Russian Far East

tie

cloth

round

a

tree

bow

in respect

Kelly has been making beaded creations like the *Siberian Tiger Intercessor* (shown here with a chair fabricated by Rhett Johnson) for several years, and she knows immediately whether an idea is doable. She explains, "I am lucky in that 99.9 percent of my ideas work out in the sense that what was in my head is what I was able to create with my hands."

"Most of the time I feel [how an idea is going to work] as I am working," Scott says. His work *Molecular Alphabet* is shown here. "Like I'll start sculpting a head and then get an idea of what I am going to do with it. It feels great to think I can see the end to something before I am half done with it, but it almost always comes out differently than the original idea that may pop in my head. That's okay. It's the excitement of what I think I'm going to make that gets me to what I actually make."

For Claudine, the realization comes as she's working. "When I am creating and I realize an idea is going to work, I get a little rush of adrenaline. Very exciting, a burst of enthusiasm. The opposite is true when I realize an idea isn't going to work. ... To me, creating art is a series of problems or puzzles to solve. You get one thing to work, then you have to adjust another and so on until it's done."

For James Michael, the realization comes near the end of a piece, when he's worked it far enough along to be able to see that it's working, rather than just anticipating that stage. "At that magical moment of realization, I feel as though I have not created something, but that I have simply discovered or uncovered something that was already there waiting. It's often a very emotional moment, with a feeling of exhilaration and gratitude and also relief that I may in fact be about to bring an idea to fruition. I'm usually given a new energy, and an unwillingness to do anything else until I finish this piece."

Michael says much the same thing, admitting, "Typically I don't know an idea is going to work out 'til about five minutes before a piece is completed. My process is one in which I keep looking for that magic moment, in which a bolt of lightning hits me and I know I've found the solution. It's quite an amazing thing how one moment a piece might seem to be days from completion and then a subtle little dab of paint or adding some unexpected object can catapult the work to a new level." It seems amazing that these artists, who have achieved success with their work, often have no idea whether or not the piece is going to work until near the end, yet they keep working on it anyway, for however long it takes.

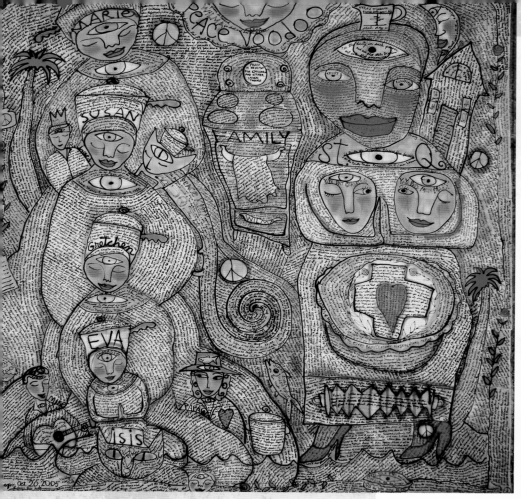

Susan says, "The ideas that are the most potent are the ones you have to wait to do, for whatever reason. You build up a big hunger to do them, and then they explode out of you!" She painted this 2005 piece *Wilma (Peace Voodoo)* on cloth she then quilted. Photo by Susan Shie

wait. And, not surprisingly, perhaps, many of them do both.

Sas says her ideas arrive ready to implement, with no waiting. "The ideas come in all forms, from clues to entire works. They are ready for the picking." Wendy Huhn's process for creating her quilts is similar. "I dive right in, gather images and then hold auditions to see who gets to be in the next piece," she says.

You might think that artists like Rebekah, for whom the next piece is always going to be a daunting haul of intense hard work, would procrastinate by letting ideas simmer for months, maybe years. Nope. She says, "If I have the supplies on hand, the idea is set into motion immediately. If I need to buy or find elements for the piece, the idea will often get expanded upon."

Other artists find that letting ideas sit does not always amount to good, thoughtful marination. Scott, for instance, finds that rather than making them ripe and juicy, time tends to make them stale and flat. "I like to get an idea and see it through as much as I can," he says. "If I put something down for too long, I will rarely go back and pick it up and finish it."

For a some of the artists, though, there's a space in there. You come up with the idea and realize it's a good one, and then what? Do you jump in immediately and get to work, or do you let the idea percolate, ripen, develop itself in your head or your sketchbook until it has formed itself fully enough for you to get a good grasp of it? Well, as you might imagine by now, there are as many answers to that one as there are artists. Some jump right in, and others wait. In some cases, they wait and wait and

And then there are the percolators, the artists who like to have one or more ideas on that little burner in the back of their brain, cooking away while they're still working on the current piece. Bean explains, "Ideas generally arrive full-blown, get jotted in my sketchbook, and sit for a long time—more than a year in a lot of cases. Occasionally I just go right into the project, but that's very rare. I like to play with my ideas and think

about them for a while. Sometimes I take more than a year before I make something that's in my sketchbook. I like to let ideas percolate and try out variations of them in my mind and on paper."

Kelly is also a percolator, saying, "Some ideas scream at me whilst others whisper. My two current bodies of work require time spent researching. Ideas percolate while I research. Rarely do I sketch out an idea. I draw my own patterns and sometimes I need to make a muslin first to get shapes right. Who knows how to draw a pattern for a horse bot fly, right? Some ideas, such as a subject for my holy dolls, will simmer for months. Since each figure takes at least one month to complete, the next doll and issue to be addressed become the meditation while working on the current figure. … There is no instant gratification in my studio!"

Linda talks about having many ideas in her head at the same time, all vying for attention. "It's just a matter of how much time I have in the day to get them done. I've had ideas to do things that float around in my head for years before I really have time to sit down and experiment." There's no sense of rush; once you know an idea is going to work, and you've captured its essence in some way to make sure you don't lose it, then it can just simmer until you have time for it. In Melissa's case, some have simmered for decades: "I've had perfect ideas swoop into my mind and emerge exactly as they arrived. On the other hand, I've been thinking about an invented alphabet for at least twenty years." Imagine the experience of having ideas like companions that grow into old friends, keeping you company for years and years, growing and changing along with you.

Gail likes to let the ideas do some of their own work, fleshing themselves out before she gets involved. "Ideas percolate a long time. I feel I save myself energy letting them develop for a while before tackling them." By the time she begins actively working on a piece, many of the planning decisions have taken care of themselves. But then what? Do artists have elaborate rituals, things they do to signal that it's time to get busy and get to work? How, exactly, do they get started on a piece?

TIME TO WORK

It's tempting to look at working artists and think, enviously, that it's easy for them: They make art full time, so the pressures of time and energy aren't the same for them as they are for someone just getting started, someone with an unrelated day job and dozens of other responsibilities. Here are a couple of things to keep in mind. First, all of our artists started somewhere, working full time at a different job, trying to fit in time for their art whenever they could. Even now, almost all of them will tell you that making art is not all they do. They teach, make commissions, run workshops, travel to shows and art retreats—in addition to regular family responsibilities. When I first talked to Scott, he was taking care of his infant daughter in the studio while he worked. These artists are not—not by a long shot—waking up leisurely at noon to wander into the studio, scratching themselves and yawning and trying to decide whether or not they want to work or just spend the rest of the day on the couch. Artists who've made the commitment to pursue their art as a career feel enormous pressure to produce. Think about it: You've given up your "real job," and your friends and family are all watching, waiting to see if you're going to make it, or if you're going

DORA yet again heads to the cool comfort of her fridge during her Nocturnal Visit

Violette says, "Being menopausal, I'm awake a great deal of the night. During these nocturnal periods, I come up with tons of ideas to work on in the morning. It is simply a question of which idea to focus on." Her *Menopausal Dora* further illustrates this routine.

to crawl back to your boss and beg to be re-hired so you can afford to put new tires on the car. Is it any wonder that they all talk about work and self-discipline? Nobody can tell you more about it than someone who's put herself out there as an artist and wants to make sure she doesn't fall on her face.

Many of the artists mentioned paperwork—all the tedious details that go into making a living at making art. You need to get that kind of stuff out of the way, and sometimes that's hard to do. Susan explains: "I just need to find the time to work. That's always the big deal. Too much paperwork usually, or other things in life that pull you away. I just need the ritual of having plenty of work time, and then I can just wallow in making my art!"

Little puttering/organizing efforts are part of the getting-started routine for a lot of artists, but they don't really think of them as part of any required "ritual." Scott, who works out of his home studio, explains, "I am very self-disciplined when it comes to how I work. I need to clean my space every time I am done for the day. I need it cleaned up before I can start fresh. 'Clean' by my standards, that is. Just organized so I can think the next day. I also like a steady schedule, like starting at 8 a.m., or earlier if I can. I didn't used to be so rigid about time, but when you have a baby around, you have to have things in some sort of order or you won't get anything done. Before we had a baby, I would work whenever and wherever, really. I prefer the schedule thing now."

Wendy Hale Davis sometimes takes a walk or lights a candle to signal her intention to work, but neither is necessary. "Sometimes I need to have stuff out on my desk—the tools I'll be using, in the right order," she says. "But otherwise, I just sort of go."

You might think that having an outside studio—one away from where you live—would work better, but that's not always the case. Those artists who do have outside studios talk about the effort involved in getting up, getting dressed, and then making sure you have everything you need before you leave

Sas says, "One ritual I've had from time to time is to begin my studio time by drawing a small object every day in a sketchbook, a centering activity. I also like to prepare the space by having only the materials I need around me." Currently, the object she draws is the bunny we met in Chapter 5, shown at right scratched into a postcard Sas purchased during the Red Cinder retreat in Hawaii. Above is a postcard she created at the same retreat.
Both photos by Sas

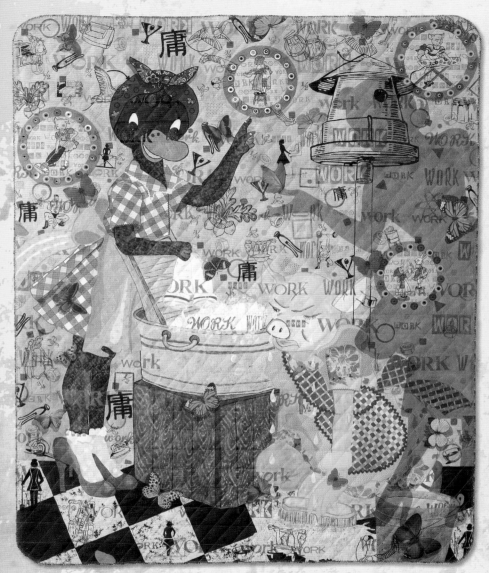

What, if any, rituals do you have that signal it's time to work? Do you putter at your desk, rearranging your tools? Do you clean the studio, getting your space ready? Do you light candles, put on a certain kind of music, make a cup of tea? For a week, keep track of the things you do just before beginning to work, however mundane. Notice the things that make your body and brain start to hum, eager to begin. If getting started is difficult for you, try lighting a candle on your desk as a signal to yourself that this is the time to work. Since you won't want to leave the candle burning unattended, you'll force yourself to stay put, rather than wandering off to start a load of laundry.

Wendy Huhn, who's adamant about not answering the phone while she's working and who guards against outside distractions, regards exercise as a vital part of preparing for studio time. "It's so important to me that I either do yoga or drive into town to go to the gym and work out every single day. I usually take a break from working to go exercise, especially if I'm feeling stumped. There's nothing like a good sweat to clear my mind. I'm very self-disciplined, and being that way is very important to me." Since she also teaches and travels, that discipline is vital. "I have to be able to transition back and forth," she explains. Her quilt shown here is appropriately titled *Work*. Photo by David Loveall

89

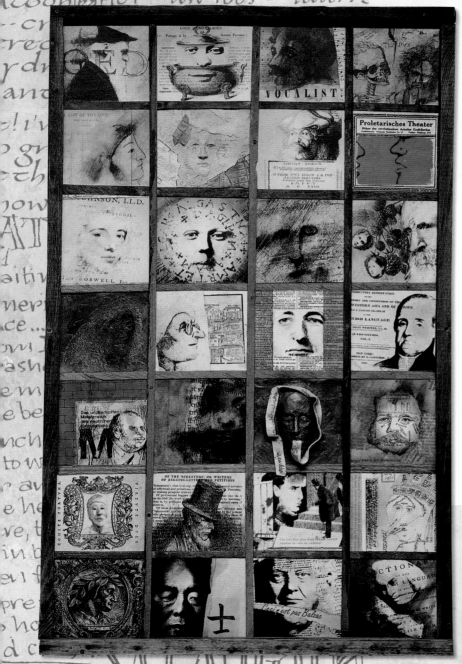

home, just as if you were going to a "regular" job. All of those preparations can interrupt the creative flow that many artists experience first thing upon awakening.

"There's a lot of self-discipline involved," Sas says. "The first step is to get out of the house and into the studio—a ten-minute drive. And to do this before all the other chores, such as e-mails, phone calls and all the distractions of daily life."

For those who work from home, it's vital to have some separation between their home life and the beginning of their work day. Linda says, "If the phone rings while I am working on a project, I don't answer it. If someone stops by unannounced, I don't answer the door. My ritual is that once I start something, I don't stop or let myself be interrupted until the project is drying or done. One hard thing about working at home is that sometimes friends expect you to be available all the time because you are at home. Saying no and staying focused took a lot of practice."

Because I've heard so many people offer excuses and complaints about not having the time to make art, or not being able to get started when they do have time, I asked these artists how they manage something that

"I am so disciplined that most of the time I am unaware if it," says Melissa, who is past the age when most people have retired. "In fact, I don't know if I am all that disciplined. I really like working, better than anything else I do. I go into the studio every morning and, if I can, I stay there all day. I will often work awhile at night. ... Is that discipline or obsession?" Her 1995 *From the Archives of a Book Person* is shown here. Photo by Pat Pollard, from the collection of Susan and Jeremy Shamos in Denver, Colorado, courtesy of *New Mexico Magazine*

ONE OF THE WONDERS OF

try this

If you live in a house with other people—especially very small, young people—you have to be able to set aside time when you're unavailable to anyone but the muse. This may have to be either late in the evenings or early in the mornings, when everyone else is in bed. But with some diligence, even the youngest members of the family can learn to give you uninterrupted time to work. One writer wears a hat when he's working, and when his family members see him in that hat—even if he's out pacing around the backyard or puttering in the kitchen—they know not to bother him unless it's an emergency. Try designating a comfortable hat as your Do Not Disturb Hat. Train your housemates to respect the rules it represents.

seems impossible to so many others. Almost every one of them mentioned self-discipline. When you're on your own, setting your own schedule, arranging your days with no one else to tell you what you have to do when, the temptation for many people might be to putter around most of the day, calling up a friend to have lunch and tuning in periodically to see what's on TV. Napping seems to be popular in certain circles, but none of these working artists even mentioned it. Even those who might argue they're not disciplined, like Violette and Bean, are working almost all the time.

Bean says, "Self-discipline is a huge issue for me. I've read all kinds of books that say, 'Go into your studio every day at the same time and treat it like a job,' but that would make me hate my studio and resent the work that I have to do. I go in and work when I feel like it, which, luckily, is often."

Michael says, "My ritual is going out to the studio, and indeed self-discipline is crucial because I go out there five to seven days a week." This signature assemblage is titled *Cyclops.*

When you love what you do for a living—whether it's sculpting or doing root canals—the idea of "work" means something different to you than it does to someone who flies airplanes for a living but really wants to do biochemical research. Work becomes an end unto itself, and the artists mentioned not needing any other ritual or studio practice but that work.

Claudine says, "I don't have ritual to get started, but I work a full nine-hour day just about every day of the week, whether it's on creating art or working on business stuff. You have to have self-discipline to be an artist."

Kelly also credits her impressive output of artwork to self-discipline, a skill she says comes easily. "My brain is always in creative mode. Ideas bombard me at all hours of the day and night. I don't need any ritual to inspire me to start sewing, beading or writing. My day begins with a pot of green tea or hot lemonade at 5:00 a.m. I can work uninterrupted for two hours before breakfast. This is good for the soul. I then push away from my work table at 5:00 p.m. for an hour of therapeutic hatha yoga. I am very self-disciplined: I make to-do lists for everyday life needs, which allows my mind to be relatively uncluttered so that ideas flow freely."

What we're hearing here is that, for most of the artists, the only thing they need—the only "ritual"—is just getting into the studio. The ideas are already there, the need to work is there, the intention and habit have become part of the rhythm of their days. For them, work is what they love, and they make it a priority. It's often a struggle to find enough hours in the day to do the work you can't wait to start, but the sacrifices are more than worth it.

try this

Make a list of all the things you do that don't absolutely have to be done. Be honest. Be ruthless. Do you really need to watch TV every night? Do you really have to make the bed every morning? Are you taking advantage of things that will make daily chores less time-consuming, such as online bill paying? You may find you come up with a lot of things that don't really require your participation. If you've always lamented that you'd make more art if you had more time, it's time for you to take a hard look at the things you do that are eating up those precious hours. Make time for the people in your life, for work and for health; everything else is negotiable.

try this

Try getting up an hour early on a workday to give yourself time to create before you have to leave for work. You've heard it before, and it may seem too horrendous to contemplate: being awake before dawn, in a quiet house. But think of Kelly in her studio in Missouri, or Violette awake at all hours of the night—or any of the other hundreds of artists around the world who are with you in spirit, up in the dark, bringing their ideas into the light of day. You're not alone. Toast them all with your first cup of coffee.

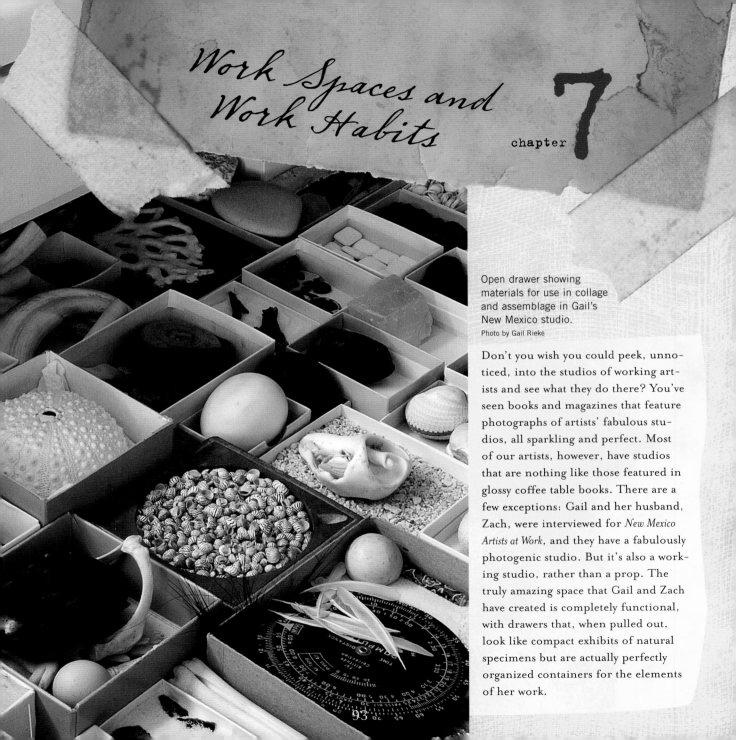

Work Spaces and Work Habits

chapter **7**

Open drawer showing
materials for use in collage
and assemblage in Gail's
New Mexico studio.
Photo by Gail Rieke

Don't you wish you could peek, unnoticed, into the studios of working artists and see what they do there? You've seen books and magazines that feature photographs of artists' fabulous studios, all sparkling and perfect. Most of our artists, however, have studios that are nothing like those featured in glossy coffee table books. There are a few exceptions: Gail and her husband, Zach, were interviewed for *New Mexico Artists at Work*, and they have a fabulously photogenic studio. But it's also a working studio, rather than a prop. The truly amazing space that Gail and Zach have created is completely functional, with drawers that, when pulled out, look like compact exhibits of natural specimens but are actually perfectly organized containers for the elements of her work.

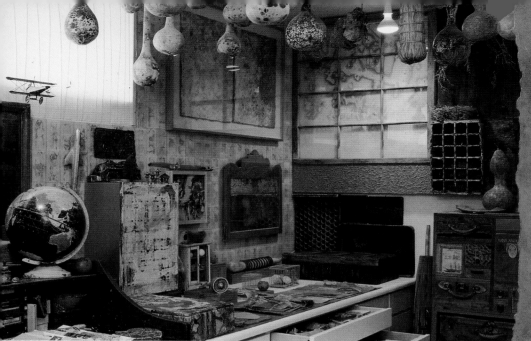

try this

In your journal, describe your fantasy studio, in as much detail as you can. Where would it be? How big would it be? What about light? Storage? What would be in it? What color would you paint the walls? What would be the view out of the windows—or would you even have any windows? Sketch a floor plan of this studio. Dream big!

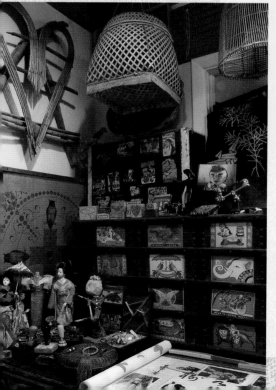

The artists profiled here are working artists. Their studios are for work. They're not filled with a lot of glitz and chintz and fresh floral arrangements. In some, there's a lot of necessary clutter; in others, there's clean space waiting to be filled. But the common attribute is that these studios are spaces designed for making art, and they're dedicated to that purpose. Most of the artists said they could work anywhere if they needed to—and many told about tiny makeshift spaces they've had in the past.

Kelly remembers, "My first studio was the dining room table. Each day my current project would have to be put away at mealtime. Supplies were stacked in a closet. In our next house, I had a [small] antique cherry table in a room where I could leave projects on the table and strewn on the floor. Supplies were still stored in a closet. This was my studio scenario for eighteen years."

Linda still works out of a closet in her home, albeit a really large closet. She says, "My workspace is a walk-in closet with lots of shelves for my supplies. My desk is an ironing board with a piece of wood on top. I love my ironing-board desk because the height is adjustable and the work surface is long. The closet is right off our family room, so I can hear the TV, music and whatever is going on in the house. There's a window near the closet so I can see outside while I work." It's not the size of the studio or what it looks like so much as it is the ease of access and functionality. For the most part, these studios are part of the artists' homes, often a former dining room or den or basement.

"I have worked in a closet and a [tiny] dining area," Claudine says, "so I can pretty much work anywhere provided I have my tools and supplies." This photo shows her current studio space.
Photo by Claudine Hellmuth

bindery is about 6,540 square feet [589 square meters]. It's very dark and cool. It's packed to the gills with equipment: two board shears, a standing press, a guillotine, a backing press, a bunch of book presses … type cases and several big, clunky desks. There are shelves for paper and books as well. It's pretty grungy. [But] the first time I walked in the door, I knew I was home."

The rest of the artists have their studios in their homes. For some, their studio is their entire house. Invariably, the condition of the home studio—messy or clean, organized or chaotic—is a constant consideration. Susan says, "My studio is kind of all over my house, but the main studio is a basement room that used to be a rec room. It's too cluttered to suit me, but I never seem to do enough to fix that problem. I'd love to have one of those big austere studios with proper storage for everything, a designer studio from some magazine layout! But I do keep my tables pretty cleaned off, and when I can, I go through the stuff and organize it. I've seen worse!"

Wendy Huhn laments, "My studio is a mess. I'll admit it. It consists of five rooms on different levels. I have more books than I should, either art books or antique books. I envy artists who have neat, organized studios, but that's not me. I work in and around piles of stuff."

Michael says his studio is also a mess, but he likes it that way. In fact, he says, that's the only possible way for it to be: "I require total chaos. Junk must be everywhere. This is important because what I do must not be planned. It's the unexpected that is important in my style. Often my workshop is pure clutter, with paint, hammers, brushes, found objects—all in a heap. Oddly enough, I usually know where everything is, more or less. The pliers are under the jar of titanium white, which is under the old dictionary."

Michael isn't the only one who likes having a crowded studio. Kelly likes to be in the presence of fodder for inspiration while she works: "I am surrounded by inspirational artwork created by friends, vintage textiles and rugs, sock monkeys, research books and antique homemade dolls."

Only a couple of artists have studios separate from their houses, and only Sas has a studio she actually has to drive to get to. "I can work anywhere, but I like a dedicated space where I don't need to clean up," she says. "I don't like living in chaos. I've been fortunate to have a big studio for the past eight years, with plenty of storage space. I expect to bring my studio to my home in the near future, which will change my work patterns." Other artists have studios that are right next door, or, in Kelly's case, just steps away. Previously, her studio consisted of the upper level of her last house, which was remodeled for that purpose. Her current studio space is in a building about fifty feet from her house, so she can make that short trek across the yard at 5:00 a.m. with her little pot of tea. "I'm extremely thankful for my current studio space."

Then there's Wendy Davis, who has two studios: one is in her home; the other is the bindery where she makes her books. "My studio at home is about eleven square feet [one square meter] with a computer hutch, an art desk and a couple of supply cabinets. There's also a bookshelf with all my journals and art how-to books. There are three windows on two walls, so there's a lot of light, which is really nice. The

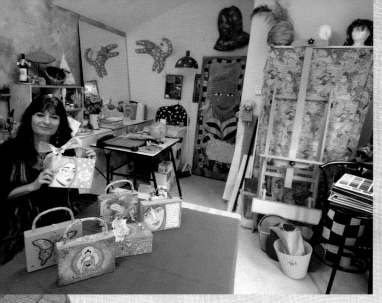

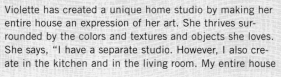

Violette has created a unique home studio by making her entire house an expression of her art. She thrives surrounded by the colors and textures and objects she loves. She says, "I have a separate studio. However, I also create in the kitchen and in the living room. My entire house is a riot of color and pattern. I thrive in gorgeous juicy colorful and kitschy places, so I've created a magic cottage like this to welcome the muse on a regular basis." She is shown here in her backyard studio (at left) and in her living room (at right). Photos by Boaz Josef

The antiques come naturally, as Kelly and her husband used to buy and sell them. Kelly kept the ones she liked and gave them a home where she can see them every day. "All the furniture in my studio is antique. My wooden worktable began its life in a dry goods store in the little town four miles south of me in the late 1800s. Fabrics were rolled out, measured and cut upon its surface." There's something about knowing that the table you are working on has been used for more than one hundred years.

James Michaels's work requires that he have not one, but two studios. Both are in the suburban home he shares with his wife, who works in clay. "The 'clean' studio is reserved for my paper-and-glue collage operation and other relatively tidy activities that won't create much dust. It's the large room, once the formal living area, just off the kitchen. It's mostly occupied by work tables and shelves filled with old books, plus some hanging files of images and pages torn from those same books. The 'dirty' studio is a converted two-car attached garage, sunken into the downhill side of our sloping site. It has a higher ceiling height than the rest of the house and almost approaches a cube shape … This is almost perfect for my working space, as I need to be able to sit or stand in the middle of a relatively small area and be able to look up and around at the walls surrounding me to review all the junk waiting to be put to use. I have sixteen feet [forty-one centimeters] of pegboard along one wall, and above that and on every available space of the remaining walls are shelves almost to the ceiling. We designed the uppermost shelf to hold the track for a bookstore-type rolling ladder system; but funds ran out before that could be purchased, so I save that shelf for things I don't need every day. A worktable sits in the middle. In various spots around the studio are a drill press, a table saw, a bench grinder, and miscellaneous other power and hand tools. It closely resembles a woodworking shop."

Besides the actual creative work of making paintings or collages or quilts, there's all the other work required of artists.

Some artists prefer to work in spaces free of visual distraction. Melissa's home studio is a large room with two smaller attached rooms for specific tasks. She says, "I can't work just anywhere, but that's only because by now I need a number of tools and materials. I have worked in a bedroom and in a drafty little greenhouse. This studio is full of north light. We designed it around my working habits. Except for a small section with pictures of dogs thumbtacked to the wall, I try to keep extraneous material out of sight. I have recently become a little less austere, and there is a picture of my daughter, a small watercolor from a friend, and two letters that are clustered together to the left of the door as one enters. Occasionally I will leave something lying around because I sense there is a possibility in it. I do have a postcard my sister sent me at least fifteen years ago of the oldest view of Stockholm, in 1535, a painting I adore. It lies flat on the top of some Sears red metal drawers where I keep miscellaneous accumulation of fabric, wood and leather. I look at it every day and have never tired of it. I would be hard-pressed to explain its appeal." Her studio is a private place, created especially for her and her needs. She explains, "I don't ask people to the studio, and I sell only through galleries." Visiting her sanctuary is memorable, indeed. The artist and her space are perfectly suited to one another, and you can't imagine either being anywhere else. Melissa is shown working in her studio here. The two photos below show **Lines in Remembrance of K. Schwitters** in progress. Photos by Nelson Zink, courtesy of *New Mexico Magazine*

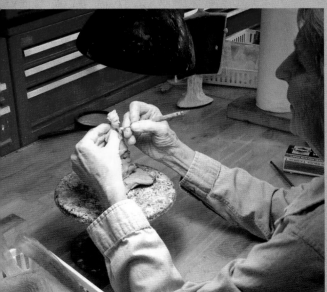

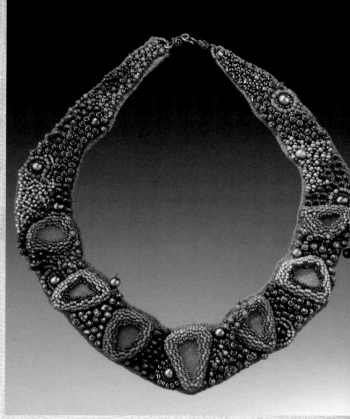

Rebekah works in a couple of areas in her house, as well as in her backyard, where she likes to bead when the weather's good. She explains, "I work from home, mostly in my living room studio. My dining room is the supply and layout room. I love to work outside in the summertime because of the wonderful natural light it offers. I plop down in a cushy chair and pull up a footstool for my supplies. I hate working at a table; it just doesn't work for me." Here you can see an untitled work in progress (above) as well as another stunning finished piece.

Some have separate areas for doing paperwork and communication and financial chores. Others have everything together in one room.

No matter how you organize your space to do all the things that have to be done, it will never, ever be perfect, except for maybe five minutes one day in July. It's going to get messy, and it's going to get dirty. Sometimes that's okay, but even the studios that are messy on purpose have to be cleaned up now and then, at least a little. For some artists, the cleaning can become a useful ritual, a signal that one work is complete and it's time for another to begin. Wendy Huhn says: "After I finish a piece, I clean up and reorganize. In doing that, I find things I didn't know that I had, which is good, as it often leads me on the next piece."

Sas, too, talks about cleaning the studio at the conclusion of each project, saying, "When I begin a new series, I like to put away extraneous materials and have only the materials I'm working with on hand. I like an uncluttered space with a big wall for pinning things to so I can move away from the work. Having good light and open space is most important."

Some artists, like Rebekah, have no choice but to keep the studio tidy all the time. She lives and works at home. She creates intricately beaded works. And she has cats and dogs. She says, "I don't have any beadwork out for inspiration due to dust and potential pet damage: You just never know when the fringe on a piece might be too big a temptation for a passerby!"

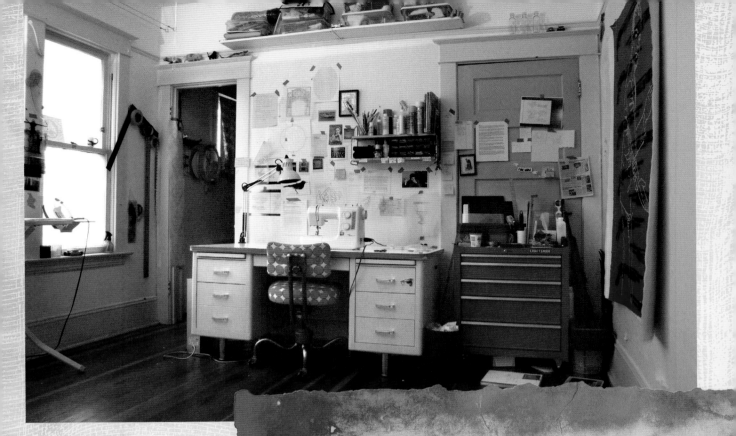
Photo by Bean Gilsdorf

Bean has developed an effective ritual of end-of-project cleaning and organizing her studio, shown here. "Generally, I clean my studio—take down all the papers and clean all the surfaces—at the end of every large project or series of quilts; and I wash the floor on my hands and knees as a kind of moving meditation. I like the ritual of cleaning the studio and having it ready for the next project."

try this

In your journal, describe the space where you actually create (as opposed to your dream space, which you described earlier). Where is it? How big is it? What are the best things about it—the good light? The quiet? The fact that it has a door that can be shut at the end of the day? Sketch the floor plan. How could you make changes that would make it more functional for you? Maybe a coat of fresh paint is all it needs to give it new energy, or maybe a sturdy shelf above your work table would free up more usable work space. If you're not happy with your space, look around. Do you have a closet that could become a studio, like Linda's? There are a number of books about living in small spaces that offer great ideas for organizing limited space. Look for them in the home decorating section of your library or bookstore.

"I feel depressed when I can't work, or feel like I can't find time to work," Scott says. "It's hard for me to go on vacation. I'm good for about a week, and then I have to get back to what I was doing right away." Pictured here are his baby daughter playing in his studio, and one of his iconic sculptured figures, this one titled *Octopus 1* (2007).

Photos by Scott Radke

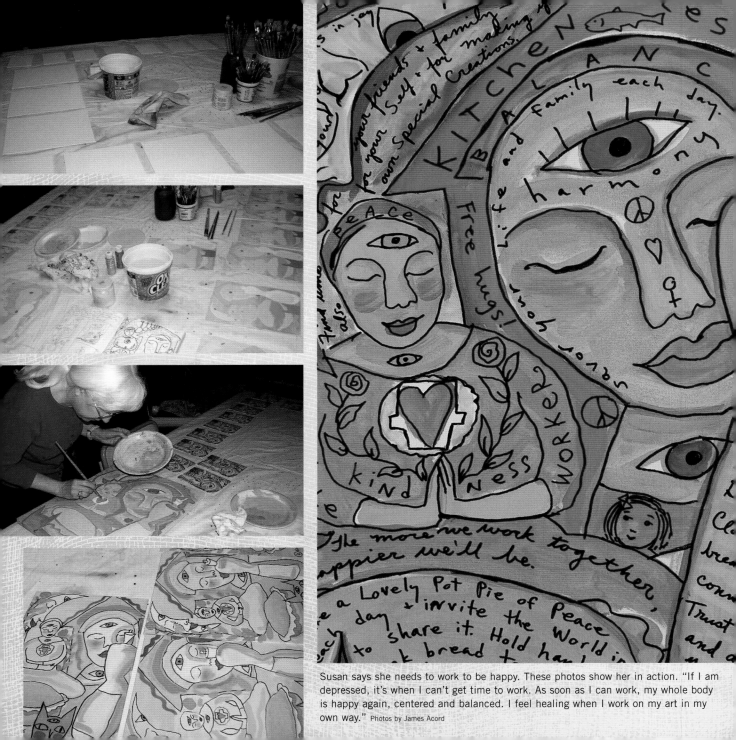

Susan says she needs to work to be happy. These photos show her in action. "If I am depressed, it's when I can't get time to work. As soon as I can work, my whole body is happy again, centered and balanced. I feel healing when I work on my art in my own way." Photos by James Acord

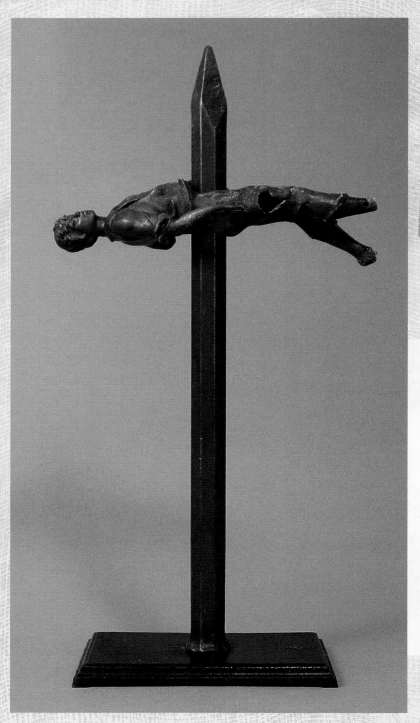

James Michael says his former career as a graphic designer trained him to be a self-disciplined artist. "Putting a yoke on creativity and forcing it to produce may seem like prostitution, but if that's the way you've chosen to make money, you have to abandon that philosophy." His nearly two-feet-tall *Common Place,* shown here, is created from an iron chisel, cast metal statuette and lab stand base.

WORK HABITS

Notice your working environment. Some artists work in complete silence. Some listen to the radio or even the television. Some like the sound of their family talking and laughing in a room nearby—not close enough to be distracting but near enough so they feel like they're a part of the life in the house. Others have more particular requirements. Very, very particular requirements. James Michael explains, "In the early stages of a piece, I can only listen to the music of contemporary composer Arvo Pärt. When things are further along and into the more mechanical assembly stage, I can listen to news or talk." It's vital to know what works for you, no matter how picky that sounds to someone else. What you want to do is to keep the ideas and energy flowing, whatever that takes.

In discussing ideas and inspiraton, many artists have already mentioned their periodic creative blocks and how they overcome them. We've all heard about creative blocks and artists who haven't worked for years and years because they're blocked, which makes it sound like a lower-gastrointestinal issue, doesn't it? The stereotypes about "the artist" all come to mind: You go into the studio, you're blocked, you're depressed, you can't paint, you slowly starve to death there with your paints and brushes. You might be surprised to discover that lots of artists, however, never suffer from creative blocks. Ever. Some, like James Michael, don't even really think they exist. You might chock this up to excellent work habits in the studio. He explains, "I don't necessarily believe in being blocked, but I do believe that there are many factors that can interfere with the creative process. Perhaps the best thing that came out of my long career as a graphic designer was that I had to get beyond the luxury of giving up, even if only temporarily, on being productive when I felt blocked. … I learned that when I had to be creative, I could do it. And once I realized that, I also knew that when I wanted to be creative, I could, as well. These lessons help me to stay disciplined in my work and to push through when I may not feel like it."

Even those who do experience blocks, or moments in the workday when the ideas aren't flowing, have found ways to get over them as quickly as possible—mostly by staying in the studio. Wendy Hale Davis says, "I am frequently blocked. It's because I'm not concentrating on what's important; I'm getting away from my goals, living in my head instead of in the present. I just sit myself down and have a long talk with myself, write myself a few notes, and try and shape up. I'm the head of my own corporation here, so it's up to me, as president of the board, to talk to me, the sole employee, and straighten me out." It's simple, it's logical, and it works. It may sound a little odd, but who cares if it gets you out of the slump and back to work?

To get herself back into the work, Sas also takes a hands-on approach. "I busy myself with the myriad chores that go along with being an artist and a teacher," she says. "There's always something I can do while I'm waiting for an idea. It's similar to not being able to get to sleep: You can't let it worry you or it gets worse. You have to look at it out of the corner of your eye. Often when I'm blocked, I'll do some reorganizing in my studio, some cleaning up. In handling my materials, I can be stimulated to work."

It can sound so very tedious, all this talk about "work," except that you realize the work we're talking about is your heart's desire, the fire in your brain, the thing you wake up every day wanting to do. It's difficult to imagine a longing to get back into, say, an office cubicle the way an artist might naturally long for his studio.

For these artists, work—though hard and demanding and sometimes frustrating, is play; and the studio is a playground. It may not have a terrific swing set, but it's got everything else they need to have a terrifically good time, never mind the occasional skinned knee.

It makes you want to jump up and rush to your studio— or kitchen table or hall closet or comfy chair on the back porch—right now, doesn't it? Go ahead; we'll be here waiting.

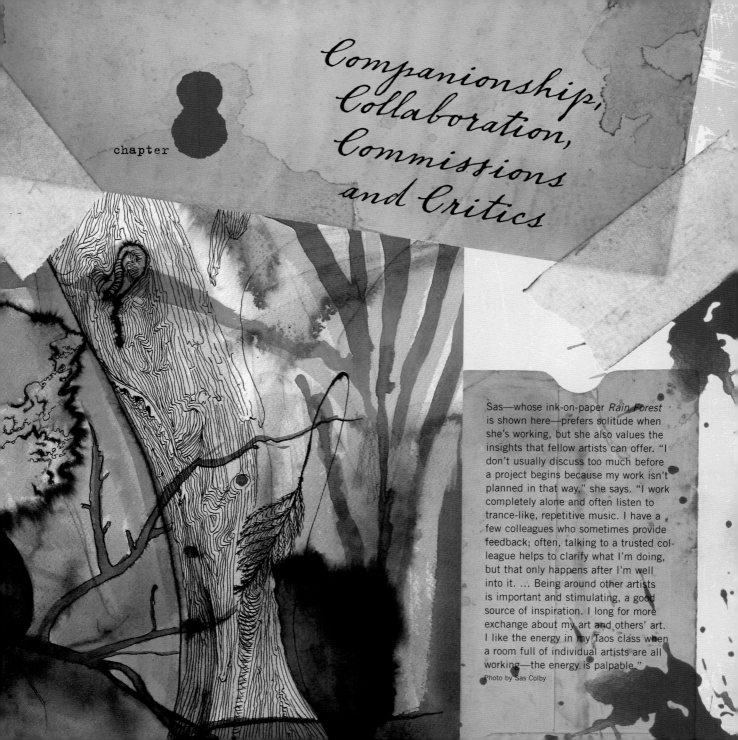

Companionship, Collaboration, Commissions and Critics

Sas—whose ink-on-paper *Rain Forest* is shown here—prefers solitude when she's working, but she also values the insights that fellow artists can offer. "I don't usually discuss too much before a project begins because my work isn't planned in that way," she says. "I work completely alone and often listen to trance-like, repetitive music. I have a few colleagues who sometimes provide feedback; often, talking to a trusted colleague helps to clarify what I'm doing, but that only happens after I'm well into it. ... Being around other artists is important and stimulating, a good source of inspiration. I long for more exchange about my art and others' art. I like the energy in my Taos class when a room full of individual artists are all working—the energy is palpable."

Photo by Sas Colby

Susan says, "Really, I guess my favorite way is to work alone to get the project started and then talk with people about it, show it to others in progress, see their work in progress. I've always made artists' support groups that do regular show-and-tells. I think we all grow a lot by seeing each other's work in progress. I never understood that attitude about being all secretive until the work is done. But I know people who feel that way. When I was an undergraduate [at the College of Wooster], our studios were all out in the open on an indoor suspended running track in an art building that used to be a gym. I loved being able to see what everyone was up to just by walking the track. When I got to grad school, all the studios were behind locked doors. I felt sad about that and missed the openness at Wooster, so I started a little artists' support group at grad school. I thrive on communication and interaction." She titled this quilted painting on cloth *The Power Out / Devil: Card #15 in the Kitchen Tarot.*
Photo by Susan Shie

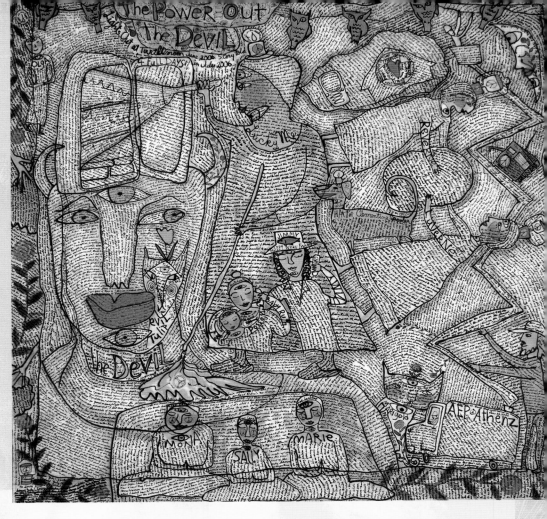

There are two popular views of how artists work. In one, the reclusive artist works alone in a room, the door shut, meals left outside the door by an adoring spouse (almost always a female spouse, of course). That's the old idea, the one featured in movies where the artist (almost always male, of course) eventually either goes mad or dies of consumption. In the more current, more popular view, the artist works in creative chaos with a group of other artists. Think of the concept of art dates, where you get together with your friends to make art. You never, ever hear of anyone dying of consumption.

As you might expect, reality isn't much like either of these scenarios. Our working artists will tell you that they generally work alone—it is, after all, work, rather than a party. But they're not nearly as reclusive and secretive as you might suspect. Not one of them keeps his work in progress hidden from everyone until the work is complete. Some, like Michael, generally don't talk about what they're working on or show anyone else what they're doing until it's done. He explains, "I think one can over-talk an idea, to a point of triviality. This is why I don't usually show works in progress.

For the other artists, there are a few specific people, or one person in particular, who's used as a sounding board, critic, consultant—that one person whose opinions they really trust. Wendy Hale Davis does much of her bookwork at the bindery, and her coworker Mark is her favorite brainstorm-ing partner. Wendy Huhn says, "There are only a handful of people with whom I can discuss work in progress. Digital cameras have made this even easier. I can e-mail photos of work in progress to a confidant and get feedback."

And then there are the artists whose confidant is their partner or spouse. Rather than the stereotype of the non-supportive partner who grouses about what you do and mut-ters about your getting "a real job," these artists have, sanely, hooked up with someone who gets them, who really under-stands what it is that they do. In some cases, this is because the partner is also an artist—sort of a built-in adviser/helper/ critic-in-the-nicest-possible-sense. Rebekah says, "When the ideas start to flow, I keep them to myself, grab my scrap paper and mull them over. I might gather beads and other supplies I need. I listen to the radio a lot if my husband is home. If I'm alone, I relish the quiet. No background noise works best for me. I will talk things over with my husband if I need something drilled or cut. He's the man with the tools." She makes a distinction between things that are still at the idea stage and pieces in progress: "I don't worry about discussing my ideas of freshly started pieces with people because these are my visions. I'm going to follow my heart. I'm more than happy to show someone a work in progress, though, even if they don't 'get it.'"

Melissa's process is similar. "I often bounce my ideas off my husband, but the best ones I usually go ahead and start because I don't need any assurance or assistance with them. I know they're correct. I don't need to be alone any more than usual, although I do resent having to interrupt 'the flow' for lunches or appointments. ... I am cautious about talk-ing about ideas before they've taken shape. I may think on Tuesday that this is great and on Wednesday change the idea completely. I occasionally show a work in progress; however,

Mostly it is because chances are it will be entirely different in the end, anyway. What's the point?" Others say that it var-ies: For some projects, they keep both the initial idea and the resulting work in progress completely to themselves. For oth-ers, they're happy to bounce ideas off someone else. Linda says, "It depends on the idea. My sister and I wrote our book, *Visual Chronicles*, together, and that was really fun and reward-ing. In general, I like to work alone, although I do listen to music or have the TV on while I work. I don't usually discuss my project with people until I am done. I don't really like input from people unless I'm having a problem with some-thing, and even then I'll try a million ways of solving it before asking for help. Again, though, it depends on the project. If it is something for a book or magazine article that requires discussion, then, yeah, I do discuss it."

Several of the artists expressed a similar longing for a group of fellow artists to provide feedback and constructive criticism—not as working companions constantly present in the studio, but as a group to meet occasionally for discussion. Violette prefers to create her art alone but seeks input from fellow artists for other reasons. "I brainstorm with others for marketing ideas more than art ideas," she says. "Once in a while I show a friend my work in progress; however, I'm sure to only show it to a sympathetic friend who will not rip it to shreds and ruin the joy of creation."

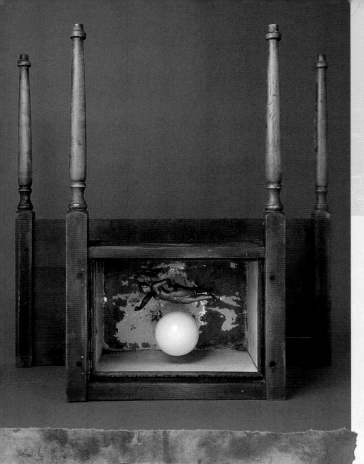

James Michael says, "For the most part, I must work very privately and usually avoid even describing to anyone but my wife what I'm working on. She's also one of the very few people to whom I will show something still in progress. I've become very careful concerning how I talk about work in progress with others. To me, one very critical element of art is its nature as a personal expression. Other than using my wife as an objective test of how a particular detail might be perceived by others, I find describing things to anyone else or asking for opinions is pointless and can even threaten the honest working out of a piece." He created this 2005 assemblage, *Temple*, using a wood cabinet, cast-metal figurine and polo ball.

I do it very seldom any more. Except for my husband, I find that even sensitive people can't see what is to come."

Scott, whose first puppet was, remember, an effort to woo the woman who's now his wife, says, "I bombard my wife with questions sometimes, ask her what she thinks about this or that. It's usually better if I just complete something before I ask questions. When I look for help from other people, it works sometimes; but for the most part it throws me in too many different directions."

Kelly prefers to work alone, but she also makes an exception for her spouse, "I am not a talker or a bouncer of ideas," she says. "No brainstorming is necessary for me, and I don't need validation. It is quiet and peaceful. The only person I show works in progress to is my husband, who is also an artist. Rhett and I exchange suggestions, and I value his thoughts because I know where they're coming from. A newborn idea, for me, is best kept to myself to evolve on its own, transforming into a tangible piece from my thoughts through my hands. If I am having a technical construction problem, I will head down the hill to my husband's studio for consultation."

Claudine also needs to be alone except for the occasional spousal visit. She says, "I don't have to have perfect quiet, but I have to be by myself and concentrating. I use my husband, Paul, to bounce ideas off. I generally show him my works in progress if I am having trouble working on it. Or if I'm not sure something reads correctly, I go check with him. And sometimes my online friends—I'll e-mail a photo to them to see what they think."

try this

Talk to other artists you know—through classes or workshops or shows—and find one who would be willing to meet one on one on a regular basis to brainstorm and discuss ideas. It can be scary to share your creations with someone before you've finished them, but the benefits—being able to see what you're doing through someone else's fresh eyes—can far outweigh the uneasiness. At first, try meeting just once. See if you click. If not, try again with someone else. Take the time to find someone whose ideas and style are enough like your own for such discussions to become insightful brainstorms.

Choose an artist whose work you admire and whose skills are comparable to yours—perhaps someone you met in a workshop or art class—and ask her if she would like to collaborate with you. Have an idea in mind—a collage, an installation, an assemblage—but don't have so many details worked out that you end up inviting someone to contribute rather than collaborate. Be prepared for the artist to decline; not every-one has an interest in collaborating. But don't give up—if the first person you ask says no, ask someone else. Or post an invitation with an online art discussion group, asking for interested people to contact you. Collaborations don't have to be done in person; you can always send work back and forth by mail.

Bean, too, keeps her work to herself unless she needs input from her spouse. She says, "I almost never talk about my ideas. Not only am I incredibly superstitious, but I rarely feel like I can explain adequately. I hate showing work in progress unless I know exactly where I'm going with a piece, which is rare. If I'm working collaboratively with my husband, we usually come to a project with some ideas in hand, and then brainstorm together."

JOINING FORCES

Ah, collaboration. That brings us to a whole other kind of human interaction. Suddenly, it's no longer about sharing a couple of ideas with your spouse. It becomes about actu-ally working with someone, considering someone else's ideas, figuring out ways to make your own artistic vision mesh with the unique artistic vision of another artist. How common is that? And how do artists feel about collaborating?

Melissa has been working alone—and liking it that way—for decades. When I asked her if she collaborates with other art-ists, you could almost hear her shudder. "NO! Horror of horrors, working with anyone." I received similar responses from Kelly ("I do not collaborate well with others, other than my husband, because I have found that most do not work as hard as I do") and Linda ("I feel I can do my best work when it is just me, my imagination and my art supplies").

Violette says, "I think my best work is done alone; however, collaboration can be a lot of fun as well. There is not as much freedom when you're collaborating, but hopefully you'll be on the same page so there is not a great deal of friction. If you are in sync, the brainstorming part can be quite electric and invigorating."

Scott's wife is a dancer, and the couple sometimes col-laborates on performance pieces. He says, "I almost always like to work alone with the exception of when I work with my wife. Even that is tricky sometimes because she has very strong views of what she wants to accomplish. But we always seem to mesh it all together nicely. I do think you get something more powerful when you work with another person or persons. I'm just not that good at it. Like with music—I don't think any art form is more powerful than music, but I wouldn't want to be reliant on other people to be able to express something."

James Michael does a great job of explaining the way he sees the difference between working alone and collaborating with another artist. He says, "I'm fairly confident that my best work is a solo thing. However, I have just begun working on a collaborative show with a close friend of mine. I feel I need to look at this with a completely different mindset than I do my personal work. It's almost that the collaboration is more the point than the work that will result—it's more an exercise in friendship, the outcome of which we will just happen to share with other people." This shift in focus is true for many such collaborations. They become about the process of working with and learning from others, rather than about the result. Remember that in earlier chapters, many artists said they value the process above the finished work. For those who like to collaborate, the process becomes external—one of shar-ing ideas and seeing things emerge through cooperation and accommodation. For those who work alone, the process is almost entirely internal.

Some artists haven't yet taken the plunge into collabora-tion but not for lack of interest; they're just waiting for the right opportunity. Sas says, "Collaborations are stimulating,

Bean frequently works with her husband on projects like this *You* installation, which they created from wood, paint, cast polyurethane fingers, solenoides, electronics and a motion censor. She explains, "I feel like we are bringing ideas and skills to the table that make the work more than the sum of its parts. I don't think my collaborative work is better than my solo work, but it's an opportunity to realize projects that I wouldn't be able to accomplish on my own." Photo by Dan Gilsdorf

try this

Several years ago, my own local cooperative gallery, Gallery 1114 in Midland, Texas, hosted a collaborative show. Member artists were paired up randomly and given a very loose, broad topic to address in a collaborative work. Try this with a group of people, either from a class or workshop or an online group. The topic can be as broad as "work" or "art," or as specific as "the ties that bind" or a quotation. You'll need to consider time frames, deadlines, any size restrictions, whether or not there will be a final showing of the works, etc.

although I don't have much experience that way. Recently I worked with two printmakers and enjoyed the exchange of ideas. We 'sparked' each other, and I would like to do more of this."

Then there are those who often collaborate. Because it's a choice, the ones who do it are the ones who love it. No one is forced into collaboration, and usually, after the first time, you know whether or not it's for you.

"I have been collaborating all my adult life," Gail says. "I love it, but I also love working by myself. One feeds the other. [My] group traveling journal events are the ultimate collaboration."

Sas offers additional insight: "Collaborations are wonderful because you get inside another person's process, and you have to really balance each other. But creating alone is better for letting things flow well. It's all right-brained, whereas collaboration is dancing back and forth, right to left to right to left, as you have to respond to something outside of yourself. You have to get analytical, and that does break the spell. Or maybe it's a different kind of spell? More like a dance instead of a sleepwalk."

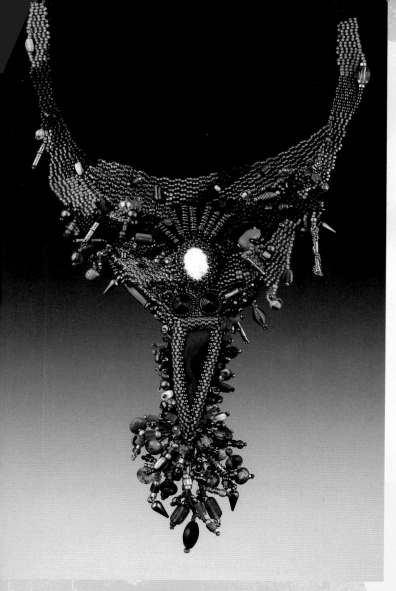

Rebekah, whose *Essence of a Goddess* appears here, says, "I have never collaborated with another artist but long to do so. It's not clear how this might be done, but the thought has often crossed my mind."

ARTIST FOR HIRE

If a collaboration can be like a dance—smooth, in sync, lovely to behold—how would artists describe a commission, where the partnership can seem more like the work of a puppeteer engineering the dance from behind the scenes? On the one hand, commissions can be affirming—it's nice to know ahead of time that your creation will have a home. And you're not working alone, in a vacuum. Instead, you're working in the spotlight, with someone interested in the process and in the progress of their piece.

Michael describes his "love/hate relationship" with commissions. "It is very stressful but extremely invigorating. … There is nothing like hearing the ideas from a client and attempting to create something that is entirely my own style, yet addresses the ideas of the patron. One has to make sure that the intuition level is at a maximum when addressing this. I usually start any commission with a disclaimer, essentially saying that what I create is my interpretation of what I have been told, and that if the client might have any reservations about this, they should purchase something that has already been created. So far, everyone has been quite pleased; but I must admit that the day of unveiling is a bit stressful for me."

Imagine: You've created the piece. It's finished. Then you have to show it to someone who's going to pay you for it. Will he like it? Will he be disappointed? Some artists choose not to go there. Other artists are more ambivalent. Some accept that commissions are a way to make money, and that no matter what people think about the lofty ideals of creativity, you've got to be able to pay the bills. Susan is one of them. "Oh, commissions are hard, as you are forever dragged out of the intuitive state," she says. "But you get money for it."

James Michael is equally honest. "I have rarely done this, and when I have, the results were less than satisfying. I'm even aware of the stifling effect of doing work for a themed show. As soon as I try to make a piece with some sort of defined outcome attached, the 'automatist' process

Scott, who has created puppets and figures (like the untitled sculpture shown here) for several movies, as well as for other projects, says, "It depends on the commission. I don't always know if it's going to work well or not at the start. Sometimes I'd rather not do commissions at all because I can be excited about one in the beginning, then find it's something I would have rather not taken. Then of course you have someone on the other end expecting results. Ninety-nine percent of the time I take commissions that I think I will enjoy, and I do; but just doing one that doesn't feel right is enough to make me think about not doing them."

that seems to produce my best work is hamstrung. However, I am exploring the possibility of doing collage for commercial illustration projects and hoping that if I confine that work to collage, and preserve my assemblage work for my fine-art life, the financial rewards will make up for any loss of energy."

Linda says that commission work comes with the stress of knowing from the start that the work will be judged. "What I see inside my head is often different than what the client sees," she says.

That problem of discovering what the client wants—when they often aren't exactly sure themselves—is one of the biggest challenges. Wendy Davis explains her approach: "A lot of it involves education of the client. Say I'm making a journal for a client. I send them a sample pack of papers that are labeled A, B, C. I know what the papers are, but they don't. I tell them to do whatever it is they do in their journal—write, draw, paint—on each of the sheets to see what works best and then tell me what letter is on it. That way the client doesn't get invested in thinking about what the 'best' paper is. The best paper is the paper that works best for what you're doing. And then," she adds, "there's the budget. I need to be able to achieve something that will please the client without losing money."

念

peacefully

"Visual people see differently than non-visual people," says Linda, creator of this *Peacefully* collage. "Sometimes I get frustrated because the client doesn't even really know what they want, so it's a matter of coming up with numerous ideas and sketches before they say, 'Yes! That's it!' Working on my own projects [like the one featured here] allows the creative flow to spill out in a much more natural fashion."

With a piece you create on your own, you can keep track of your hours, however many there are, and price your piece accordingly. But if you're working on a piece for someone who isn't willing to spend more than a certain amount, you have to rein yourself in to avoid going over that amount. It can be tough when you know in your heart that a dozen more hours of detail work would make the piece ever so much better, but you also know in your head that your client isn't willing to pay for it. Do you go ahead and put in the extra work and lose the sale for the satisfaction of a piece that you know is the best you can create, or do you stop when there's still work that you believe needs to be done? Or do you put in the

hours and not get paid for them? This conflict was a constant issue for Bean. "I tried working on commissions for a little while—just over a year—and I had to stop," she says. "I was trying very hard to give people what they wanted instead of doing what I wanted. I was interrupting my regular work and taking way more time than I was comfortable billing for. Now I've come to a place where I am happy to say, 'I'm so glad you like my work, but I don't do commissions. Thank you for asking.'"

In addition to the stress of trying to please someone else's taste, there's also the loss of freedom. If you're doing a commission, it's less a process of discovery than it is the following of a plan. Claudine explains it this way: "I create a lot of work on commission, and the process is different. It's less of an 'I'm along for the ride' kind of a piece and more of something that I have to plan in advance. I have to take into consideration the colors and theme that they have commissioned me to create and try to make it all work. I try to keep my commissions feeling as fresh as the work I create for myself; but it is harder to keep them from getting stiff and too planned, especially if the client has a lot of specific things they want included."

That last part is a real chore sometimes—trying to include the things, either images or colors or text—that a client wants. Linda says, "Before taking on a commission, I ask my potential clients a few questions to help me determine if I want to do the work. If the client wants me to do what I do in my own voice, but with their choices of colors or images, then that's great. But if they want a list of specific things and are super picky about shades of colors and tones, I won't do it. Working with someone on a commission or assignment is a partnership, and if the client and I don't see things the same way, it just won't work."

Beyond the collaborations with other artists and the commissions for patrons, there's also Society, that huge public out there with its own ideas about what art is and who artists are. This public is a source of joy: We want to share what we create. If we didn't, you wouldn't be seeing any of the work that's included here. It's marvelously gratifying

Wendy Huhn, creator of this piece, *Not Diamonds*, says, "I think the majority of the public just doesn't get it. It never ceases to amaze me that time after time when I tell someone that I'm an artist, they in turn will ask, 'Oh, how much money do you make in a year?' ... You wouldn't ask a doctor or a lawyer how much they make. So why are artists fair game?" Photo by David Loveall Photography Inc., Eugene, Oregon

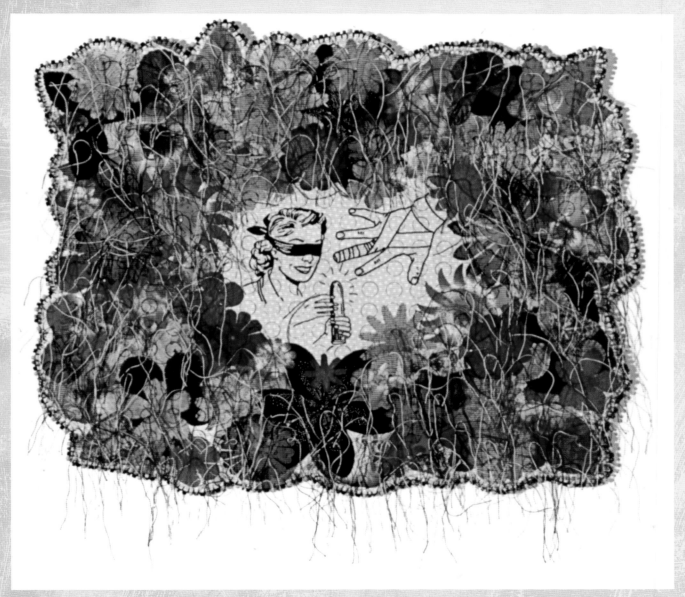

113

to have someone look at a piece and get it, right off. There's nothing better. You've made a connection, and life is immediately richer. But not all people are going to "get" your work. Some will be completely confused by what you're doing, and some may be openly hostile—perhaps because, deep in their soul, they wish they had the courage to be doing it, too.

Kelly also mentions people's attitudes about money and art, saying some of the biggest irritants are "people who ask you to donate artwork for their auctions so that bidders can get 'art for cheap' and people expecting a discount." Scott relates another common artist's lament. "I get frustrated when people think of me as too dark or weird. I can totally understand that perception, but I am not out to be spooky and moody. I wish my work reflected more of how good I feel about life. I fear the day my little girl brings friends home and they see my work, and their parents say things like, 'You're never going over there again,' or stuff like that. I don't want my work to affect my child's life in a negative way."

Ah, yes—the critics. They're always going to be out there, offering their opinions, however unwanted those may be. Bean says, "My plan for a better creative life involves getting rid of uninformed critics, most types of nepotism and conflict of interest, anyone who is competitive and hostile, and people who handle artwork despite the signs that say, 'Please do not touch the quilts.'"

Wendy Davis sums up her views on all the various attitudes of the public, the occasional frustrations of dealing with people who don't understand art, and the general lack of support for artists: "It's so hard to be declared a National Treasure in this country! They do it in Japan, but here, other than a year-long do-hickey for Poet Laureate, there's nothing. No Artist Laureate of the United States." Indeed, it doesn't seem right. Perhaps we need a petition?

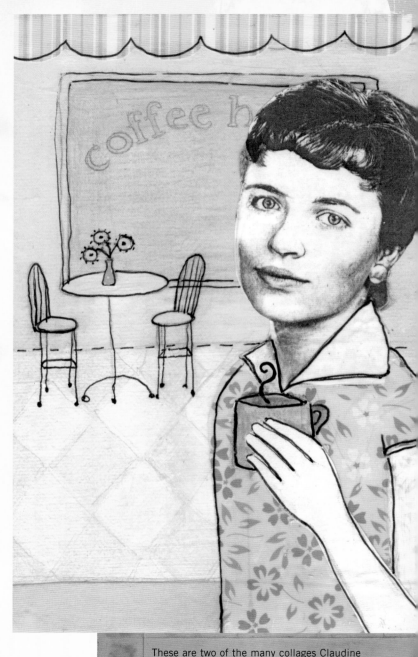

These are two of the many collages Claudine has been commissioned to create for clients.

You've worked hard, and now you're finished. What does that feel like? I asked the artists, wondering if they feel elated or let down, if they begin another piece immediately or take some time off. Do they have rituals to celebrate a piece after it's completed? And a really big question: Is it hard to let the work go? When you finish something, do you want to hang onto it as long as possible? As you no doubt expect by now, they had a bunch of different answers.

Part of the attitude toward finishing a piece depends on how long the artist works on it. There's a lot of difference in the time it takes to do a small-format illustration and the time required for an intricately beaded neckpiece. For those whose work is finished relatively quickly, in a matter of hours or days, the completion of a work isn't that momentous. Linda says, "When I finish a piece, I just move on to the next one. Sometimes while I'm working on one thing, I get an idea for the next thing. When my sister and I finished the book, we did celebrate with sweet treats and a day of shopping, but normally finishing a piece is not that big of a production. I suppose I don't let my art out into the world until I am ready, and then I'm happy to let it go."

Wendy Hale Davis says, "Every piece I've just finished is absolutely the finest thing I've ever done ... for a couple of hours. Or days. Or the worst thing I've ever done. On books, I can see all the mistakes. I do have to fondle the books a lot. They're very tactile—with books, it's very hard to leave them in the book press to dry!" This is the front cover—made of Moroccan goatskin—of her *Poco Más* journal.

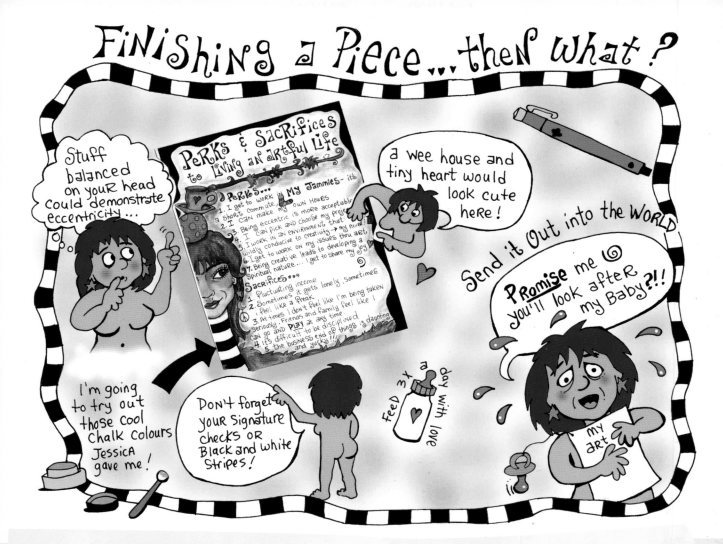

Violette concurs. "I'm usually pretty excited when I finish a piece. Many of my pieces take an hour or two to create, so it's an ongoing process. I rarely celebrate unless it's a huge project I've just completed. The huge projects that I've worked on for months are rather anti-climactic when completed. There is no finishing ritual for me. I do have difficulty sending certain pieces out into the world, especially if they've been in my possession for a while. It's like selling one of my babies." The art by Violette shown here illustrates this sentiment.

Susan prevents this problem—of not wanting the pieces to leave—with photography: "Sending out work is a little sad sometimes, if it's going to be gone on tour or sold, but that's why you get good pictures! It's thrilling to finish a piece. The ritual is when I take photos and edit the digital ones and get back the slides and write the artist's statement. I love to have another piece ready to go, and the truth is that I always have tons of unfinished pieces to work on, besides brand-new ones!" It turns out that's a common way to prevent a sense

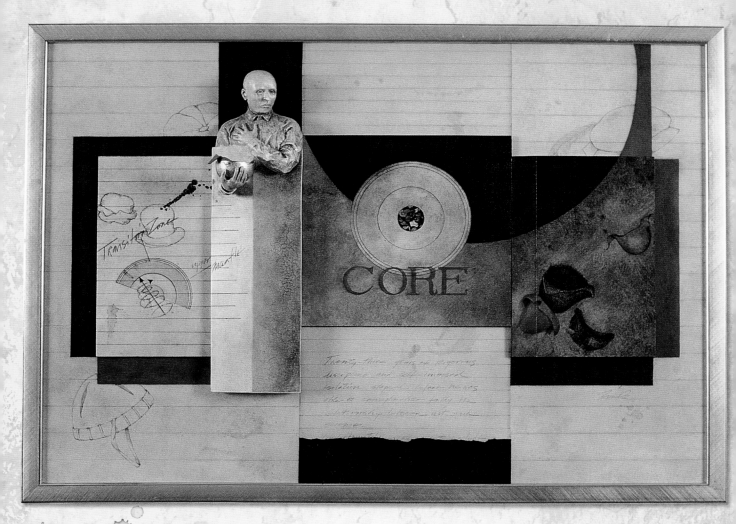

Melissa says, "I work on most pieces flat these days, so there is a moment of thrill when I see a piece hanging for the first time. There is a brief period of intense pleasure, and then I begin to look critically and usually find some elements that need to be changed. I sometimes think this might be an unconscious ritual, but I have assumed it is a necessary process. I don't mind things leaving at all unless it's the first piece in a series, in which case I want to be sure I've understood the direction before I let it go. I am usually working for a show, so I accumulate pieces. Normally, I am anxious to have everything gone and the studio clean and ready for a new day." She likens the feeling of being between works to the way she felt as a child when she was creating things. "After that excitement and being able to have something to look forward to, there was a flatness when the project, whatever it was, was completed. I still experience that, and the waiting for the next thrill." Her 1989 ceramic and mixed-media work shown here is titled *The Relationship Between Art and Science*. Photo from a private collection, courtesy of Gerald Peters Gallery, with assistance from *New Mexico Magazine*

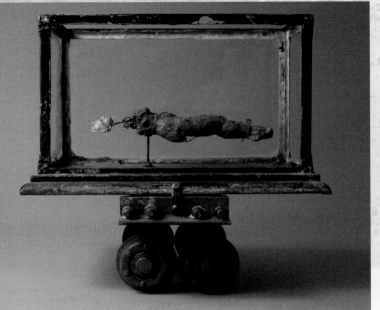

"For me, it's all about the making of art and very little about the holding onto of it," says James Michael, creator of this 2006 *Breach of Contract* assemblage featuring a terrarium, ceramic figure study, plaster head and industrial carriage. "I would love to have our home filled with the work of other artists I like, but not my own."

of letdown when finishing a piece: having something else ready and waiting for your attention, especially if it's something you've already begun and are excited about working on.

Wendy Huhn says, "As soon as I finish, I take the work to be photographed, send out digital images, then I clean my studio and start again. It isn't hard to let go of a piece; I'm always chompin' at the bit to start again. Often I work on three pieces at a time, each being at a different stage."

Sometimes the toughest part of finishing a piece is looking at it with a critical eye. You've put in the hard work and now have the result in front of you, and you must decide whether or not you created what you envisioned and how you feel about that.

For many of the artists, it's important to get the finished work out of the studio and into the world. Sometimes they're just tired of it, and sometimes they're tired of tinkering with it. Bean says, "Usually, I'm elated when I finish a piece. Then three months later I hate it and can't look at it. Then a year later I see the beauty of it, and I can't bear to part with it. The best thing for me to do, then, is to get it out of my studio and into the world before I've had a chance to change my mind."

Sas also has no trouble sending her work out of the studio. She says, "When I finish a work, I usually spend a lot of time just looking at it, in a kind of trance. Then the next day I begin something new and am no longer interested in the piece I just finished. The interest is always in the process of making. I decided early on that everything I made would be for sale. In a few cases, I'll decide that a piece needs to stay in the family. My daughters want everything I make and don't like to hear that a piece has sold."

When Michael finishes a piece, he reports that he always says, "Thank God (or whoever) I got through that." He says he feels relief, and admits, "The sooner I get it out of my sight, the better. Once a piece is completed, I've done my job. I suppose it's kind of like being a channeler. I reached in and found something from somewhere else. At this point it is time for the piece to say what it needs to say, and this can only be done out in the world. It's an intriguing idea to think of the lives my work experiences without [me]. It's quite nice to think about the various eyes looking at my little creations."

You might think artists you admire would surround themselves with the very work you would love to have surrounding

Scott, too, knows about the vagaries of the mind. He says, "I do not like my work sitting in my studio staring at me. I tend to want to rework things that I did in the past. I don't like looking at work I did even if it's only a year or so old. I am much happier when someone else has it in their home or gallery." He puts his work on his Web site as soon as each piece is finished, and he's so popular that it sells immediately, which prevents that urge to tweak just one more tiny detail. These are two of his 2007 works: *Octopus 2* (at left) and *Deer 1*.

Take a piece of work you've finished and exhibit it: on the wall, on a table, somewhere you can see it throughout the day. Take time to stop and really look at it as if you were seeing it for the first time. How does that feel? Can you step away from the work enough to imagine it was made by someone else? Notice any itching to tweak the piece, but avoid the scratching of that itch! Instead, study the work as if you'd gone to a lot of trouble or expense to have it in your home.

try this

you: their collages on every surface, their quilts on every wall. Again, though, that's not always necessarily so. James Michael says, "This touches on one of the most significant revelations I've had recently about my own life as an artist. As I've finished more and more art, and inevitably had to find places for it, I've learned that I really don't care to have much of it around. … I love making the art, and I love when a piece is finished and it seems successful, but then I'm ready to go on to the next thing and only want to see my work in the gallery or someone's home or some beautiful exhibition space where it can fulfill its purpose in the eyes of others."

Many artists work this way, assuming from the beginning that everything they create will go out into the world. Melissa says, "I create everything—with very, very rare exceptions (and these exceptions are experiments)—for sale. I have only between fifteen and twenty pieces that have never sold, but I still like them well enough to lend them to shows. And among the unsold pieces are some of my favorites." All of the other work, though—and there has been a lot of that, over thirty years—has found new homes.

"I can't say that I am either excited or let down when I finish a piece," Kelly says. "The next idea is always waiting for me in my journal and files." She made this *Four: Red Crosses Peregrine Visions* coptic-bound comments book from hand-made, painted book cloth embellished with metal *milagros* fabricated by Rhett Johnson.

Sometimes that finishing-a-piece feeling is good, and sometimes it's not; and sometimes it's a little of both. Kelly says, "It is a good feeling when I finish a piece because, as a rule, right towards the end, when I'm about 80 percent done, I get a knot in my stomach because I'm not sure if the piece will be what I had envisioned. I also know, though, that if I get that knot, it is going to be a success. But I still have a cold chill until I get over the hump. ... [Then] I usually take a day or two away from the worktable to do paperwork, research, tidy up the studio or shop for groceries and run errands. It is not difficult to send one of my babies out into the world, since that is what it takes to allow me to continue. Selling a piece means grocery money."

WORKING HARD FOR THE MONEY

And that's what it comes down to, in the life of a working artist: You need to sell your art in order to pay the bills, buy more supplies, continue living the creative life, whatever sacrifices it requires. Kelly adds, "Not having a steady income is a frustration. Part of living simply for me is to live within my means, so I put off buying things until, or if, I can afford them." While most artists have some other additional source of income—whether it's from teaching or leading workshops or a partner's regular paycheck—there are still the financial considerations of the working artist. What is that like, thinking of your art and money as one and the same? Does it feel odd to sell your work? Most of us would think it's a wonderful feeling, and sometimes it is; but that's not always the case.

Gail says, "I have no discomfort about people supporting [artists] by buying our artwork. It's a joy. People sometimes ask if I feel badly about selling a work that has been in process a long time, and I say that I need to make room for the next thing and the next thing. There are pieces that I make that I don't sell, such as my travel journals; and that creates a good balance." In addition to making her art, Gail also teaches workshops—a common way for many artists to supplement their income. She says, "I teach because I love to teach and have been an impassioned teacher all of my adult life. When and if I am no longer energized by teaching, I will stop."

MARKETING AND PUBLISHING YOUR ARTWORK

Adele Sciortino, a figurative artist in British Columbia (www.artillusionsetc.com), has studied marketing and has developed a wonderful packet she uses in presenting her work. She graciously offers these tips for working artists, culled from a workshop she's developing for art retreats.

JAZZING UP YOUR MARKETING!

By following just a few simple marketing rules, you can present yourself as a professional artist.

* Always sign your works. This is a big part of marketing.
* Keep tags simple. A nametag to match the theme of the art is good, but a simple elegant nametag will do. Tags should include the name of the piece and your name. On this tag you can add your Web site and phone number.
* Create professional-looking business cards. Your cards should be clear and not cluttered. A nice logo or a picture of your best work included on your business card is always a good idea to start branding who you are. You can create inexpensive business cards with kits found at most office-supply stores.
* Have professional letterhead and envelopes. These items are a bit more expensive, but you still can achieve a professional look with elegant paper and professional fonts on your computer. This should always be a part of your marketing communication package when composing letters to editors and prospective customers.
* Keep an address list of potential buyers. This list can be gathered from communications with potential buyers and interested viewers. Always announce a new piece to your mailing list and include a picture. You never know when they may want to add to their collection.
* Compile a portfolio of your best work and keep it updated. Be prepared if someone wants to see your work.
* A Web site is great, but you have to direct people to see your site. Notify your mailing list and organizations. A clean Web site with good-quality photos of your work is important. Don't clutter it up: Show off your artwork in the best manner.

MAGAZINE AND PUBLICATION SUBMISSION

Getting your art into magazines and books is an important part of marketing your work. Here are some tips:

* Use the best materials you can afford to submit your work. Well-made pieces get noticed.
* Take good, in-focus photos of your artwork on a plain white background.
* Send high-quality photos to the editor with a full description of your work and a bio of yourself.
* Always check submission guidelines before you send your work. Most publications require that you submit your photos at least six months in advance.

Materials in Adele's own marketing packet, including custom letterhead, envelopes, business cards, a brochure and a media kit.
Photo by Adele Sciortino

THE ARTIST'S WEB SITE

If you're an artist who wants to get your work out there, you must have a Web site. Even if you hate technology and have no desire to participate in the wonderful world of cyberspace, you must have a Web site. It's how editors find you, it's how people find out more about your work before they invite you to submit to a magazine, show or gallery. One of the most important things you have to think about when you design your Web site is what it's going to look like. It's a given that you don't want a site that includes photographs of your nephew at Disneyworld. Save that for another, purely personal site. You want your site to focus on your work and the relevant information about you: your bio, your résumé, your background. But what about the actual design of the site? You hear the conventional wisdom that Web sites must be clear, clean, easy-to-read and immediately accessible. That's good advice, usually. But what about artists' Web sites? Is there any room for creativity there? James Michael recently overhauled his site, www.jamesmichaelstarr.com, and incorporated his own funky handwriting into the text. He created a navigation system that focused on the art itself, using parts of an image as links. A few visitors to the site grumbled about this new design, complaining that it was hard to read and confusing to navigate. Here is his reply.

"I was a graphic designer for more than twenty years before I ever began doing my art, and one thing that I saw over and over again was that any design that was at all fresh or different from what people were used to seeing was usually met with objections. Naturally, something different may indeed be challenging in that it requires more of you—for instance, that you more actively 'look' or work harder to break your established patterns or ingrained habits of 'reading.' So that in itself might warrant complaints. But what I observed as a graphic designer is that, to a surprising degree, many of those with objections to unconventional visuals were unaware of what appeared to me to be an unconscious resistance to things that look different. On many occasions, I was convinced that they were actually objecting to difference rather than to the suitability of the design.

"I wonder if a little of that is what might be going on for some people in the case of my Web site, because if you look at it objectively, it's about as simple a design as one might imagine. Yes, my navigation doesn't announce itself as clearly as on most sites and fails in a couple different places, but once you get past the first couple introductory pages, the way the navigation looks (hand-drawn arrows mostly) is pretty consistent, relatively large and easily spotted. ...

"I should also note that I decided early in the design process that I'd be satisfied if nobody read the handwriting [used as a design element that conveys information about my art on my site]. That's because the words are secondary to the art itself. For one thing, I'm not trying to sell my work from my Web site, and the people I communicate with the most about my art—galleries and curators—hardly pay any attention at all to the text, but concentrate almost entirely on the images. Yes, it's helpful to be able to read the title, the year it was made, and the dimensions. But I know these things are not that difficult to read, even in my handwriting, and are relatively easy to spot within the mass of the text. As for everything else written there, I believe that if someone wants to read it, they'll be willing to expend the relatively low level of energy to do so, and I think will most often respond positively to the meaning implicit in the presence of the handwriting itself, even beyond what the words say.

"The simplest way I can sum up my feelings is to say that I want my site to be as organic as possible, that I want to make 'the hand of the artist' rather than 'the hand of the HTML code writer' the most evident presence.

"All this is not to defend myself or convince anyone to change their opinion. I'm saying it because I'd like us to stop and think about the things we make, to alert us to the opportunities we have to make a difference in the visual world we're helping to create, and to encourage young artists to push the envelope. We can turn so much of the everyday things we touch into art, and sometimes, as with art itself, that means making something challenging, not easy, not normal, and definitely not just about functionality. It disappoints me to see artists creating wonderful things in their art and then leaving everything else in their world very conventional and mundane, when they could have such a powerful influence in so many spheres."

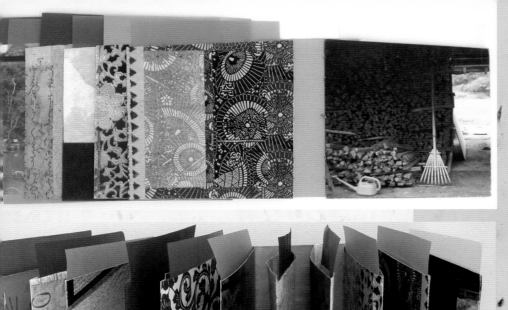

Gail says, "Since I am married to an artist, it's been a challenge to live and work in Santa Fe. Some years have been bountiful, some not. It's a wild ride for sure, not for the security-minded or the faint of heart. We've learned a lot about this process in the many years we've been attempting this near-impossible feat. Commercial concerns are never part of the decision to make an artwork. Some work needs to command a high price, and some can be sold for considerably less. I am delighted when something can be sold inexpensively because people of varied incomes should be able to buy and live with quality art. I would love it if people who wanted to support the arts would supply the financial needs of a chosen artist for a year so they could create with no thought given to earning for a specified period of time." *Wonder Wander*, a suitase travel journal she created in honor of her 2001 trip to Kyoto, is shown here in several parts. Counterclockwise: an envelope book splayed out and lying flat, a packet of Japanese handmade paper, an "introductions book" (which she shared with strangers on her travels), a photo-filled "flag book," and the contents of one of the envelopes.

Photos by Gail Rieke

Sas says, "I'd tell beginning artists to develop a skill that makes good money. I know artists who are also art administrators (I've been one), accountants, nurses, real estate agents, teachers, house cleaners, carpenters, plumbers, etc. They should know it's highly unlikely they will be able to support themselves making art. Artists who are big sellers at one point in their careers often find that fashion changes, and their next body of work is not as well received. It's necessary to understand how your particular part of the art world works as a business. … You have to figure out where your work belongs." Sas titled this 2003 piece *Communicating in the Late 20ᵗʰ Century.* Photo by Kate Cameron

Sas also teaches, and she says, "I've never been a commercially viable artist. In addition to teaching, I've held part-time jobs and found other ways to make money besides selling my art. I've been teaching in workshop situations for more than thirty years now. My teaching is directly based on my studio experience and is an important component of my work." Sas goes on to add to what Gail said about creating art that is affordable to a diverse audience. "I love making money from selling art. The only problem for me is the eliteness of creating things that only prosperous people can afford to buy. Since I don't make much money selling my art, I've entertained a fantasy that the only way someone could have a piece is if they ask me for it and we agree on some kind of an exchange or trade. My criteria for giving it would include how much they loved it and wanted it, and how much it would enhance their life and how much I wanted them to have it! I've never acted on this fantasy, which is rather like a conceptual art piece than something that's possible to activate." Many artists do trade artwork with each other, supporting the network of working artists. It's a wonderful way to increase your collection of art you love. The problem arises when you're trying to support yourself by making art: Trading your work

for art, or for services or supplies, doesn't pay the water bill or put gas in the car.

Sas says, "I've always spent all my money on my art. The costs of good photography, framing, printing, announcements, travel, etc., have always been beyond my means; yet, somehow, I've managed. If I'd had more money, it would have been spent to accomplish these tasks better. I'm a Yankee girl who was brought up to live within her means, so it's possible to say that my finances govern my art career. My 'art business' has always been a loss. It's been red ink all the way and still is. As I get older, I'm trying to bring this more into balance as both my time left and my resources are not infinite."

Melissa is one of the few artists who are able to support themselves entirely from their artwork. She explains, "My husband has an income, also, but we could make it on mine alone. This has been the case for at least twenty years, although we are now less frugal than we were in the beginning. How did this come about? Like most of life, through accidents." Early on, they bought houses, moved in, renovated the houses and sold them for a profit that they then put into the next house. "This was an especially satisfactory occupation for me because, during the inevitable letdown

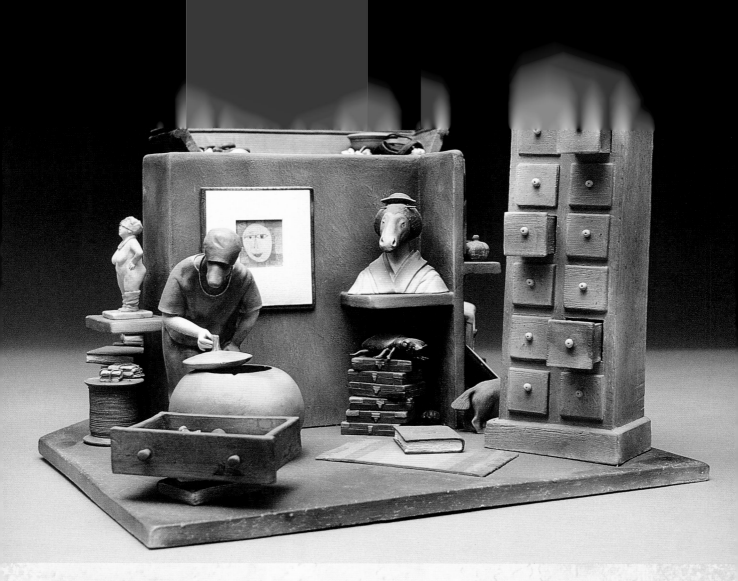

Even with financial success and security, Melissa used to worry about her career choice. While artists working as teachers or nurses or social workers might think that art is a higher calling, she thought the opposite. She explains, "I used to feel that I should be making a greater social contribution than I was. To be a teacher, a medical professional, a social worker—that was the only way to justify one's existence. ... It took me many years to accept that I do no harm, and to accept money from people who want what I have made is not a bad practice. I think of all the photographers, art material suppliers, art transporters, printers and framers whose incomes I have supplemented, and I can do nothing but say to myself, 'That's how the world goes 'round.' All I can do is say that for some unfathomable reason my work sells." She titled this 1985 ceramic and mixed-media piece *Gypsy Dog and Hattie Maxwilliam Visit the Store of Associations*.

Photo from a private collection, courtesy of *New Mexico Magazine*

after a show, I could throw myself into redecorating, refining, replanting another house and garden." Riding the crest of the real estate boom in the 1980s, they were soon in the position of never again owing money. "I remember having arguments with friends who said this was a silly way to handle money, that we could make more by putting our money in investments and carrying a mortgage, but the freedom of being debt-free was enormous. We began supporting ourselves from art by my doing scrimshaw and Nelson making jewelry. We lived in southwestern Colorado then and every six months or so would journey to Taos with our art wares. We did this until we both had shows in Taos that were successful. That helped us to decide that we could make a better living from art being in Taos.

"One of the most important things that Nelson ever told me was to invest in myself. I had had a pretty successful show. It didn't mean we had a lot of extra money, but he insisted that I buy a slab roller for my ceramic work. It paid for itself many times over. Our show profits almost always went into better kilns, computers and a color copier, stamp-making equipment, compressor and spray equipment, good saws and grinders.

"Of course, every time I changed direction in my work, and I did that regularly, I was frightened. 'This time it won't sell.' I couldn't even be telling this were it not for the galleries that have supported me. To try to sell my own work would be a devastating experience."

She then points out that when she thinks she's worrying about money, it's usually about something else. "The real anxiety was not over money but over ego. Perhaps one of the most difficult aspects of art these days, particularly here in Taos with so many artists and galleries, is that money has become the most common way to judge success. If you make a lot of money, it means you're a good artist. But most of us know that selling just means selling. Bad things sell as well as good things. People's reasons for acquiring art are often shaped by fad and fashion, to say nothing of the color of a living-room sofa. For some people I know, their decision has been to make a living at an undemanding job, cut their

127

"I think artists have this romantic idea that they can just make art and it will sell and they'll make lots of money by just making art," says Linda, creator of this collage, *Namaste*. "It doesn't happen that way. To be successful financially, you have to be a good business person."

expenses to the bone, and use all their spare time to work. I think they are less anxious and perhaps happier than many of the highly visible successes. They know their priorities and they have defined the struggle with honesty. They have accepted that to deal with the pressure—both inner and outer pressure—of sales is not worth the suffering. They have chosen their peace of mind."

Linda also supports herself with her art. She says, "Part of my art is inspiring others to live a more artful life, and that involves teaching and writing books. Part of being successful as an artist is realizing that your art may not necessarily be in a tangible form. Sometimes the art is in writing, sometimes in actual art, sometimes it comes in teaching, and sometimes it is a combination of all these things. I think being published in national magazines has been a bigger help because more people learned about me and my art that way. I do worry about money in the sense that I never know what to charge for a piece. I have no method for pricing other than picking a number that sounds good. So far, that has worked for me. Like most married couples, I have a spouse who works. We are a dual-income family, and I probably would try harder to sell stuff at higher prices if it weren't for the security of my husband's income. My income is unreliable, and there are times when it comes in great amounts and times when it trickles in. ...

"The irony is that the more successful you get, the less time you actually have for making art. Part of making money with art is selling and promoting yourself, your brand. You have to let go of the title of 'artist' and think bigger. Realizing that you have to be a marketing expert, a public relations person, an accountant, and the person who goes to the post office six times a day doesn't make you less of an artist. You have to be all those things in order to be successful and make money. Or, you have to have started out with enough money to hire all those people to help you."

Susan has a lot to say about this. "I have heard so many people say things like 'Oh, I wish I could just play in my studio all day, like you do!' That's bad enough, 'cause self-employed artists really get very little studio time, compared to their other-hat-wearing chores. But what's even worse is when people quit their jobs and then ask me what to do in order to make that kind of money from making art!!! Noooooooo! Crawl back to your boss and get that job back!

Advice from Susan for Those Considering a Career in Art

This self-employed, full-time-artist gig is not for chickens. The people doing it are dedicated, and we find ways to make it work. But advice to those thinking about this lifestyle: It will scare you to pieces if you need predictable income. It'll wear you out if you expect eight-hour days. But it'll save you lots of money on chic work clothes, beauty parlors and makeup if you've been dressing for success in the office. Here are the skills you'll need to have, besides creativity:

* bookkeeping
* grant-writing
* paperwork-handling (for teaching workshops)
* making travel arrangements
* record keeping (for keeping track of where your art is)
* knowing and meeting needs/requirements for upcoming shows
* financial haggling (with galleries and buyers)
* photographing your work and storing those images
* public relations
* computer skills
* networking
* foreman skills (to keep yourself driven)
* storing work
* housekeeping/studio-keeping
* organization (for sorting and tossing old files—a biggie!)

Susan notes that she could have gone on and on but got tired of thinking of it all and went off to do some painting.

"We [artists] work way more hours than most people, but yes, it's work we really believe in," Susan says. "Most of us can't even tell you how many hours we put in because the reality is this: We work whenever we're not having to be doing something else. That's the bottom line. We run into the studio every single chance we get, and we have work stations set up all over the place: around the house, in the car, in the garage, on the patio, in our tote bags. We live to make this art." This photo depicts a detail view of her 2006 quilted painting on cloth *The Punch Bowl / Star: Card #17 in the Kitchen Tarot*.

Photo by Susan Shie

Getting Your Art Noticed

James Michael says, "When I first began seeking representation, I wanted to find a way to get my slides in front of gallery owners without giving them the opportunity to turn me away. I felt that if I sent them a slide packet unsolicited, but at least made it fun for them to receive, I might get them to look without antagonizing them.

"I thought about how sometimes the most mundane mail was much more interesting if it had come from overseas. ... So I distressed some envelopes by crumpling them and soaking them in a bleach solution. I found a stamp collectors' store that sold old, uncancelled postage stamps, which I was surprised to find were still valid. Most of these were in denominations of five cents or less, and had a really vintage look to them, which added greatly to the effect, since postage of a couple dollars would require me to cover at least a fourth of the front of the envelope. I made mailing labels from old paper and used every inked stamp I could justify, adding "First Class," "Handle with Care," etc. By the time I was finished, the envelope looked as though it had gone around the world. This little trick worked like a charm and got my foot in the door with many galleries that might not otherwise have ever agreed to view my slides."

"Every single job has its drawbacks. We artists have flextime and can't be fired—those are great perks of our jobs. But unless your spouse has a regular job-job, who can afford insurance? Who has money for lots of things other people take for granted? The straight job workers enjoy lots of security with insurance, paid sick days and vacations, maybe even retirement funds." As adamant as she is about the importance of thinking this through, she admits that some artists just don't have it in them to follow the path of people who hold regular jobs—not even for the sake of security.

"Many of those people hate their work. We artists love our work—though we hate the paperwork and other stuff that's a big part of our jobs—and we know we're willing to have this trade-off. Self-employed artists must be very driven people in order to keep finding ways to make enough money to pay the bills and, hopefully, buy a little something nice once in a while. We're fighters, determined to keep living this bizarre lifestyle, where you sell something and don't know how far you'll have to stretch that money before the next sale. We want insurance and secure retirements, but we keep hoping we'll start selling well enough to have all that before we get in trouble not having it. ... But is anybody in any job secure with money? We've got so many friends who've lost their jobs or lost their health insurance and/or retirements, and they're still doing work they hate. ..."

Bean does not rely entirely on her art to make her living. "I've taught English since 1998," she says. "In the past, I taught some weekend fiber-arts classes and workshops; and although I loved my students, it took away from the time and energy I could spend on my own work." Now she teaches English at night and has her days free for the studio. This is something that may sound odd if you've always believed that the perfect supplement to making art

try this

Have you thought about helping others learn to make art the way you do? Teaching workshops can be a joy as well as a good way to supplement your income. Try taking a workshop from someone in your field whom you admire. Notice what makes it successful—or keeps it from being successful. Not all great artists are good teachers. Pay attention to the instructor, and think about whether or not this is something you want to do. Would you like preparing lessons? Would you like buying and organizing supplies with students in mind? How adaptable are you? If something didn't work during a lesson, would you be able to switch directions and move on? Make a list of the pros—"I love being in front of an audience, I love sharing my ideas, I'm really good at explaining techniques to others" and the cons—"I hate traveling and living out of a suitcase, I don't want to share the techniques I've developed, I don't know of anywhere I could teach, I get irritable when people don't follow instructions perfectly." If the pros outweigh the cons, contact a local guild or shop or private group that might be interested in holding the workshops you want to teach.

is teaching the making of art, but it's something you'll hear over and over from artists in all fields. In fact, I first heard it in graduate school, studying English and just beginning to send writing to literary magazines. It seemed like the perfect combination: writing at night and teaching writing during the day. Older professors confided, though, that the teaching during the day drains your writing energy far, far more than working at some other job—at almost any other job. I didn't believe them until I tried it myself and found that trying to teach for money the things you do for love can sap you in ways that are inexplicable. That's not always the case, of

try this

Start small: Invite a group of friends over for a free workshop. Then ask them to fill out an evaluation questionnaire:
· Did the title of the workshop grab your interest?
· Was the supply list too long or not long enough?
· Were the instructions easy to follow?
· Was the instructor both informative and entertaining? Did he make you feel comfortable?
· Did you have enough time to complete each step? How was the pacing?
· Would you recommend this workshop to others?
 Then ask them for any additional feedback, promising to be perfectly happy with whatever they tell you about how you might improve your class. Then give them snacks!

course—you might find yourself the exception to the rule (and if so, you'll be the envy of your colleagues).

For Bean, teaching something completely removed from her art frees her to create what she wants to, rather than what sells. She explains, "Since my work has been described as 'edgy,' 'aggressive' and 'startling,' I don't really expect to have much of a market, especially within the fiber arts community. When I have sold work, I feel awkward during the transaction, (that's what makes galleries so nice: they take the checks and worry if they clear!) but I end up satisfied with both the money and the buyer. Twice I have refused to sell work to people that I didn't like. I grew up poor, so I know all about money and worry. By comparison, my life now is stable and comfortable."

She offers this to artists just starting out: "I meet young artists who think they're going to make a living right away, and I think a lot of people can't stand the pressure of it and stop making art. They feel like the art must be terrible if no one will buy it. That's not true—so few people can make a living making exactly and only what they want to make, with no eye toward what's marketable. There's no shame in a day job."

Don't let all this talk about money and security discourage you. When I asked the artists if they'd give up art if they could do something else and make lots and lots of money, there wasn't anyone who said, "Sure! I'd do that!" Linda even said, "If I could make a million bucks doing something else different, I would do that and *still* make art!" It's not something you can easily turn away from, once it's taken hold of you. It is, in many cases, a path you're on forever.

There are two divergent ideas about the way artists live their lives in general. One reflects Gustave Flaubert, who wrote, "Be regular and orderly in your life, so that you may be violent and original in your work." People who subscribe to this view believe that you should save your creative energy for your art, and that you, as the artist, should stay in the background and be unobtrusive so that your art takes center stage. Rebekah says, "I try to fit in. I want people to notice my work, not my wild dress or funky boots. I think it's a conscious choice."

Some artists made that conscious decision to try to blend in after a period when they didn't. Michael says, "I suppose I am outwardly normal, more or less. I think it can sometimes be a bit exhausting living the persona of one's art. It is nice to leave it in the studio once in a while. I think that when I tended to dress more the part, I was spending so much time on the image and not enough time in the studio."

Scott, too, has made a conscious decision to tone it down. He says, "When I was young, I thought expressing yourself in every way was the best thing to do. I liked thinking I could look however I wanted, say whatever I wanted, and all that. I'd rather just blend in and not be noticed now. There comes a time when you get sick of getting judged by your looks."

There's a lot of comfort in order and normalcy. "A friend once told me I was 'too normal' to be an artist!" Sas says. "I like a sense of order around me. ... I don't think it matters how the outside world sees me—the point is to do the work."

James Michael says, "I believe the tenet that artists have license to do things other people don't is at best a conceit and at worst a way of separating ourselves from people we are afraid to commune with, sometimes called the 'other.' This is evident in the way the word 'normal' has taken on a pejorative interpretation in slang."

Most of our artists would fit in almost anywhere. You wouldn't spot them at the supermarket and think "artist"; you wouldn't be drawn to their appearances as markers of creativity. In short, they blend. And they like it that way.

But that is the majority—not everyone. There's that other view of being an artist, the one that says that because you don't have to go to a job in an office, you don't have to "dress for success" and you can adjust the things in your life—from your hair and your clothes to the vehicle you drive and even the house you live in—to fit your creative soul. Kelly admits, "I am not outwardly normal. I do not take life, or myself, too seriously. I do not wear my hair so short, wear mismatched ear bobs, and wear funky cowboy boots and clothes to shock

Bean says, "Not only does trying to dress and act 'artistically' take away from the energy I want to reserve for my artwork, but being 'normal' is a kind of camouflage. I don't like to draw attention to myself. I am so outwardly normal that people are shocked when they find out that I'm an artist, and then doubly shocked when they see what I make. Last year I went to an art opening and was introduced to an artist by a mutual friend. The artist said, 'You're Bean Gilsdorf? I can't believe you're the girl who makes all those gun quilts! You look so sweet!'" She painted her *Sweet Prince*, shown here in full and in detail, on cotton that was commercially quilted. It measures an impressive 54" × 444" (137cm × 1,128cm). Photos by Dan Gilsdorf

"My greatest joy comes from expressing myself fully, which I've grown to learn is integral to my happiness, even if it goes against the norms of society," Violette says. "In doing so, I give others permission to do the same. I've mentored teenagers and had them return to me and let me know how simply knowing me and speaking to me has influenced their lives and helped them embrace who they are more readily.

"Being different is not a ploy to get attention; it's simply an innate desire to express myself fully. When I do that I become happier. Being different seems to encourage creativity and uniqueness. I'm happier when I dress funky and am ecstatic when my environment reflects who I am. When you walk into my home, it's as if you are walking into my soul. People have told me that, and it's the most wonderful compliment anyone could give me." This piece, *My Bedroom Sanctuary*, is from Violette's tiny sketchbook.

anyone. I dress for myself, what pleases me—not what is in style. I must confess, though, that I enjoy the shocked looks I get when I go out in public. It makes me laugh."

And then there's Violette, who lives in the Magic Cottage, a house she painted and embellished exactly as she wanted. Local schoolchildren come in for tours, and their teachers love showing the kids through the home of a working artist—especially a home that's unlike any other, anywhere. When she leaves home, she drives a mobile version of artistic expression: The Glitter Girl Van. "Oh, this is a really good and wonderful opportunity for me to be honest with whoever will listen about embracing the real and authentic us without restrictions!" she says. "Just the other day I told someone that it's important to be one person all the time because it's easier to remember how to be you, rather than scanning your memory as to who you should be with a certain group of people. I would not say that I am outwardly normal by societal norms. I'm very happy to report that. Many have even called me eccentric. My home appeared on *Weird Homes TV*, and my van appeared on a show called *Head over Wheels*. I receive much media attention for the way I live my life. My happiness is inextricably linked to giving myself permission to act, dress and live the way I wish to live. I'm fifty-one and have been told that I should cut my hair, not paint my shoes or live in a colorful home, etc. Societal rules are stifling to the creative spirit and are meant to be broken. I question the status quo all the time. Some folks think I drive a painted and embellished van because I want attention. I painted the van because my relatively conservative yet wonderful and supportive grown children encouraged me to do so. I was delighted because I had always wanted a moving piece of art that was inspiring and that would encourage a community dialogue. As I approached my van one day in a parking lot, I noticed a woman reading the sayings and crying. I felt very timid as I moved towards her to ask if she was okay. She said she was a bank teller, but her true bliss was to be a jazz singer. She had been reading the sayings 'Live your life out loud' and 'Follow your bliss.' ...

"I just came to realize that the real reason why I dress the way I do, drive a painted van and own a magic cottage is

because I am being the person I needed in my life when I was younger. In a way I have fashioned myself into the mentor I had always wanted. I teach a nine-year-old girl art once a week, and it pleases me to no end to give her the encouragement to be creative, different and unique. ... It is as if I'm going back in time and creatively feeding the little Violette who desperately wanted and needed the love and encouragement to be herself."

Fortunately, there's room for us all; there are no rules for how you must live the creative life. Wendy Hale Davis says, "I have pretty much lived my life like I wanted to. I made a decision when I was twenty-three to have an interesting life." She lived in a commune and on a Sioux reservation and studied with medicine men, and then traveled across the United States. She admits, "I do have some regrets; I wish I had lived in a foreign country when I was young. Instead, I came to Texas." (Well, like Texans say about Texas, "It's a whole 'nother country"—so maybe she really did live in a foreign country.)

Along with no rules for living a creative life, there are no real perks—no guaranteed fame, no unlimited riches. What is it, then, that makes the creative life so very attractive? Sure, it's about being able to express yourself, in whatever form that takes. It's about being able to make time and space for your art. But what else is it that keeps so many chugging happily along year after year, no matter what the sacrifices?

I asked the artists what they find most satisfying about making art: The making itself? Seeing the finished work? Sharing it with others? Knowing you're leaving something behind after you're gone? What is it

Gail says simply, "I give myself permission to play." She titled this piece *Evening in Paris*. Photo by Zachariah Rieke

"Live your life out loud!" What does that mean to you? What would you change about the way you live if you had permission to do whatever you wanted? Would you, like Violette, drive a painted ride? Or would you wear art—on your clothes, or as jewelry, or maybe even a tattoo—on your body? List ten things you could do to live more loudly, and then pick one of them that doesn't seem too scary and try it, if only for a day. Maybe you'd color your hair orange; do that with temporary hair color. Maybe you'd wear artwear to work. Maybe you'd have a piece of your art made into a bumper sticker and display it on your car. Or maybe you'd invite all the most creative people you know to a "Living Out Loud" party, where you'd dress in your most flamboyant clothes and toast each others' creative spirits.

Wendy Hale Davis enjoys all the aspects of creating, from the work itself to holding the finished book and paging through it. She likes the idea of creating something that will be around for a while. And of her journals, she says, "I do have a vague idea of people in the future enjoying them, finding out about life in Austin, Texas, around the year 2000." This pen and ink centerfold is from her *Poco Más* journal.

that drives them when the time is tight and the money isn't there, when nobody wants to buy their work and their families don't really get what it is that they're trying to do? The most common answer was this, as summed up succinctly by Susan: "Making it, for sure!" Claudine echoes that: "The most satisfying part of making art is the creative process. I enjoy every part of it, from coming up with ideas to playing with materials." Melissa explains, "It's only the doing it. The thought that this time I'll really get 'it,' whatever 'it' happens to be at the moment, no longer compels me, although it once did. Now the pleasure of watching a piece develop and the thrill of an unexpected turn in direction is the motivation. I like seeing the finished work, but that pleasure is hardly great enough to produce the amount of energy required for the working and/or thinking. The thought of leaving something that will remain after I'm gone makes me laugh."

Bead artists Kelly and Rebekah both mention the act of beading itself as a form of meditation. We're talking hours and hours and hours of beading, an art form that requires true passion and dedication, not to mention strong fingers and good eyesight. Rebekah says, "I embrace its meditative qualities. Quiet moments turn into hours. Seeing a piece take shape, bead by bead, is very satisfying." Kelly adds that being able to use the vintage beads and lace and trims and

buttons that others have discarded is her own form of recycling, allowing her to give life to something that would otherwise be wasted. That idea of making good use of resources, often by recycling discarded material into new artwork, is an important concern for many artists who see the rampant consumerism and waste of modern life as a real problem—and a very frightening one. Combating that attitude and finding ways to spark awareness in others is difficult, but many artists see it as a responsibility they embrace.

But not everybody feels that way (and by this point, that shouldn't surprise you). Michael says that leaving something behind after he's gone is the most appealing part for him. He takes the things others have discarded and gives them a new life—and leaving them behind in that new incarnation, knowing they'll be valued instead of tossed out, is a really good feeling.

Sas says, "Since I've been making art for more than thirty years now, I have a sense of my evolving work and my accomplishments. My work has been published, so it is on record, and students come to me for guidance. One does live on in the work, and I like leaving a legacy of influence and inspiration. There are times when I feel I got it right!"

Another kind of social responsibility is in stirring the creativity in others. For Violette and Linda, that soul

stirring is a really vital part of what they do. They believe that inspiring others to live creatively is a part of the art they create. Violette explains, "The most satisfying part of the creative process for me is the act of creation and then, of course, being surprised at how it all came together. Knowing that what I've created has brought joy and inspiration to someone else is also very gratifying. More than actually leaving something concrete behind, it's important that I've made a difference in someone's life, whether it be to inspire them to embrace their authenticity or to encourage them to also be creative and discover the same joy that I have."

Linda adds, on a practical note, "Finding a way to make a living off my art is also pretty satisfying."

Choose Your Adventure

You've already heard the artists say that they'd make art no matter what, even if they could make lots and lots of money doing something else. So I asked them if they feel they're following some sort of path, something that is leading them to a specific goal. Do they all have a plan that's been guiding them lo, these many years? Susan is the only one who offered a concrete, easy-to-follow plan on which we can all agree: "My plan is to get to where I can have a long list of buyers who all want first refusal on my newest work, which they scarf up immediately, so I can always have enough money coming in and make whatever I want to make, not having to teach or do commissions." She adds, on a more serious, less day-dreamy

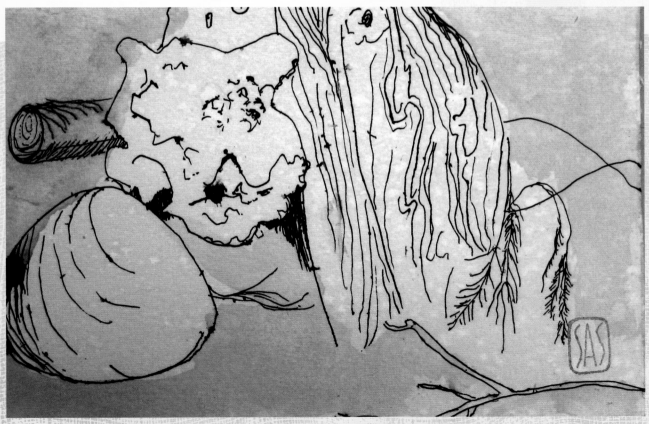

"The most satisfying thing is having others value my work, or knowing it was received and had an effect," Sas says. She created this ink-on-paper postcard at the Red Cinder retreat in Hawaii.

137

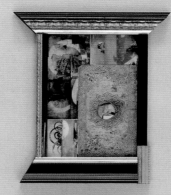

Melissa's 2005 mixed-media piece *Wall with Light, etc. et cetera,* shown here, is quite different from some of her older works. She says her ideas about her path have evolved. "I used to believe that I was on a path," she says. "I was looking for 'it,' which I would someday find. Then I would relax and just enjoy doing whatever 'it' required. I now think that I have been circling the same preoccupations, visual and intellectual. Sometimes the path is circular, sometimes elliptical. I would like to think that it is also a spiral, but that implies there is a pot of gold at the end of the rainbow or, in this case, at the center of the spiral. I don't look forward to that achievement. I think the search is the journey, and it will end only when I do."

Photo (from the collection of the Harwood Museum of Art in Taos, New Mexico) by Pat Pollard, courtesy of *New Mexico Magazine*

try this

What is the most satisfying part of art-making for you? Is it the process? The finished work? Hanging it on your wall? Showing it to friends? Hoping that someone will love it enough to buy it? In your journal or sketchbook, make a list:

* dreaming up ideas
* making the art
* experimenting with the materials
* finishing a piece
* having my art around me
* showing it to friends and family
* showing it to the public in a gallery or museum
* selling it to someone who loves it
* making enough money from my art so I don't need a day job

* becoming famous in my art field
* teaching others my techniques
* traveling around the country—or the world —to teach or show my work

Number these in order of their importance to you. It will help you think about your motivations for making art.

note, "I just want to be more and more focused and better in what I do."

For many of the others, the path has been surprising and hasn't led exactly where they thought it was going to go. Bean says, "At one point, I did have a plan: I was going to be a psycholinguistic researcher at a major university with my own lab. But the truth was that I hated being in school, and somewhere around 1999 I began to realize that I didn't want to live in the ivory tower. During the time I was figuring all this out, I was making more and more art as a way of occupying myself, and eventually I broke through some kind of wall and allowed myself to think of art making as a direction for my life, rather than a sideline or a hobby. Now I don't have a plan; I'm just going to let this be what it is and see where it takes me." She went from the pressure of university academia to a job teaching English classes at night to at-risk high school students, a situation that works well for her art life.

Sas says, "My path didn't become conscious until I was well into it. There was nothing else I wanted to do—the work chose me. I like this quote from Lee Bontecou: 'Being an artist is not a career—somehow it just grabs you.' There are milestones in any career, such as important exhibitions, being included in publications, being recognized, getting grants, doing breakthrough work, discovering a new vision and materials. These things have all kept me going. … I must be doing something right because somehow I'm able to continue, and I'm very grateful for the artistic freedom in my life."

Then there are those who say they're following a path, but it's not the straight one they might have expected. Instead, it curves and forks, and it's sometimes hidden by vines and leaves. Gail says, "I'm following my own unique path, and I'm completely amazed most of the time about where it takes me."

Violette says much the same thing, "I did have a vague plan but am sort of surprised at where I've

Scott says, "Right now in my life the most satisfying thing about what I do is the fact that I don't feel like I'm being irresponsible. I know that what I chose to do was the right thing, and I don't feel like I will ever have to get the 'real' job. Getting that monkey off my back is the most beautiful thing of all. It took a very long time, and I have a very understanding wife who helped me through all the ups and downs of trying to make it work. I don't stop and think too much about what I have actually created and what it means or where it came from. Maybe now I'll have some time to actually do that." He titled this 2007 work *Antler 2.*

Think about your creative path. Sketch it in your journal. Has it been a fairly straight creative shot from childhood, like Linda's, or one with many wonderful forks, like Michael's? Is it a path you've chosen, or did you stumble onto it and decide to see where it leads? Mark the place you are right now, and then go from there, making note of the markers and milestones and scenic vistas you hope to encounter along the way. Is there a finite goal or destination at the end, or does your path continue on to the horizon, taking in the view and bringing new surprises around each curve?

"I think I'm on a path, but I find I'm trying to notice the forks in the road," Michael says. "More and more I try and take the interesting path, as opposed to the safe path. Isn't that what being an artist is all about? What is fascinating is that the interesting path seems to be where most of my opportunities have occurred. I think the safe path can lull people into sleep. As a friend of mine says, 'Say yes to everything.'" This piece is titled *Señor Calisto*.

ended up so far. It began with the movie *Field of Dreams*, which I bought to motivate me to achieve my dreams. That was about six years ago. Things seemed to snowball from there. The message to my soul was 'If you build it, they will come' . . . well, they will come, but you do have to have something to say in order for them to come and you have to be really passionate about what you're doing, because there will be many instances when you're on the path when you simply want to throw in the towel and just go get a regular job. An all-consuming passion is essential in order to keep following your dreams and not be overly daunted by the inevitable setbacks."

James says, "I'm following a plan in the sense that I have an image of where I'd like to be at different points in the future, but I also realize that peace comes in bending with the wind and knowing that things cannot always go the way I'd like them to, that it's not a race, and that the main thing is that I'm doing the work I love." If you enjoy what you're doing as you go along, the scenery will be more spectacular and the ride will be smoother.

Wendy Hale Davis also says she's following a path. "But don't ask me where it's going. It's one of those things where you don't know where it's going, but you're not surprised

Linda says, "I feel like I'm following a plan dreamed up when I was a young girl. The plan changed a bit as I grew up and circumstances changed, but overall I am living my best life. I don't feel like I was born to be an artist. I feel like I was given a certain situation and certain choices, and what I did with them determined where my life is today. As with any business, you have a plan and goals; and when your business is your art and your art is about your life, it is everchanging." She titles this collage *Energy*.

when you get there. I do have a plan. I've even written it down. I just keep misplacing it and seem to have trouble sticking to it; but I'm working on that."

For Kelly, one of the most important considerations in her creative life is in living simply. She's very conscious of the footprint she will leave on the earth after she's gone. She says, "My path and plan is to live simply, to tread lightly on Mother Earth and to make 'pretties' with my hands for as long as I am able. I wrote the following words to accompany one of my Nightmarchers, [my artistic works representing] the forgotten ancient ones who come out at night: 'Upon migrating from one world to another, the Nightmarcher carried token pinches of soil from every sacred place and mountain in tiny pouches. The trailers on his ragged shift softly erased his footprints.' I hope the trailers on my ragged shift softly erase my footprints, also."

Of the path on which he finds himself, Scott says, "I'm a little surprised. I feel totally blessed that I am able to do something I love all because I followed what my heart told me, not what everybody else told me. I'll use that in whatever direction life takes me."

And that, of course, is what living the creative life is all about: following what your heart tells you. I hope that the words and advice and ideas from these fifteen artists have inspired you to really listen to what your soul is telling you. Living the creative life isn't always easy. But it's truly a lovely way to live the life you have, and it's never, ever dull. Here's to you and your very own Creative Life!

Namaste

try this

"Say yes to everything"—what a wonderful way to live a creative life! No matter what adventure, what opportunity, what possibility presents itself, try saying "yes." Pick something you would normally say "no" to and say "yes," instead—a night out dancing, a weekend road trip, a class you're not sure you'll like. You can always change your mind later if you find that you wish you had said "no."

Index

Add more inspiration to your Creative Life with these fine titles from North Light Books!

KALEIDOSCOPE
Suzanne Simanaitis

Kaleidoscope delivers your creative muse directly to your workspace. Featuring interactive and energizing creativity prompts ranging from inspiring stories to personality tests, doodle exercises, purses in duct tape and a cut-and-fold shrine, this is one-stop-shopping for getting your creative juices flowing. The book showcases eye candy artwork and projects with instruction from some of today's hottest collage, mixed-media and altered artists.

ISBN-10 1-58180-879-8, ISBN-13 978-1-58180-879-7
paperback, 144 pages, Z0346

WIDE OPEN
Randi Feuerhelm-Watts

Open yourself up to a whole new way of looking at yourself, your world and your art journaling. The *Wide Open* book and deck set is all about challenging yourself to take your art to the next level. The set includes 50 idea cards featuring mixed-media artist Randi Feuerhelm-Watts's art on one side and thought-provoking instruction on the other, plus a journal for recording your ideas and artwork.

ISBN-10 1-58180-911-5, ISBN-13 978-1-58180-911-4
50-card deck in a box with accompanying 64-page journal, Z0653

VISUAL CHRONICLES
Linda Woods & Karen Dinino

Visual Chronicles is your no-fear guide to expressing your deepest self with words as art and artful words. You'll learn quick ways to chronicle your thoughts with painting, stamping, collaging and writing. Friendly projects like the Personal Palette and the Mini Prompt Journal make starting easy. You'll also find inspiration for experimenting with colors, shapes, ephemera, communicating styles, symbols and more!

ISBN-10 1-58180-770-8, ISBN-13 978-1-58180-770-7
paperback, 128 pages, 33442

SECRETS OF RUSTY THINGS
Michael deMeng

Learn how to transform common, discarded materials into shrine-like assemblages infused with personal meaning and inspired by ancient myths and metaphors. Author Michael deMeng will show you the magic in creating art using unlikely objects such as rusty doorpulls, sardine tins and other odds and ends. This book provides easy-to-follow assemblage techniques, shows you where to look for great junk and provides inspiration for making your own unique pieces.

ISBN 10 1-58180-928-X, ISBN 13 978-1-58180-928-2
paperback with flaps, 128 pages, Z0556

These and other North Light Books are available at your local craft store or bookstore, or from online suppliers.